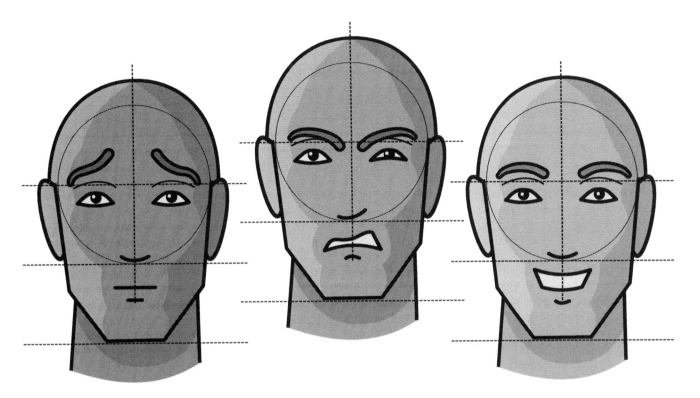

FAST FACE

HOW TO DRAW 100 EXPRESSIONS TO BRING ART TO LIFE

Event Horizon. PUBLICATIONS

FOREWORD

Designed for aspiring artists, this guide teaches you how to draw facial expressions. Learning new skills takes some effort, time, and a proper attitude, so above all else, remember to have fun along the way.

You are an artist. Your artistic spirit is a treasure no one can take from you. It is an intrinsic part of you that you are sharing with others. Respect yourself, your talent, and your drive to make the world a more beautiful, interesting, or imaginative place through your art.

At its core, art is storytelling. It is conveying thoughts, emotions, insights, ideas, hopes, and dreams. A single image can be potent.

Art is communication. Its ability to inspire, enchant, educate, enlighten, and entertain is also its power to connect people across time and space from all walks of life and through the Ages - now and into the distant future. Since the first human beings began introducing art to their environment, art has helped shape our civilization. You are their legacy - their torchbearer, bringing your vision into the light to share with others, and in so doing passing along your inner artistic fire.

This guide is a way of sharing some light.

-Brian Wyant

If you can draw very simple shapes - a circle, straight line, curved line - you can learn how to combine them to draw faces and expressions.

B.W.

FAST FACE How to Draw 100 Expressions to Bring Art to Life

ISBN 978-1-883788-32-2

Written and Illustrated by Brian Wyant Edited by Judith Hancock

CONTENTS

The A, E, I, O, U, and sometimes Y behind EXPRESSIONS

These are six major factors that influence how you decide to draw an expression on a face. Carefully take them into consideration when selecting and drawing any expression.

Attention

This is where the character is literally focused - what they are looking at or who they are attempting to influence. Sometimes their focus is the target of their expression. Sometimes the mechanics of their expression diverts their attention, such as rolling one's eyes.

Emotion

This is what the character is feeling in the moment. Sometimes it is not as simple as matching what appears on the surface of their face, such as crying when overjoyed.

Intention

This is the inner goal of the character. They may be sincerely reacting to unfolding events or they may be plotting to deceive someone such as feigning injury or playing along with someone to get out of a bad situation.

Occasion

This is the present situation enveloping the character, which can have a decisive impact on their reaction, such as determining whether they remain calm or lose their cool during current events.

Understanding

This is understanding any personality or background-related factors of the character that influence the selection of the most appropriate expression. For instance, in the presence of something specific, under certain circumstances, or in a particular setting, the character may instinctively or accidentally exhibit an entirely different expression than the one they would otherwise display.

You

Sometimes as a storyteller you have a reason to show an expression even if it appears to contradict all other factors in determining the correct one. In this case, it is your prerogative as an artist to do so as long as you are confident in your reasoning and purpose.

Simply changing the expression instantly alters the meaning of other story elements like comic book thought and speech balloons.

INTRODUCTION

Expressions are the sparks that give your facial drawings life. They ignite that very important connection with viewers.

To create expressions, you have to learn to draw faces. There are different approaches and styles to faces. You may have your own that you decide to adapt, but if you don't know how to draw faces, this book also teaches my approach as a framework.

Drawing faces can seem intimidating at first, yet step-by-step, line-by-line, with a little bit of practice you will not only acquire the skill to create faces but also master how to bring them to life with expressions.

If you can draw very simple shapes - a circle, straight line, curved line - you can learn how to piece them together to draw faces and expressions. Each step along the way is easy but is also very powerful and effective when combined with other steps.

This manual teaches how to draw facial expressions **using the minimum number of lines necessary** - a very important skill to acquire. Rules of optics dictate that the farther objects are from the viewer, the less details are visible. Facial drawings you create as an artist will often show faces at a distance rather than up close. Being able to depict expressions with a minimal amount of lines will expand the number of faces in your drawings that can hold an expression and will strengthen your overall storytelling skill set.

We'll begin by mastering the 15 easy steps to creating a neutral face, followed by the variations of facial features. Then we'll learn the facial configurations that lead to distinct expressions, and discover finishing touches to your marvelous faces.

These finishing touches address elements of the head surrounding the face such as ears, neck, jaw, and hairstyles. Contours are also explained along with proper shading for those faces you want to enhance with highlights and shadows. This guide also augments your training with the easy steps to creating facial features close up so you can add expressions to faces drawn both far and near to the viewer. Lastly, we'll learn variation as well as cover a range of extras.

GETTING STARTED

Before beginning, there are three helpful things that will make your efforts even easier.

First, you'll need these basic supplies to use this book: a pencil with an eraser, a pencil sharpener, and sheets of paper to practice your new skills.

Second, you need to give yourself a break. Learning any new skill takes practice and you'll get better with practice so don't beat yourself up while you are learning. You can do it if you give yourself permission in advance to mess up, to fix any mistakes, and to let yourself screw up without getting down on yourself. A pencil has two tips. The one with the eraser is as important as the tip with the graphite. Mistakes mean you are learning. They are what it takes to learn or improve any new skill. Number and/or date each drawing. Keep your first drawing attempts and compare them to your 20th drawing, your 100th drawing,

then your 300th drawing. You'll witness your skills steadily develop with practice.

Third, think about the amount of pressure you apply when you use your pencil. A low amount of pressure lets you draw very lightly so you can easily erase lines, while applying a high amount of pressure gives you solid pencil lines, but they are not easy to erase. Always keep that in mind when you draw. Drawing lightly when you create guidelines, for instance, makes it easier to erase the guidelines after you finish adding features to a face. If you use a low amount of pressure to draw a facial feature, you can always go over the light lines a second time using greater pressure to make them more solid once you are satisfied with their shape and placement.

CREATING A FACE

There are 15 steps to creating a face. The first six steps are setting up quick, easy, and effective guidelines followed by nine steps to build facial features. The guidelines are vital for proper placement of features. They also empower you to scale your original creations whenever you want to draw them with different expressions while keeping the features in correct proportions.

The nine steps that build facial features will produce a face with a Neutral expression. This Neutral Face shows all the features in a relaxed position. It is the default expression from which all others are measured. When you develop a new character that you plan to draw with varying expressions, begin with the Neutral Face of your character to use as a reference model.

1 Draw a circle. This is the **Circle Guideline**. Draw all guidelines lightly to make them easy to erase.

2 Draw a vertical line down the middle of the circle, halving it. This is the **Center Guideline**.

3 Draw a horizontal line through the middle of the circle, halving it. This is the **Eye Guideline**.

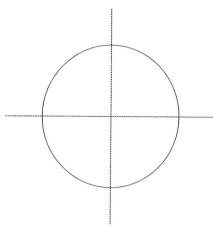

4 Draw a 2nd horizontal line that touches the bottom of the circle. This is the **Nose Guideline**.

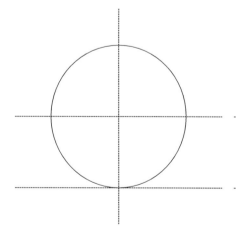

5 Draw a 3rd horizontal line below the circle - the **Chin Guideline**. Keep equal spacing between the Eye, Nose, and Chin Guidelines.

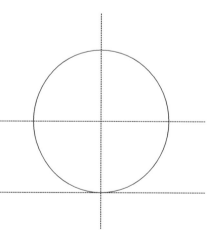

6 Place 2 gentle arcs on the Eye Guideline each midway between the Center and Circle Guidelines, using half the available space. These are **Ridge Guidelines**.

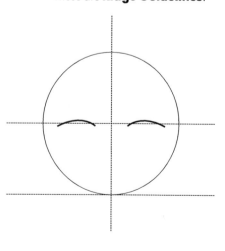

7 Draw 2 upward-curving arcs centered under Ridge Guidelines and placed below the Eye Guideline. These are the bottoms of the **Upper Eyelids**.

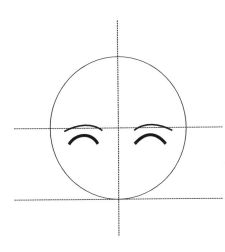

8 Draw 2 downward-curving arcs connected to the upper eyelids to create eye outlines. These are the tops of the **Lower Eyelids**, and are a quarter of the way between the Eye and Nose Guidelines.

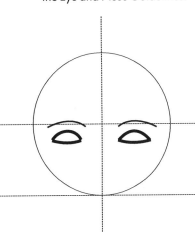

9 Draw a black filled-in circle inside each set of the eyelids, touching one lid and close to or touching the other lid. Width is a third of the eyelids and finishes the **Eyes**.

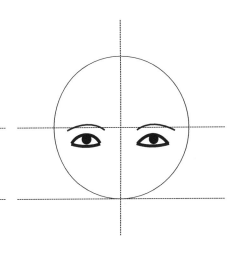

10 Draw a gently-downward-curving arc, bisected by the Center Guideline and set just above the Nose Guideline. This is the **Nose**.

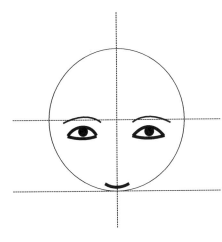

11 Draw a short horizontal line on the Center Guideline, midway between the Nose and Chin Guidelines. Above the short line, draw a longer horizontal line no wider than the space between the eyes. This is the **Mouth**.

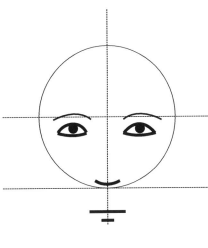

12 Draw 2 tapered arcs above the Ridge Guidelines. Make each arc thinner on the outer tip nearest the Circle Guideline, and thicker on the inner tip nearest the Center Guideline. These tapered curves are the **Eyebrows**.

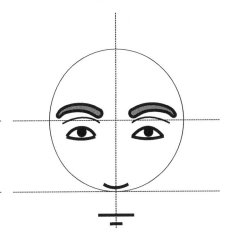

13 Starting and ending where the Circle Guideline meets the Eye Guideline, draw a symmetrical five-sided line that changes its angle at the mouth line and Chin Guideline. This is the **Jaw and Chin**.

14 To create the **Neck**, draw 2 slightly-outward-angling lines from the jaw to below the Chin Guideline. Start at the level of the short mouth line for males and midway between the short line and Chin Guideline for females.

15 Where the Circle Guideline meets the Eye Guideline, draw curves that loop up and outward from the head then down and back inward to the head just above where the Nose Guideline meets the jaw. These are the **Ears**.

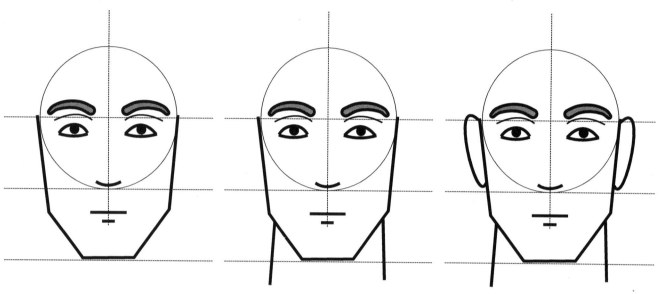

Practice

These blank guidelines are provided for you to practice drawing faces.

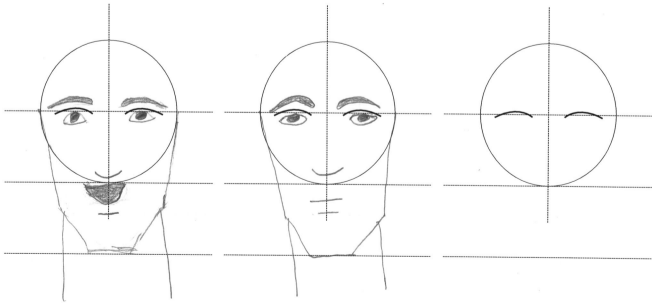

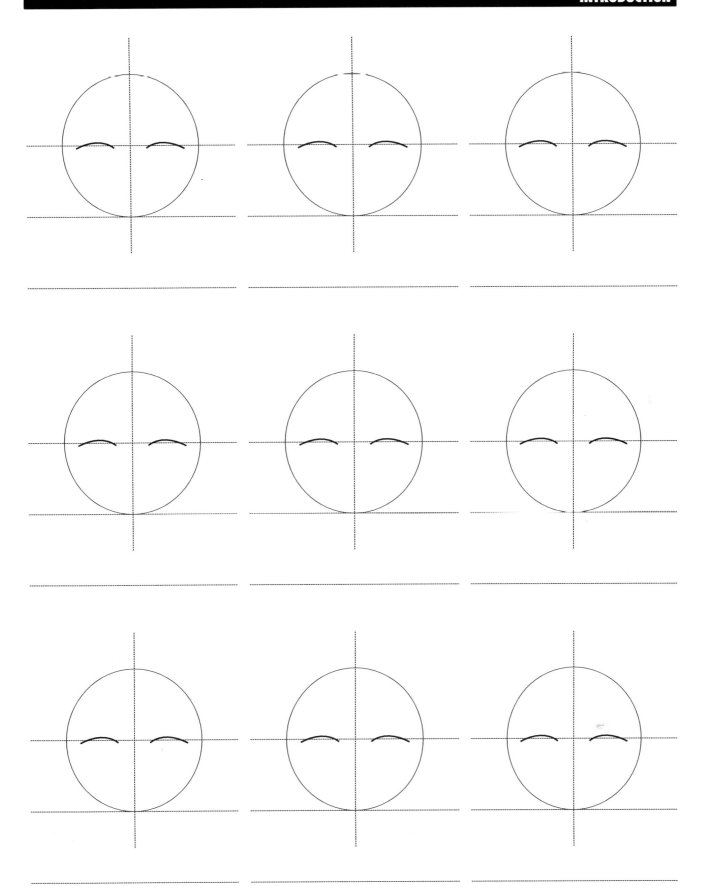

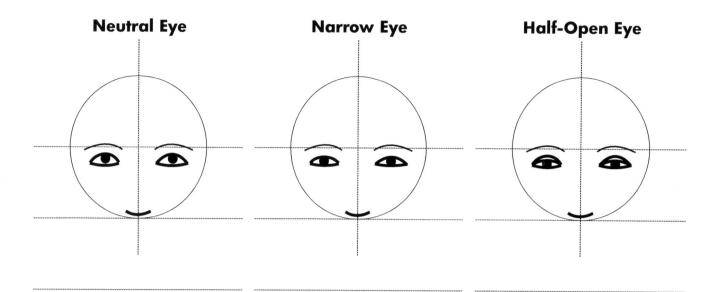

Neutral Eye **Narrow Eye** **Half-Open Eye**

EYE

A Neutral Eye is drawn with an upper line, black filled-in circle, and a lower line. The lines represent the parts of the eyelids with eyelashes, so the upper line is the bottom of the upper lid and the lower line is the top of the lower lid.

A Narrow Eye is drawn with the same three pieces as the Neutral Eye (i.e. two lines and a black filled-in circle). The gently-curving lines are drawn closer together to make it a Narrow Eye.

A Half-Open Eye has a black filled-in circle and three lines, instead of two. It is a mixture of the Neutral Eye and the Narrow Eye. Start by drawing a Narrow Eye, then add the upper line from a Neutral Eye to create the third line, which represents the top of the upper eyelid.

An Upturned Eye is drawn as a Neutral Eye with the lower line simply flipped to bend gently upward rather than downward. This upward bend represents the cheek of the face pushing up on the lower lid.

A Lower-Wide Eye is drawn as a Neutral Eye with the lower line bending downward a bit more. Draw the upper line first, then the lower line.

An Upper-Wide Eye is drawn as a Neutral Eye with the upper line bending upward a bit more. Draw the lower line first, then the upper line.

A High-Upward Closed Eye is drawn with one line that is the same as the upper line of a Neutral Eye.

A Low-Upward Closed Eye is drawn with one line that is the same as the lower, upward-bending line of an Upturned Eye.

A Downward Closed Eye is drawn with one line that is the same as the lower line of a Neutral Eye.

SPACING

The space between two eyes is the same distance as the side-to-side width of an eye.

Divide the distance between the Eye Guideline and the Nose Guideline in half. Split those halves in half again, so the distance between the Eye and Nose Guidelines is divided into quarters. Neutral eyes rest on the top quarter line.

Now do the same divisions but this time use the Center Guideline and the two points where the Eye Guideline crosses the Circle Guideline. Divide the spaces into vertical quarters. The four corners of the eyes rest on these quarter lines (see illustration).

You don't need absolute precision. Aim to have the eyes appear equidistant from the Center Guideline and the Circle Guideline. These are rough spacing goals to shoot for. You don't have to measure every time - just eyeball it (pun intended).

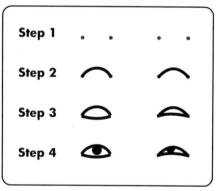

Step 1		
Step 2		
Step 3		
Step 4		

Use dots to aid in placement. Put two dots where you want the corners of the eyes then connect the dots with one, two, or three curved lines depending on the type of eye before adding the black filled-in circle, as needed for the type of eye.

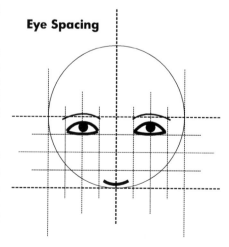

Eye Spacing

Upturned Eye
Lower-Wide Eye
Upper-Wide Eye

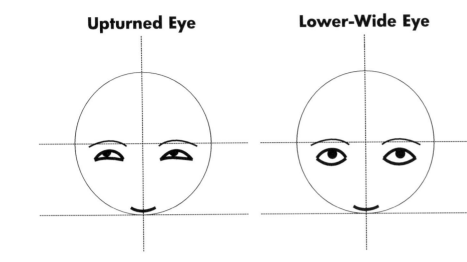
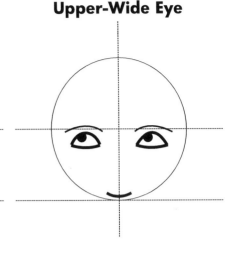

High-Upward Closed Eye
Low-Upward Closed Eye
Downward Closed Eye

LASHES

Drawing lashes is optional. They appear on the bottom of the upper eyelid and the top of the lower eyelid. Individual lashes would appear unsettling at any distance other than an extreme close-up (where they can be seen as both slender and tapered), so lashes are depicted as clustered together.

Only the lashes on the upper eyelid are depicted. The simplest way is to draw the bottom line of the upper eyelid slightly thicker than other lid lines to represent the presence of upper lashes.

On female faces, you can further depict the upper lashes by not only drawing the bottom line of the upper eyelid slightly thicker than other lid lines but also adding a filled-in black triangular shape at the upper outer corner to represent the curl of lashes on the outer ends. This roughly-triangular wedge shape with gently-curved edges resembles a tiny shark fin sticking out of the lid line and "swimming" *away from* the Center Guideline. The tip of the fin points outward from the Center Guideline and upward on all eye types except for one - the Downward Closed Eye, where it is flipped downward, points outward, and appears in a less pronounced manner. On a Downward Closed Eye, draw the fin-like shape below the lid line at half its normal height and "swimming" *towards* the Center Guideline.

Female Outer Lashes on all Eye Types such as Low-Upward Closed Eye...

...or Neutral Eye...

...or Half-Open Eye...

...except Female Outer Lashes on Downward Closed Eye

Neutral Eyebrow

Dipping Eyebrow

Raised Eyebrow

High Neutral Eyebrow

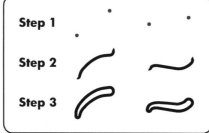

Step 1

Step 2

Step 3

High Raised Eyebrow

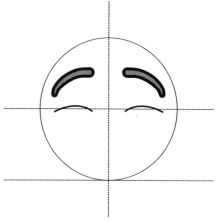

Use dots to make placing your eyebrows simple. Place two dots and connect them with a line looping back upon itself to create the hollow eyebrow arc. Notice the open space inside each tapered eyebrow. Leaving space in the middle of the arc lets you color in the eyebrows if you color your drawings. A variety of eyebrow forms are explained later, but this common tapered shape is the one used as the example for illustrating expressions.

EYEBROW

The shape of the eyebrow remains the same - a tapered line - so you only have to draw one shape regardless of the type of eyebrow configuration, but the positioning, angle, bend, and direction depends on the configuration.

The overall curve of the eyebrow may be in a downward-drooping or upward-bending direction, while the slope of an eyebrow may be either inward towards the Center Guideline or outward away from it.

When drawing an eyebrow, always base its position relative to the Ridge Guidelines and the Center Guideline.

A Neutral Eyebrow has both tips equidistant above the Eye Guideline. The bottom of the tips rest the same height above the Eye Guideline.

A High Neutral Eyebrow is the same as a Neutral Eyebrow except it is drawn twice the distance above the Eye Guideline.

A Dipping Eyebrow starts with the thinner outer tip drawn a bit closer to the Center Guideline than a Neutral Eyebrow and barely touches the Eye Guideline, while the thicker inner tip is drawn lower so it falls onto the Eye Guideline just inside the Ridge Guideline.

Slightly Raised Eyebrow

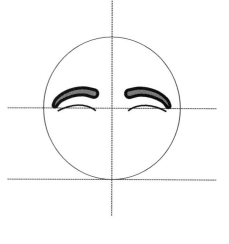

A Raised Eyebrow begins with the thinner outer tip just touching the Eye Guideline and the overall curve climbing a 45 degree angle towards the Center Guideline to the thicker inner tip, which ends up one third of the distance between the Eye Guideline and the top of the Circle Guideline. The thicker inner tip of a Raised Eyebrow winds up slightly higher the thicker inner tip of a High Neutral Eyebrow. The thinner outer tip points downward and the thicker inner tip points horizontally at the Center Guideline.

A High Raised Eyebrow is the same as a Raised Eyebrow except it is drawn with the thinner outer tip starting above the Eye Guideline instead of touching it and ends with the thicker inner tip touching the half-way point between the Eye Guideline and the top of the Circle Guideline.

A Slightly Raised Eyebrow is the same as a Raised Eyebrow except it climbs at only a 30 degree angle (if you drew an imaginary straight line between tips), with the thicker inner tip ending at half the height above the Eye Guideline.

An Outward Droop Eyebrow is created the same as a Neutral Eyebrow except it sags near the outer tip to droop downward over the Ridge Guideline to just below the Eye Guideline before gently climbing towards the Center Guideline to the thicker inner tip.

An Inward Droop Eyebrow is created the same as a Neutral Eyebrow except it sags near the inner tip to droop downward over the Ridge Guideline to just below the Eye Guideline before rapidly curling upward towards the Center Guideline to the thicker inner tip.

An Outward Slope Eyebrow is created the same as a Raised Eyebrow except as it rises from the thinner outer tip, it sags toward the Eye Guideline before reaching the thicker inner tip, which points diagonally up at the Center Guideline rather than pointing at it horizontally. If you draw an imaginary straight line connecting the tips, it slopes outward from the Center Guideline.

An Inward Slope Eyebrow is created the same as a Neutral Eyebrow except the thicker inner tip is lowered and brought inward closer to the Center Guideline, so

Outward Droop Eyebrow Inward Droop Eyebrow

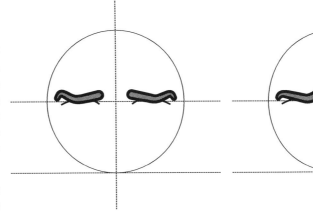

Outward Slope Eyebrow Inward Slope Eyebrow

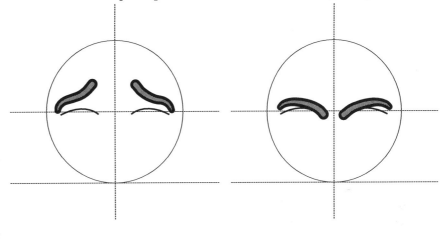

the curving arc crosses the Ridge Guideline and Eye Guideline to the thicker inner tip, which winds up below the Eye Guideline. If you draw an imaginary straight line connecting the tips, it slopes inward towards the Center Guideline.

TEXTURE

As long as you maintain the positioning and shape of the bottom line of a particular type of eyebrow, you can alter the texture at the top of the eyebrow. For instance, the top line can become furry or tuft-like. So always draw the bottom line of an eyebrow first then add any desired top using, for example, a zigzaggy or bumpy line. If you want an ultra-thin eyebrow, just compress the

eyebrow into a thin line that follows the shape and positioning of the bottom of a standard eyebrow.

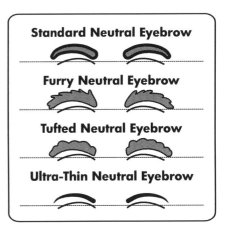

Standard Neutral Eyebrow

Furry Neutral Eyebrow

Tufted Neutral Eyebrow

Ultra-Thin Neutral Eyebrow

MOUTH

Always start by drawing the shortest line. This anchors the mouth. In every configuration on this page and the opposite page, this short line is the bottom of the lower lip. Place this line horizontally on or near the Center Guideline as illustrated and vertically at roughly the halfway point between the Nose Guideline and the Chin Guideline. A nose has been included in each illustration above the Nose Guideline as an added size comparison and positioning reference.

Draw the second mouth line, which represents the bottom of the upper lip. *This line should never be wider than the distance between the black circles in the eyes.* In configurations described as Narrow, this line should not be wider than the space between the eyes. To ensure proper placement of your mouth, you might find it easier to start by drawing two dots where you want the corners of the closed mouth (Step 1) and then connect them with the appropriate curved or straight line (Step 2).

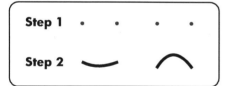

For a Neutral Mouth and a Narrow Neutral Mouth, the upper and lower mouth lines are flat. They run parallel to the Nose and Chin Guidelines.

The upper and lower mouth lines of a Closed Smile, Closed Frown, and Narrow Closed Frown cross the Center Guideline at the same vertical points as the lines of a Neutral Mouth. The difference is that the tips of the lines of a Closed Smile slightly bend upward to create gentle curves, while the tips of the lines of a Closed Frown and Narrow Closed Frown slightly bend downward to create gentle curves. It is important to note that mouths described as Narrow do not alter the width of the lower mouth line. Also, notice that the upper mouth line of a Narrow Closed Frown does not bend

Neutral Mouth　　**Narrow Neutral Mouth**

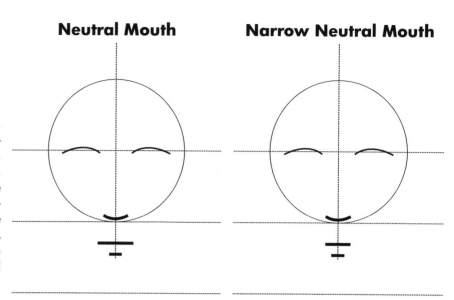

Closed Smile

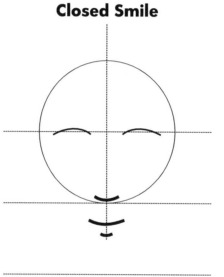

Closed Frown　　**Narrow Closed Frown**

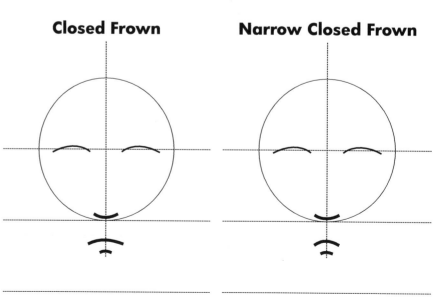

Slanted Neutral Mouth Slanted Contradictory Mouth

downward to any greater degree than the Closed Frown.

For a Slanted Neutral Mouth and a Slanted Contradictory Mouth, the mouth lines sit at a slight diagonal, with either the left or right side higher than the opposite side. It is your choice which side is higher, but keep it the same side for both lines. Instead of being evenly split by the Center Guideline, two-thirds of the upper line - on the raised side - falls to one side of the Center Guideline. The diagonal upper mouth line crosses the Center Guideline at the same place it does for a Neutral Mouth. The mouth lines of a Slanted Neutral Mouth run parallel to each other. On a Slanted Contradictory Mouth, the upper line dips slightly at the ends and in the middle, making it into two connected shallow arcs, while ends of the lower mouth line slightly bend upward in a gentle arc.

Slanted Closed Smile

For a Slanted Closed Smile, the mouth lines rise on one side or the other - your choice of which side, but the same side for both lines. Like a Slanted Neutral Mouth, two-thirds of the upper line fall to one side of the Center Guideline - the same side that rises. The lower mouth line falls on that same side but just touches the Center Guideline. Both the upper and lower mouth lines contact the Center Guideline at the same vertical spots where the lines of a Neutral Mouth do.

For a Slanted Closed Frown, the mouth lines bend downward on one side or the other - your choice of which side, but the same side for both lines. The mouth lines are centered horizontally on the Center Guideline. Both cross the Center Guideline at the same vertical spots where the lines of a Neutral Mouth do.

Slanted Closed Frown Deep Closed Frown

For a Deep Closed Frown, both mouth lines bend downward. They are centered horizontally on the Center Guideline and cross the Center Guideline at the same vertical spots where the lines of a Neutral Mouth cross it. The tips of the upper mouth line extend down to reach the same level as the tips of the lower mouth line.

In some cases, a lower mouth line will be flipped so the ends bend upward instead of downward. This reflects the lower lip pushing up and out against the upper lip.

Open Smiles, Open Frowns, and Grimaces

Always start by drawing the shortest line at the bottom. This anchors the mouth. In these configurations, this short line is the bottom of the lower lip. Place this line horizontally on the Center Guideline as illustrated and vertically at the halfway point between the Nose Guideline and the Chin Guideline.

Draw two dots where you wish to place the upper corners of the mouth and two dots where you wish to place the lower corners of the mouth. Then connect the upper dots, the lower dots, the left upper and lower dots, and the right upper and lower dots to complete the mouth, as illustrated. The left, top, and right lines represents the bottom edge of the upper lip and the bottom line represents the top edge of the lower lip. Placing the dots first instead of simply drawing the lines, ensures proper and easier positioning of the mouth. *The dots should never be placed horizontally farther apart than the distance between the outer edges of the black circles in the eyes.*

A Teeth Open Smile, Teeth Open Frown, Open Smile, Open Frown, Narrow Open Smile, Narrow Open Frown, Teeth Grimace, and Grimace have upper mouth corners equidistant from the Nose Guideline. A Lopsided Teeth Grimace and Lopsided Grimace have one upper corner placed slightly lower than the other upper corner.

A Teeth Open Smile, Teeth Open Frown, Teeth Grimace, and Lopsided Teeth Grimace represent displaying teeth by remaining white inside. When you draw the outline of an Open Smile, Open Frown, Narrow Open Smile, Narrow Open Frown, Grimace, or Lopsided Grimace fill the outline with black to represent an open mouth without teeth showing.

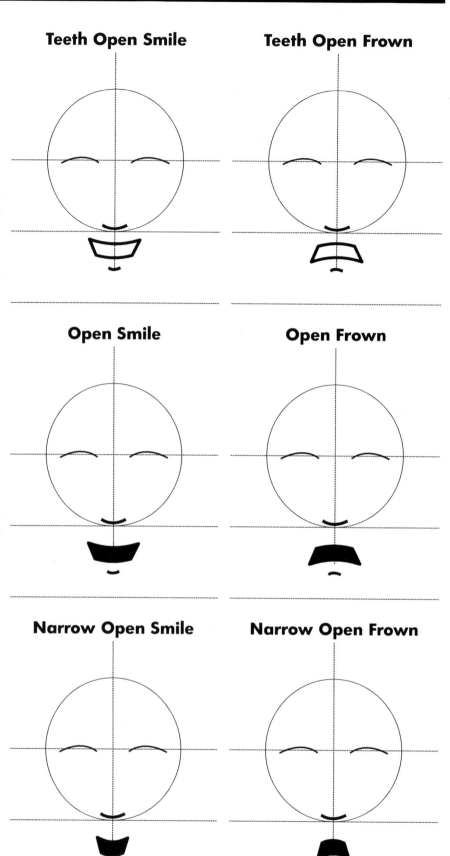

16

Teeth Grimace

Lopsided Teeth Grimace

Grimace

Lopsided Grimace

Rounded Mouth

Small Rounded Mouth

Rounded Mouth

Always start by drawing the shortest line at the bottom. This anchors the mouth. In these configurations this short line is the bottom of the lower lip. Place this line horizontally on the Center Guideline as illustrated and vertically a third of the way up from the Chin Guideline to the Nose Guideline for the Rounded Mouth, and at the halfway point between the Nose Guideline and the Chin Guideline for the Small Rounded Mouth.

A Rounded Mouth is drawn as a Grimace that has been narrowed, with the lower lip line flipped to curve downward in a semi-circle. A Small Rounded Mouth is simply a miniature version of the Rounded Mouth that is half the height and width.

Draw two dots where you wish to place the upper corners of the mouth and two dots where you wish to place the lower corners of the mouth. Then connect the upper dots, the lower dots, the left upper and lower dots, and the right upper and lower dots to complete the mouth, as illustrated. The left, top, and right lines represents the bottom edge of the upper lip and the bottom line represents the top edge of the lower lip. Placing the dots first instead of simply drawing the lines, ensures proper and easier positioning of the mouth. *The dots should never be placed horizontally much farther apart than the distance between the eyes for a Rounded Mouth, and half that distance for a Small Rounded Mouth.*

Step 1

Step 2

Step 3

Step 4

Step 5

Step 6

Step 7

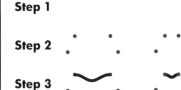
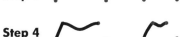

Open Grins, Gaping Frown, and Roaring Mouth

Always start by drawing the shortest line at the bottom. This anchors the mouth. In every configuration on this page, this short line is the bottom of the lower lip. Place this line horizontally on or near the Center Guideline as illustrated and vertically slightly below the halfway point between the Nose Guideline and the Chin Guideline.

Draw two dots where you wish to place the corners of the mouth. Then connect the dots using two curved lines. The top line represents the bottom edge of the upper lip and the bottom line represents the top edge of the lower lip. Placing the dots first instead of simply drawing the lines, ensures proper and easier positioning of the mouth. *The dots should never be placed horizontally farther apart than the distance between the outer edges of the black circles in the eyes.*

A Teeth Open Grin and a Slanted Teeth Open Grin represent displaying teeth by remaining white inside. When you draw the outline of an Open Grin, Slanted Open Grin, or Gaping Frown, fill the outline with black to represent an open mouth without teeth showing.

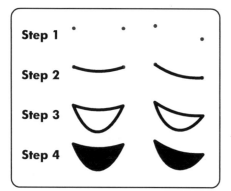

A Roaring Mouth is drawn as an Open Frown but with the line representing the top of the lower lip drawn curving downward rather than upward to open the mouth fully.

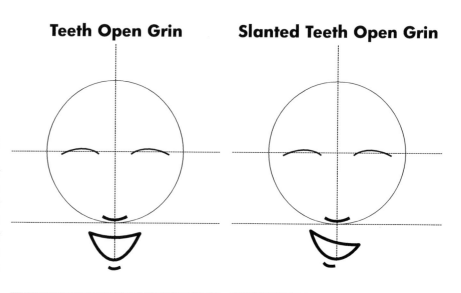

Teeth Open Grin **Slanted Teeth Open Grin**

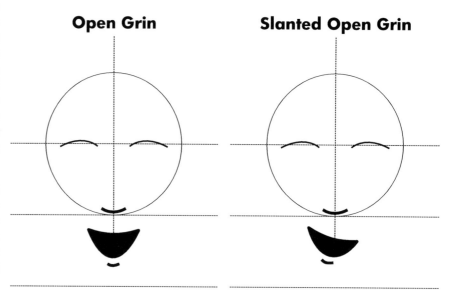

Open Grin **Slanted Open Grin**

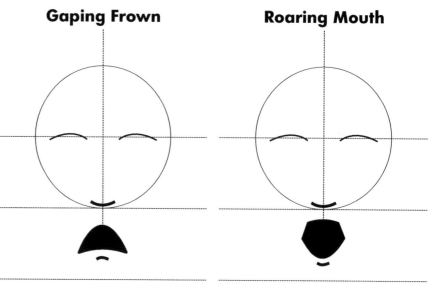

Gaping Frown **Roaring Mouth**

Neutral Nose

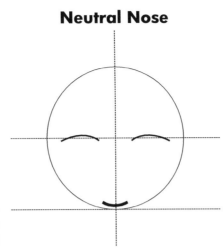

NOSE

For a Neutral Nose, draw a single upward-curving line horizontally centered on the Center Guideline as illustrated. Place it vertically just above the Nose Guideline. This curved line should be roughly the same width as the space between the eyes.

For a Slanted Nose, draw the same line you do for the Neutral Nose but lift one side of the curved line so it gently rises twice the distance from the Nose Guideline as the other side.

For a Lifted Nose, you are in effect creating a nose that is slanted on both sides, which raises the entire facial feature. Draw the same curved line you do for the Neutral Nose but place it twice the distance from the Nose Guideline to create a Lifted Nose.

To assist in proper placement of a Neutral Nose or a Slanted Nose, start by drawing two dots and connect them with a curved line to complete the facial feature.

Step 1

Step 2

A variety of noses are explained next, but this is the simplest form and can be read as a nose both close-up and at a fair distance.

VARIATIONS

Stick with drawing the single arc above until you have drawn fifty or more faces using this simplified nose shape. Then, try out the variations described in this section.

Variations of the simplified nose shape are all based on the original nose curve which represents the bottom of the tip.

Slanted Nose

Lifted Nose

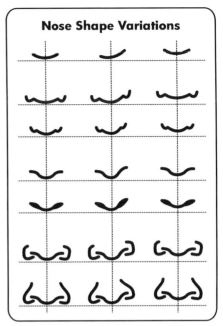

Nose Shape Variations

Some examples of nose shape variations are illustrated above. The classic original curve appears first for comparison. The Nose Guideline is shown beneath each example to demonstrate proper positioning. The first column displays a Neutral Nose, the second a Slanted Nose, and the third a Lifted Nose. Draw these variations centered horizontally on the Center Guideline as shown in each of the three columns.

The alae (the flesh coverings over the nostrils on either side of the nose tip) are shown in the first two variation examples. These are tiny downward-bending curves placed on the left and right sides of the main tip curve. One of these examples is broader and the other is narrower.

The next two examples extend the tip curve out to show the undersides of the alae. The first shows just the alae undersides flanking the tip, while the second shows the alae undersides along with the nostril holes. This second example reflects the fact that some noses have more visible nostrils.

The last two examples show the alae drawn as separate lines placed on both sides of the line that forms the bottom of the tip.

You can also develop your own simplified nose shapes. Use the section on Close-Up Details for further insight into the appearance of the lower parts of noses. Simplified shapes are bound by the size and placement rules governing detailed noses.

EXPRESSIONS

The reference list below clusters expressions with related ones. If you want an alphabetical listing, use the one in the table of contents or flip through the breakdowns on the next pages.

The breakdowns show the expressions in alphabetical order. Each one lists the type of inner features - eyebrows, eyes, nose, and mouth - required to draw the expression. After the breakdowns, the next section explains the outer features. Once you have read that section, return to this one to begin practicing.

Practice is vital to building your skills and confidence. At the bottom of the breakdowns are three sets of guidelines. Use them to practice each expression. Create unique faces that incorporate both the inner and outer features. After you fill a breakdown with your designs, continue to practice on blank pieces of paper.

NEUTRAL	DISAPPOINTED	ASSURED	STERN
	DEFLATED	CONFIDENT	SOMBER
CONTENT	DESPONDENT	COCKY	SERENE
PLEASED	HEARTBROKEN	PROUD	MELANCHOLY
HAPPY	FORLORN	RELIEVED	SINCERE
EXCITED	SAD	WORRIED	UNHINGED
GIDDY	DISTRAUGHT	CONCERNED	
MIRTHFUL	ANGUISHED	ANXIOUS	GOOFY
ECSTATIC	DISPIRITED		SERIOUS
AMUSED	DEJECTED	STARTLED	
DELIGHTED		AFRAID	STARING
	ATTENTIVE	TERRIFIED	GLARING
ASHAMED	AWARE	STUNNED	
SORRY	CAUTIOUS	SHOCKED	DISPLEASED
REGRETFUL	INTERESTED	PETRIFIED	MAD
THANKFUL	ANTICIPATIVE	DUMBFOUNDED	ANGRY
	EAGER	CONFUSED	FURIOUS
EXHAUSTED	STOKED	BEWILDERED	DISGRUNTLED
WEARY	RELUCTANT	PUZZLED	MIFFED
YAWNING	DISBELIEVING	AWESTRUCK	ENRAGED
	SUSPICIOUS	FLABBERGASTED	SNEERING
MEDITATING	INTRIGUED	EMBARRASSED	GRUMPY
SLEEPING	SLY		RESENTFUL
REMEMBERING	ENVIOUS	BLUSHING	
CONCENTRATING		SHY	APPALLED
FOCUSED	SNOBBY	FLIRTATIOUS	DISGUSTED
INTROSPECTIVE	DISMISSIVE	CHEEKY	GALLED
PONDERING	SMUG	SUAVE	SPEECHLESS
DOUBTFUL		TEASING	CRINGING
SCHEMING	DISCOMFORTABLE	WINKING	PITYING
ENVISIONING	PLEASURED	LOVESTRUCK	SYMPATHETIC
DAYDREAMING		NURTURING	EMPATHETIC
CONTEMPLATIVE			IMPRESSED
			AMAZED

AFRAID

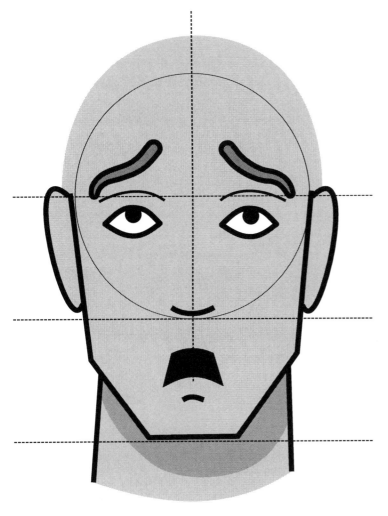

EYEBROWS
Use OUTWARD SLOPE EYEBROWS.

EYES
Use LOWER-WIDE EYES.

NOSE
Use NEUTRAL NOSE.

MOUTH
Use NARROW OPEN FROWN.

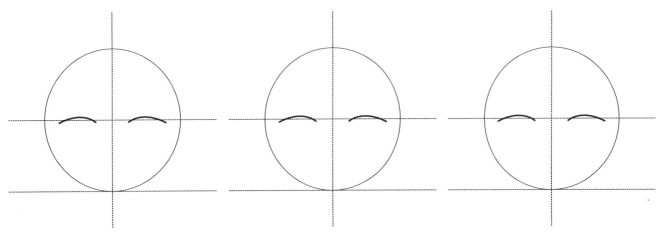

AMAZED

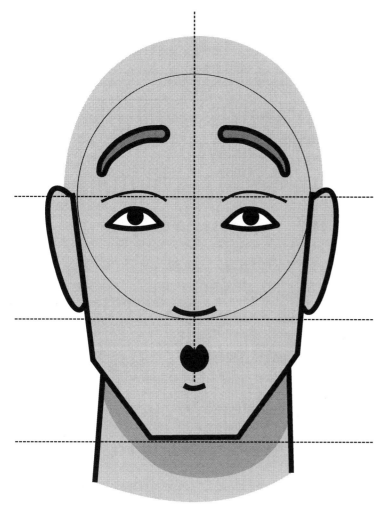

EYEBROWS
Use HIGH RAISED EYEBROWS.

EYES
Use NEUTRAL EYES.

NOSE
Use NEUTRAL NOSE.

MOUTH
Use SMALL ROUNDED MOUTH.

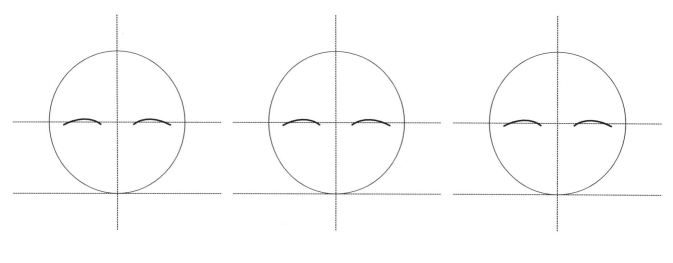

AMUSED

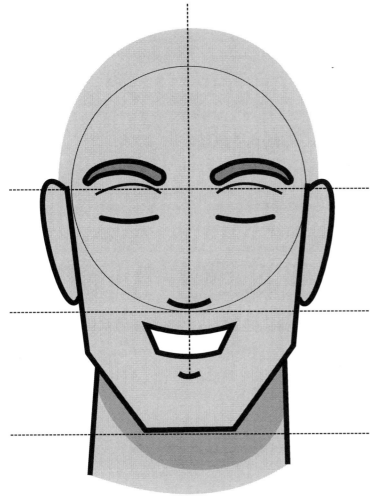

EYEBROWS
Use NEUTRAL EYEBROWS.

EYES
Use DOWNWARD CLOSED EYES.

NOSE
Use NEUTRAL NOSE.

MOUTH
Use TEETH OPEN SMILE.

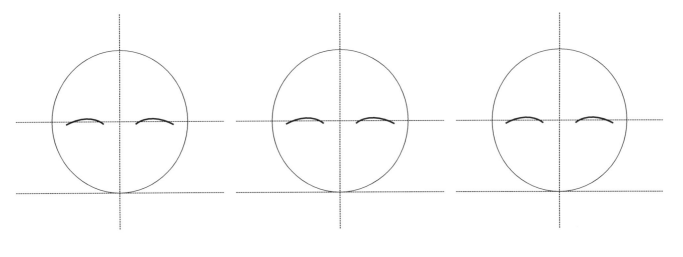

ANGRY

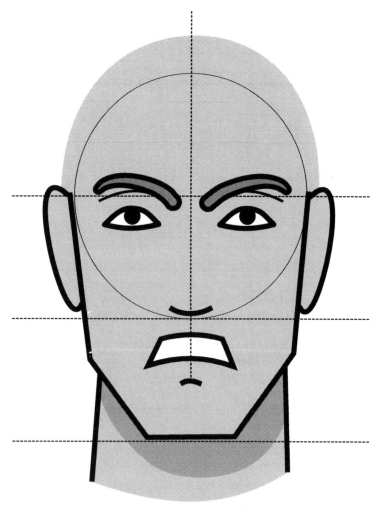

EYEBROWS
Use INWARD SLOPE EYEBROWS.

EYES
Use NEUTRAL EYES.

NOSE
Use NEUTRAL NOSE.

MOUTH
Use TEETH OPEN FROWN.

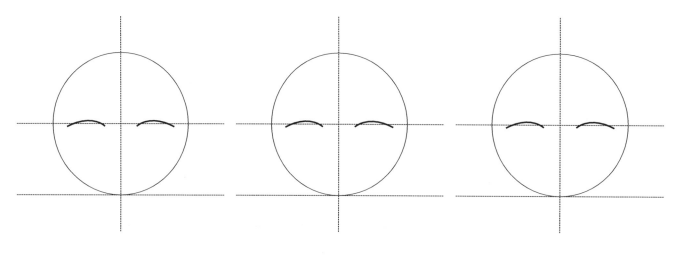

ANGUISHED

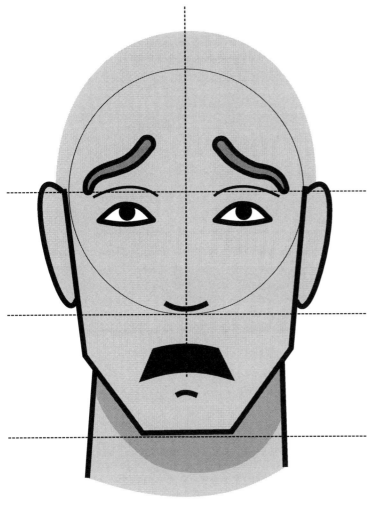

EYEBROWS
Use OUTWARD SLOPE EYEBROWS.

EYES
Use NEUTRAL EYES.

NOSE
Use NEUTRAL NOSE.

MOUTH
Use OPEN FROWN.

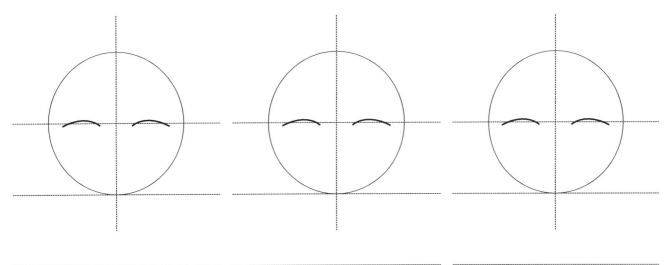

ANTICIPATIVE

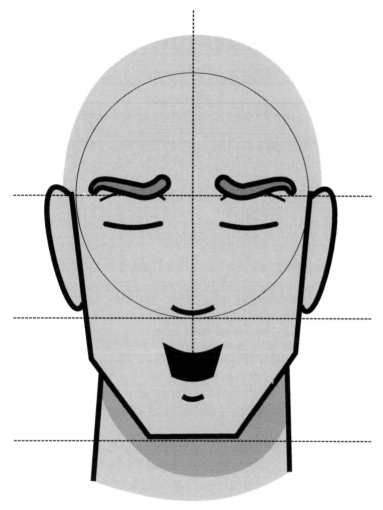

EYEBROWS
Use INWARD DROOP EYEBROWS.

EYES
Use DOWNWARD CLOSED EYES.

NOSE
Use NEUTRAL NOSE.

MOUTH
Use NARROW OPEN SMILE.

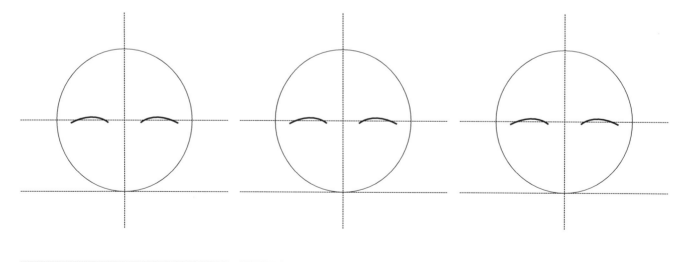

ANXIOUS

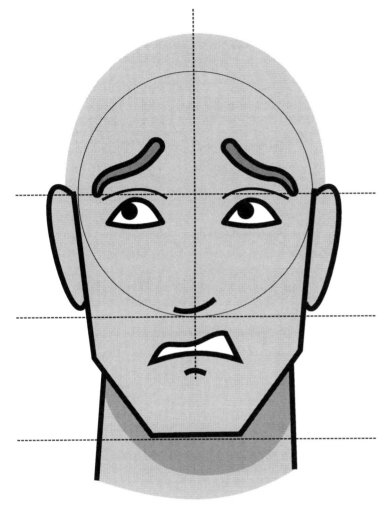

EYEBROWS
Use OUTWARD SLOPE EYEBROWS.

EYES
Use UPPER-WIDE EYES.

NOSE
Use SLANTED NOSE lifted on the same side as the raised upper lip of the mouth.

MOUTH
Use LOPSIDED TEETH GRIMACE.

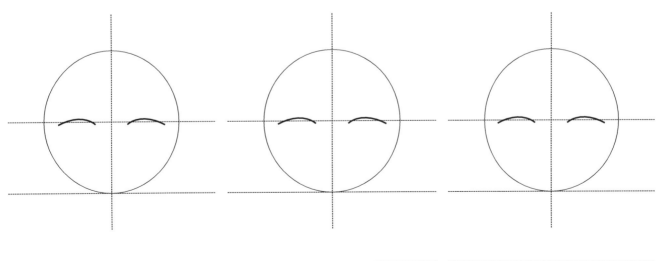

APPALLED

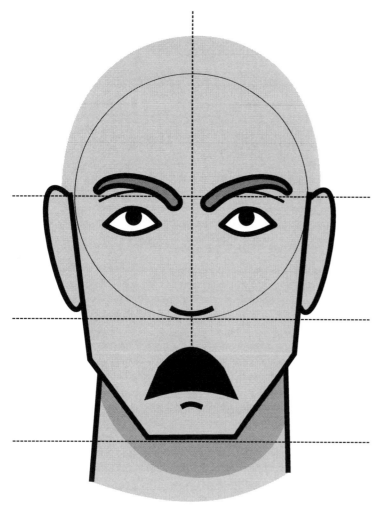

EYEBROWS
Use INWARD SLOPE EYEBROWS.

EYES
Use LOWER-WIDE EYES.

NOSE
Use NEUTRAL NOSE.

MOUTH
Use GAPING FROWN.

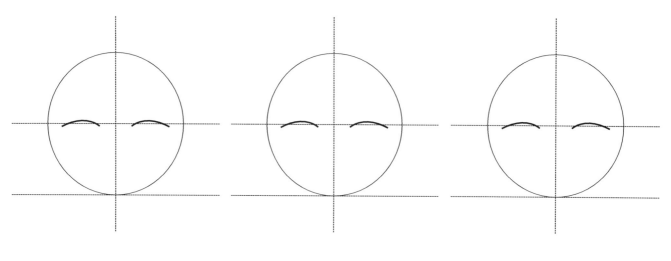

ASHAMED

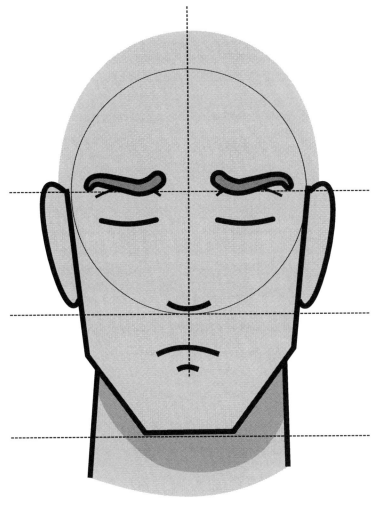

EYEBROWS
Use INWARD DROOP EYEBROWS.

EYES
Use DOWNWARD CLOSED EYES.

NOSE
Use NEUTRAL NOSE.

MOUTH
Use CLOSED FROWN.

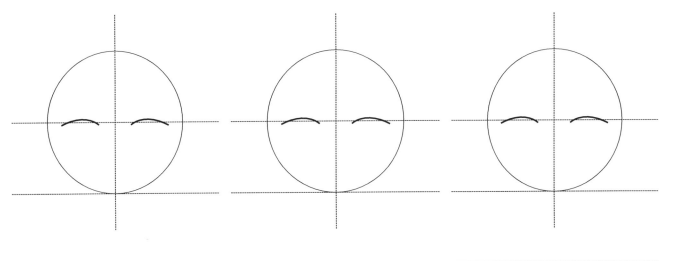

ASSURED

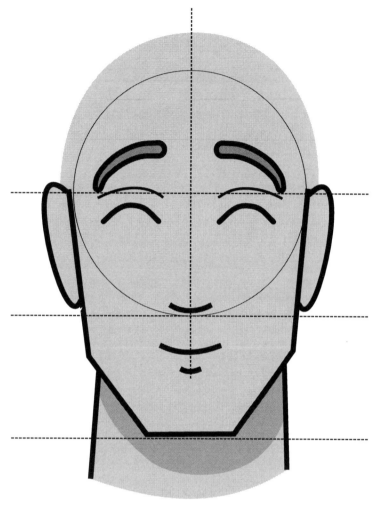

EYEBROWS
Use RAISED EYEBROWS.

EYES
Use HIGH-UPWARD CLOSED EYES.

NOSE
Use NEUTRAL NOSE.

MOUTH
Use CLOSED SMILE.

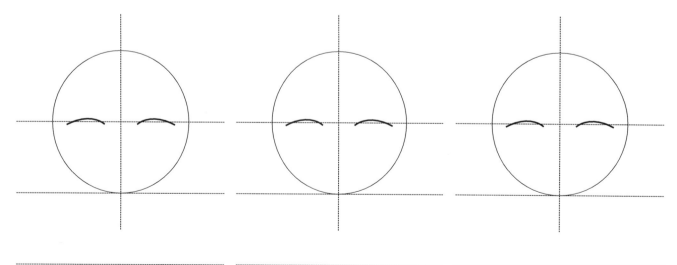

ATTENTIVE

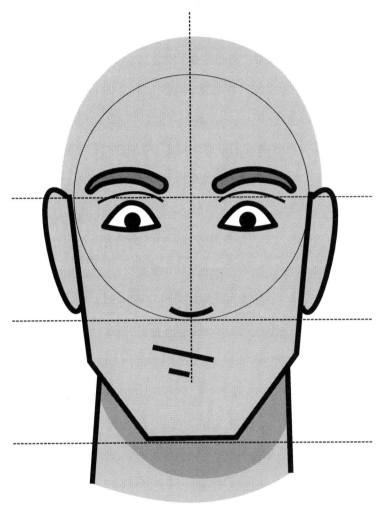

EYEBROWS
Use NEUTRAL EYEBROWS.

EYES
Use UPPER-WIDE EYES.

NOSE
Use NEUTRAL NOSE.

MOUTH
Use SLANTED NEUTRAL MOUTH.

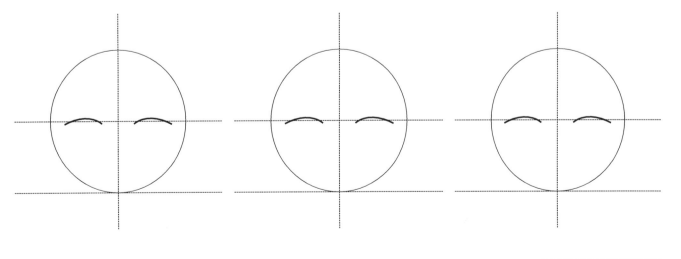

31

AWARE

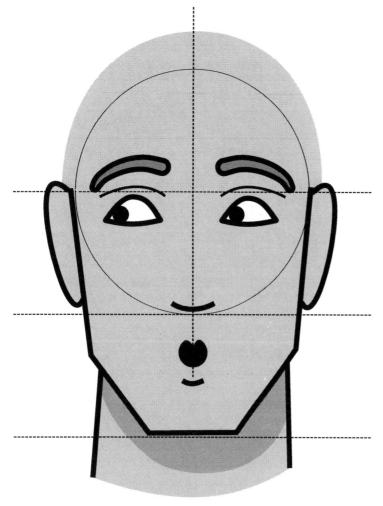

EYEBROWS
Use SLIGHTLY RAISED EYEBROWS.

EYES
Use UPPER-WIDE EYES.

NOSE
Use NEUTRAL NOSE.

MOUTH
Use SMALL ROUNDED MOUTH.

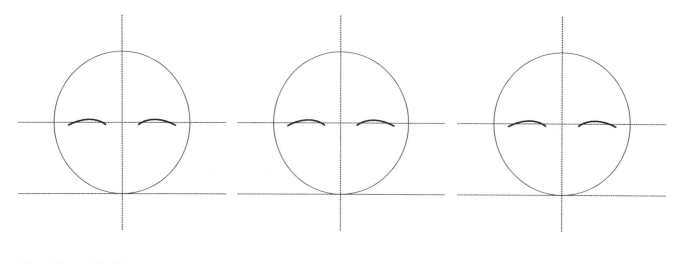

AWESTRUCK

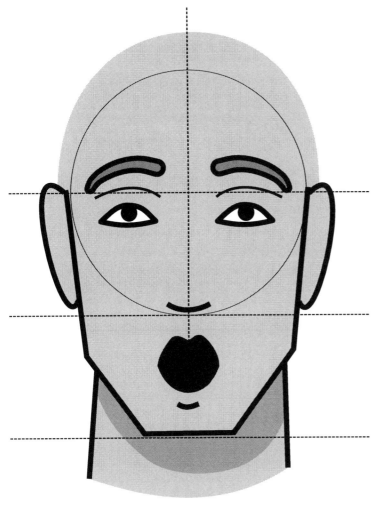

EYEBROWS
Use SLIGHTLY RAISED EYEBROWS.

EYES
Use NEUTRAL EYES.

NOSE
Use NEUTRAL NOSE.

MOUTH
Use ROUNDED MOUTH.

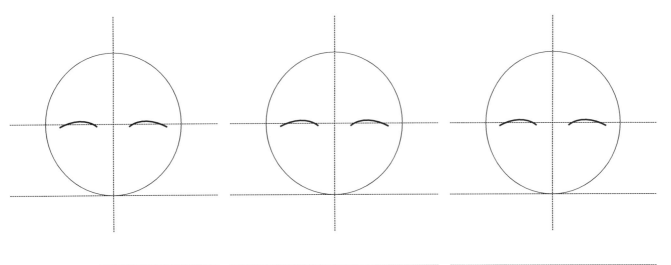

BEWILDERED

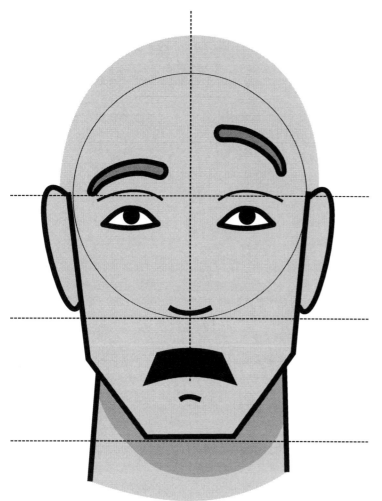

EYEBROWS
Use a SLIGHTLY RAISED EYEBROW on one side and a HIGH RAISED EYEBROW on the other.

EYES
Use NEUTRAL EYES.

NOSE
Use NEUTRAL NOSE.

MOUTH
Use OPEN FROWN.

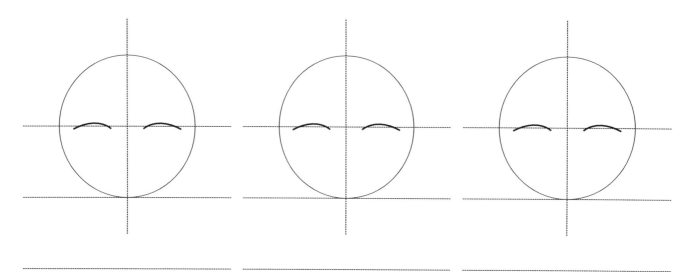

BLUSHING

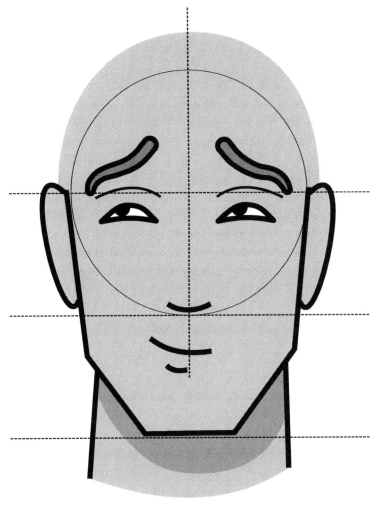

EYEBROWS
Use OUTWARD SLOPE EYEBROWS.

EYES
Use UPTURNED EYES.

NOSE
Use NEUTRAL NOSE.

MOUTH
Use SLANTED CLOSED SMILE.

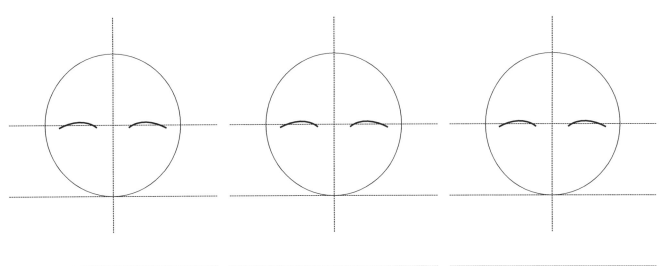

CAUTIOUS

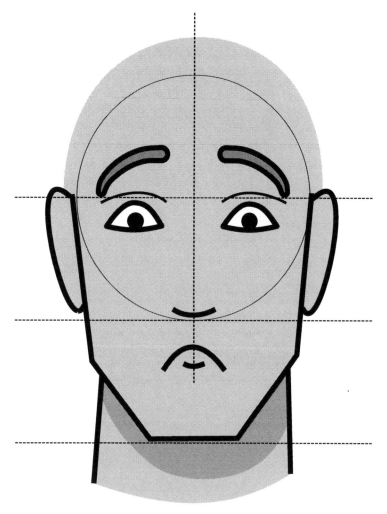

EYEBROWS
Use RAISED EYEBROWS.

EYES
Use UPPER-WIDE EYES.

NOSE
Use NEUTRAL NOSE.

MOUTH
Use DEEP CLOSED FROWN slightly raised with the smaller of the two lines flipped so the ends bend upward.

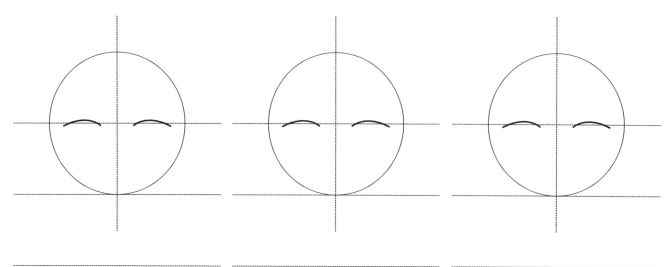

CHEEKY

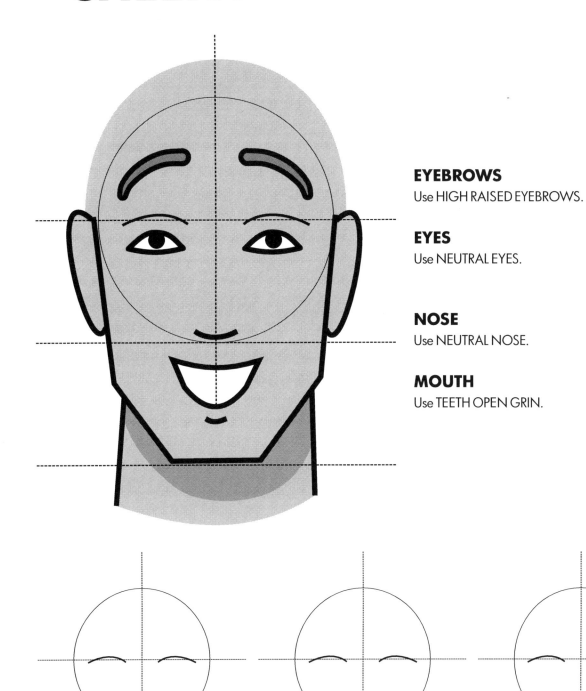

EYEBROWS
Use HIGH RAISED EYEBROWS.

EYES
Use NEUTRAL EYES.

NOSE
Use NEUTRAL NOSE.

MOUTH
Use TEETH OPEN GRIN.

COCKY

EYEBROWS
Use DIPPING EYEBROWS.

EYES
Use NARROW EYES.

NOSE
Use NEUTRAL NOSE.

MOUTH
Use SLANTED TEETH OPEN GRIN.

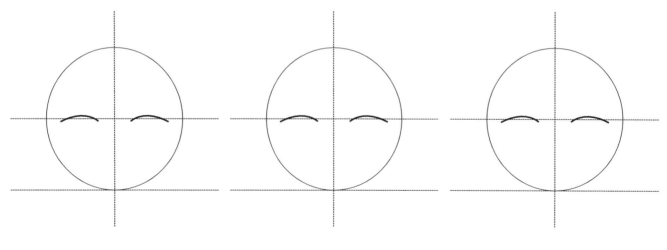

CONCENTRATING

EYEBROWS
Use INWARD SLOPE EYEBROWS.

EYES
Use DOWNWARD CLOSED EYES.

NOSE
Use NEUTRAL NOSE.

MOUTH
Use NARROW NEUTRAL MOUTH.

CONCERNED

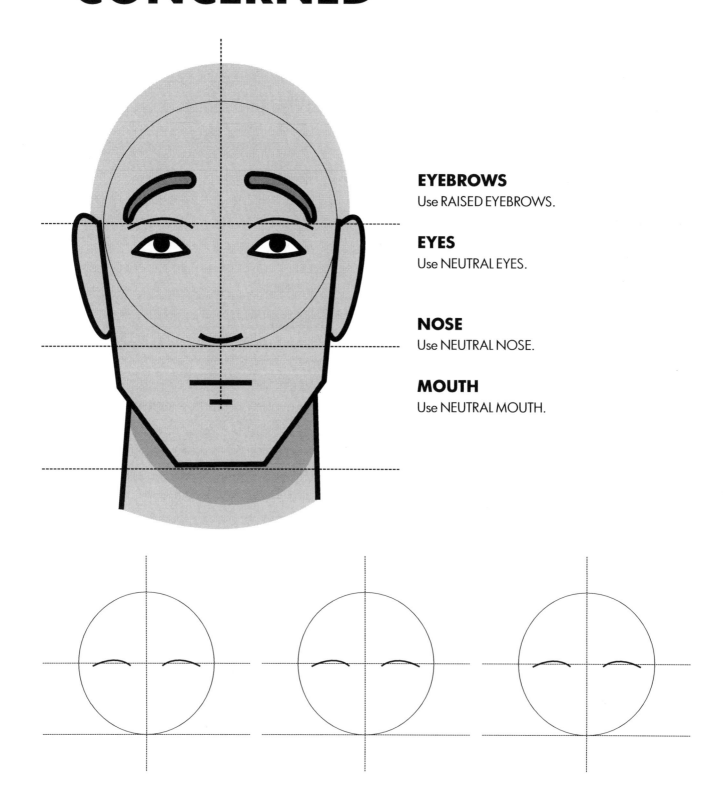

EYEBROWS
Use RAISED EYEBROWS.

EYES
Use NEUTRAL EYES.

NOSE
Use NEUTRAL NOSE.

MOUTH
Use NEUTRAL MOUTH.

CONFIDENT

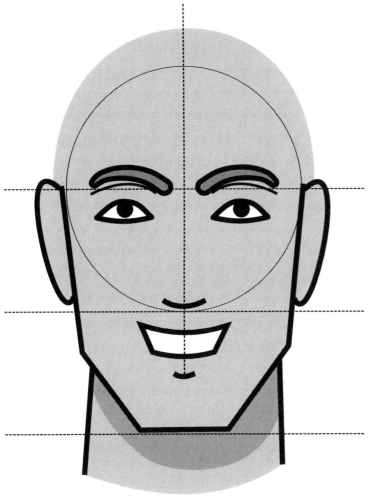

EYEBROWS
Use DIPPING EYEBROWS.

EYES
Use NEUTRAL EYES.

NOSE
Use NEUTRAL NOSE.

MOUTH
Use TEETH OPEN SMILE.

CONFUSED

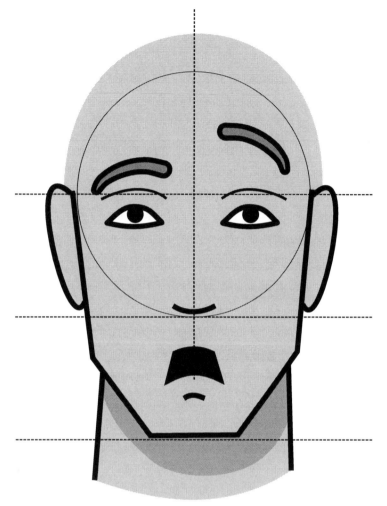

EYEBROWS
Use a SLIGHTLY RAISED EYEBROW on one side and a HIGH RAISED EYEBROW on the other.

EYES
Use NEUTRAL EYES.

NOSE
Use NEUTRAL NOSE.

MOUTH
Use NARROW OPEN FROWN.

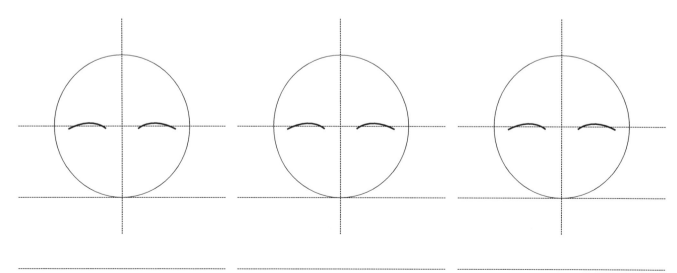

CONTEMPLATIVE

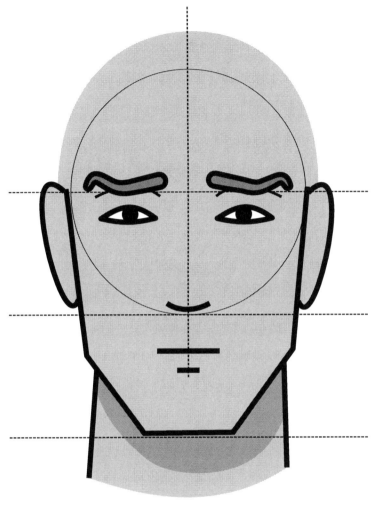

EYEBROWS
Use OUTWARD DROOP EYEBROWS.

EYES
Use NARROW EYES.

NOSE
Use NEUTRAL NOSE.

MOUTH
Use NEUTRAL MOUTH.

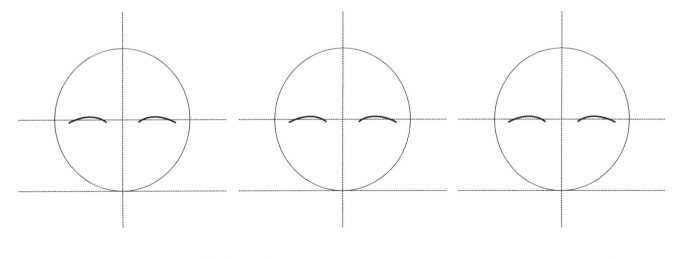

CONTENT

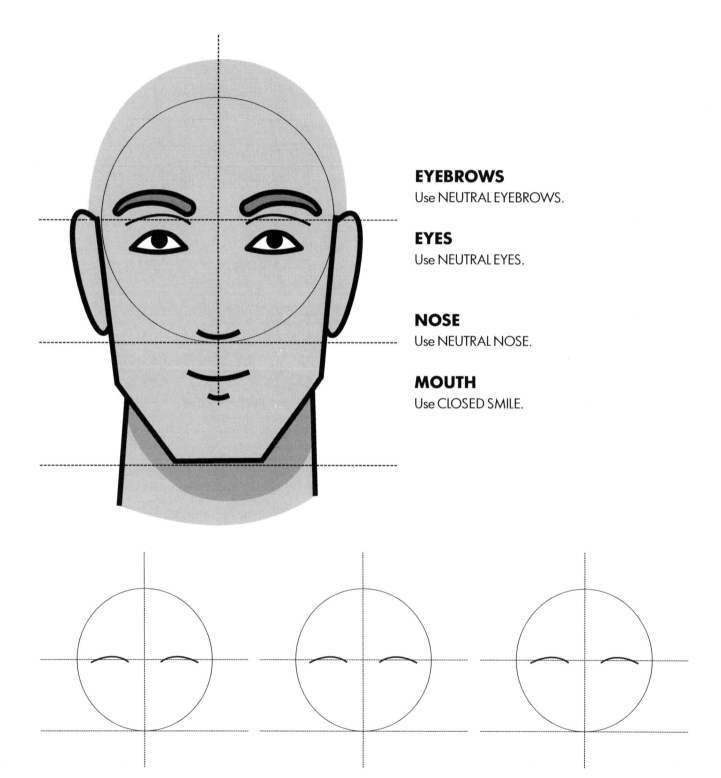

EYEBROWS
Use NEUTRAL EYEBROWS.

EYES
Use NEUTRAL EYES.

NOSE
Use NEUTRAL NOSE.

MOUTH
Use CLOSED SMILE.

CRINGING

EYEBROWS
Use INWARD DROOP EYEBROWS.

EYES
Use an UPTURNED EYE on the same side as the raised upper lip of the mouth and a NEUTRAL EYE on the other side.

NOSE
Use SLANTED NOSE lifted on the same side as the raised upper lip of the mouth.

MOUTH
Use LOPSIDED TEETH GRIMACE.

DAYDREAMING

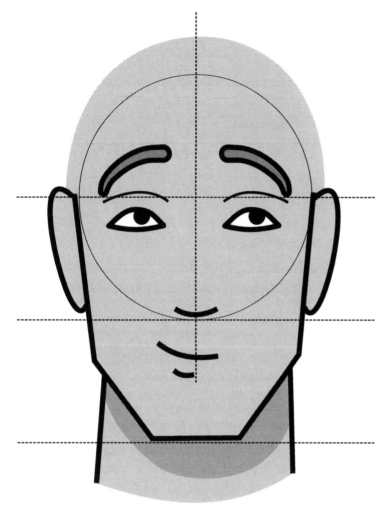

EYEBROWS
Use RAISED EYEBROWS.

EYES
Use NEUTRAL EYES looking up and off to one side - the opposite side to which the mouth is shifted.

NOSE
Use NEUTRAL NOSE.

MOUTH
Use SLANTED CLOSED SMILE.

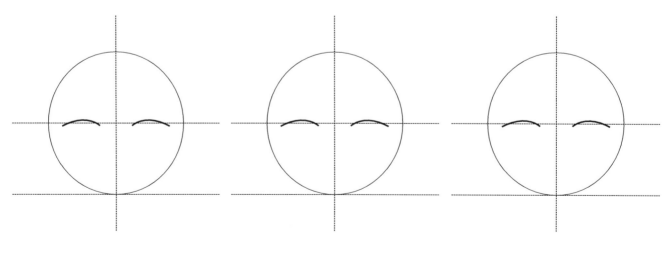

DEFLATED

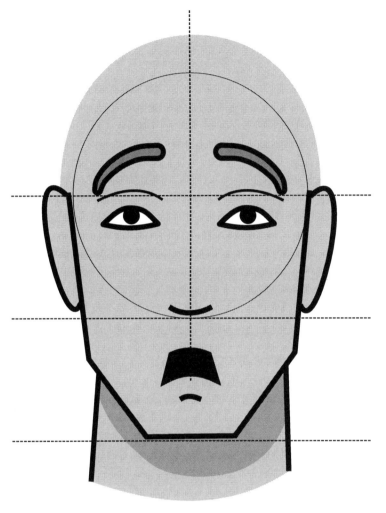

EYEBROWS
Use RAISED EYEBROWS.

EYES
Use NEUTRAL EYES.

NOSE
Use NEUTRAL NOSE.

MOUTH
Use NARROW OPEN FROWN.

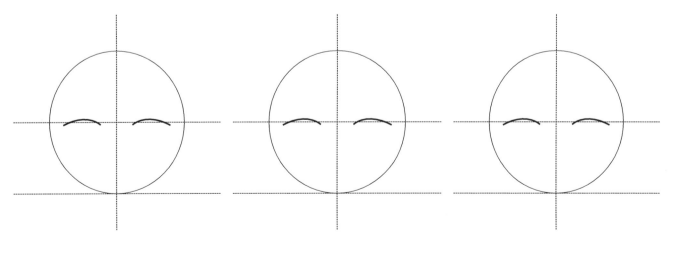

DEJECTED

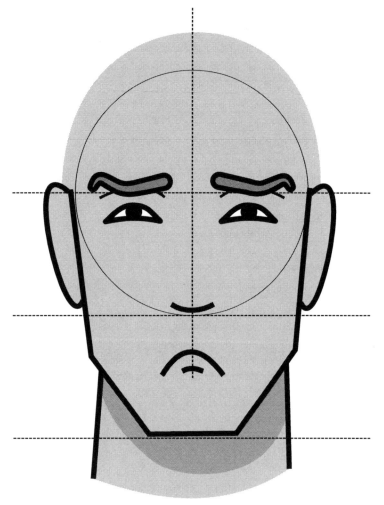

EYEBROWS
Use OUTWARD DROOP EYEBROWS.

EYES
Use UPTURNED EYES.

NOSE
Use NEUTRAL NOSE.

MOUTH
Use DEEP CLOSED FROWN.

DELIGHTED

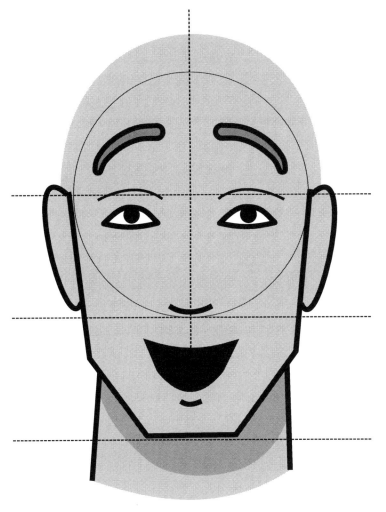

EYEBROWS
Use HIGH RAISED EYEBROWS.

EYES
Use NEUTRAL EYES.

NOSE
Use NEUTRAL NOSE.

MOUTH
Use OPEN GRIN.

DESPONDENT

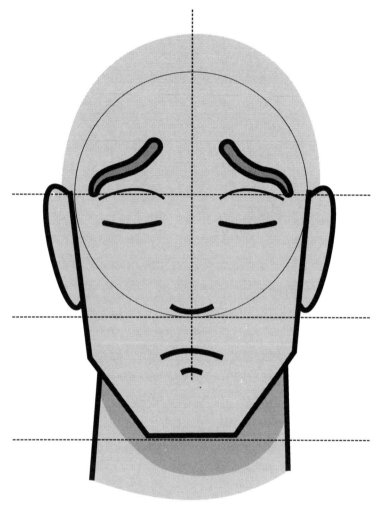

EYEBROWS
Use OUTWARD SLOPE EYEBROWS.

EYES
Use DOWNWARD CLOSED EYES.

NOSE
Use NEUTRAL NOSE.

MOUTH
Use CLOSED FROWN.

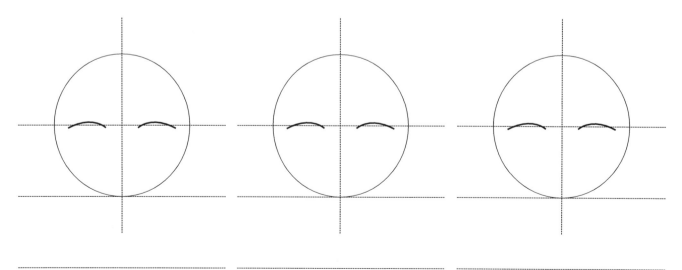

DISAPPOINTED

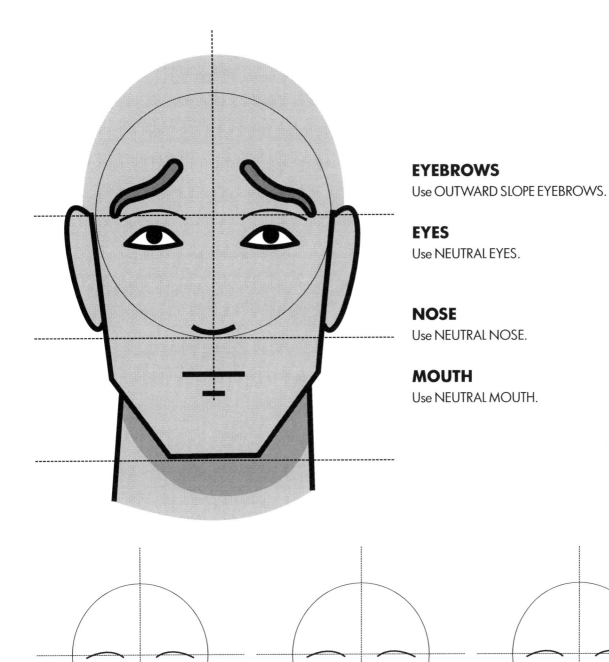

EYEBROWS
Use OUTWARD SLOPE EYEBROWS.

EYES
Use NEUTRAL EYES.

NOSE
Use NEUTRAL NOSE.

MOUTH
Use NEUTRAL MOUTH.

DISBELIEVING

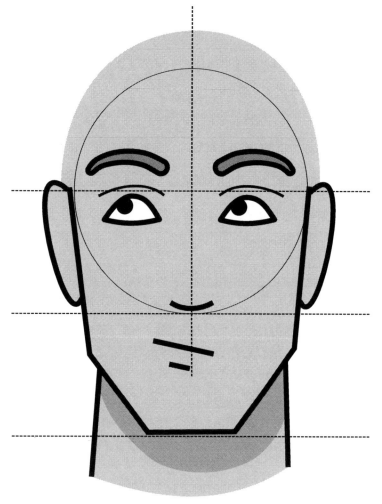

EYEBROWS
Use HIGH NEUTRAL EYEBROWS.

EYES
Use UPPER-WIDE EYES looking up and off to the side - the same side to which the mouth is slanted up.

NOSE
Use NEUTRAL NOSE.

MOUTH
Use SLANTED NEUTRAL MOUTH.

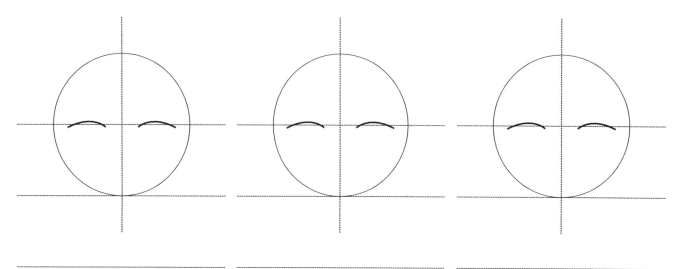

DISCOMFORTABLE

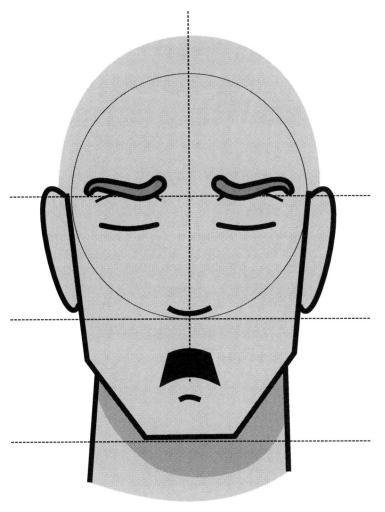

EYEBROWS
Use INWARD DROOP EYEBROWS.

EYES
Use DOWNWARD CLOSED EYES.

NOSE
Use NEUTRAL NOSE.

MOUTH
Use NARROW OPEN FROWN.

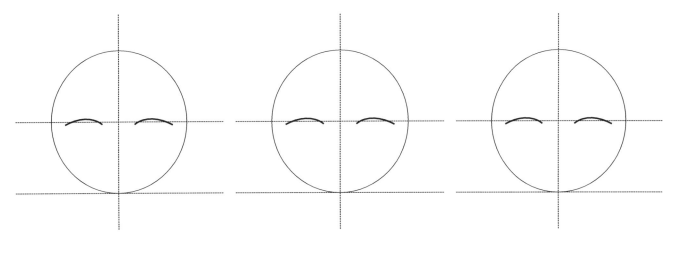

DISGRUNTLED

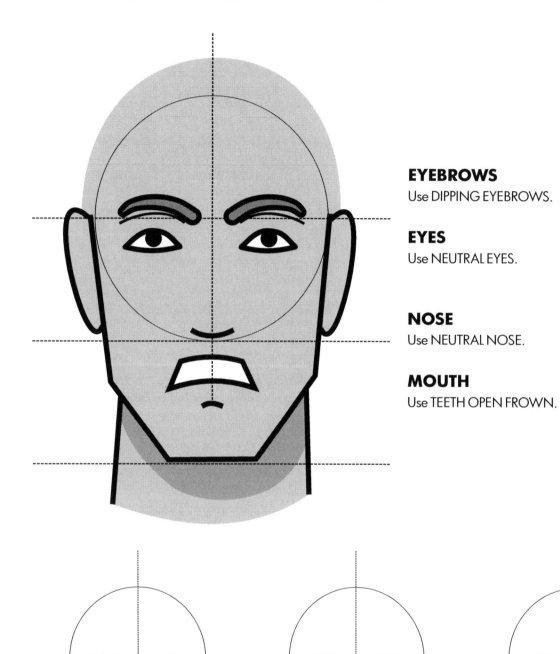

EYEBROWS
Use DIPPING EYEBROWS.

EYES
Use NEUTRAL EYES.

NOSE
Use NEUTRAL NOSE.

MOUTH
Use TEETH OPEN FROWN.

DISGUSTED

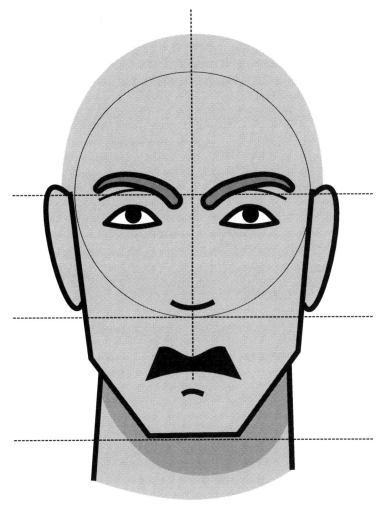

EYEBROWS
Use INWARD SLOPE EYEBROWS.

EYES
Use NEUTRAL EYES.

NOSE
Use LIFTED NOSE.

MOUTH
Use GRIMACE.

DISMISSIVE

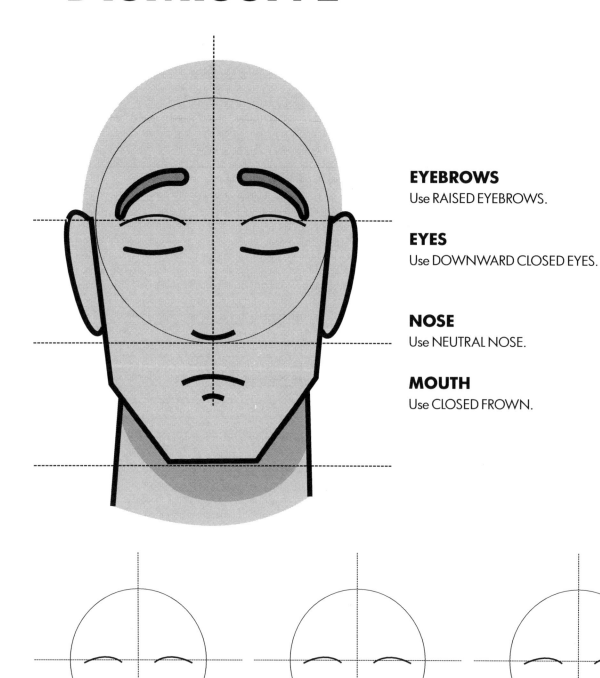

EYEBROWS
Use RAISED EYEBROWS.

EYES
Use DOWNWARD CLOSED EYES.

NOSE
Use NEUTRAL NOSE.

MOUTH
Use CLOSED FROWN.

DISPIRITED

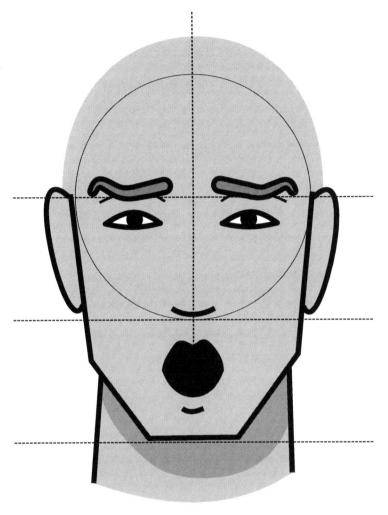

EYEBROWS
Use OUTWARD DROOP EYEBROWS.

EYES
Use NARROW EYES.

NOSE
Use NEUTRAL NOSE.

MOUTH
Use ROUNDED MOUTH.

DISPLEASED

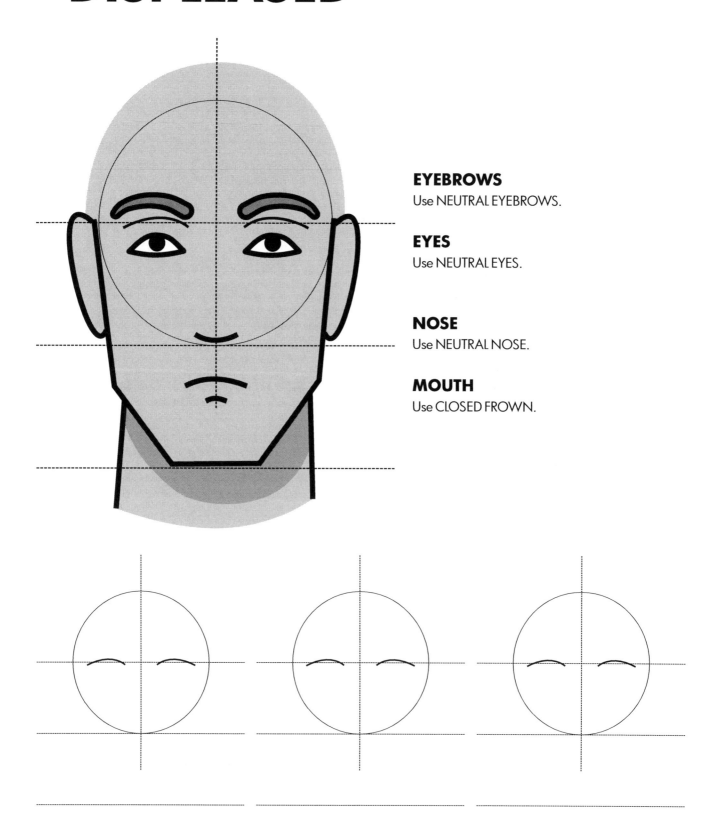

EYEBROWS
Use NEUTRAL EYEBROWS.

EYES
Use NEUTRAL EYES.

NOSE
Use NEUTRAL NOSE.

MOUTH
Use CLOSED FROWN.

DISTRAUGHT

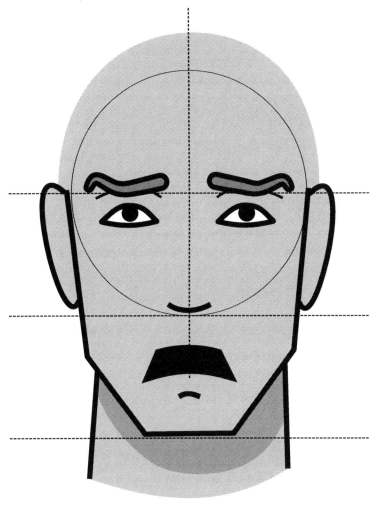

EYEBROWS
Use OUTWARD DROOP EYEBROWS.

EYES
Use NEUTRAL EYES.

NOSE
Use NEUTRAL NOSE.

MOUTH
Use OPEN FROWN.

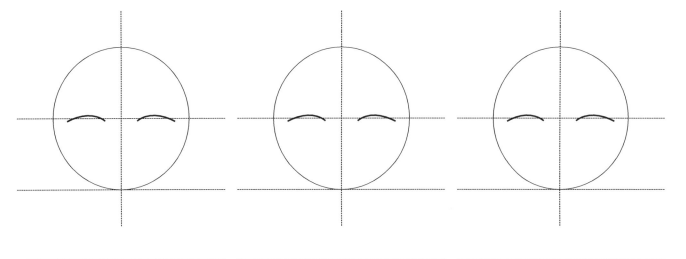

DOUBTFUL

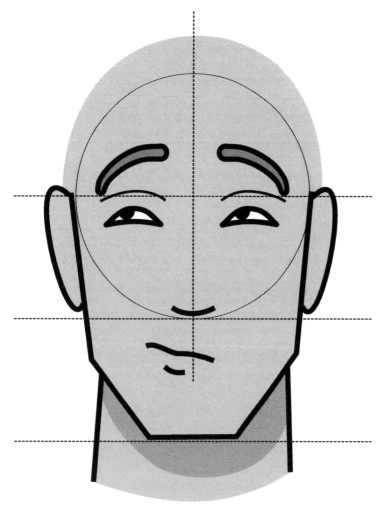

EYEBROWS
Use RAISED EYEBROWS.

EYES
Use UPTURNED EYES.

NOSE
Use NEUTRAL NOSE.

MOUTH
Use SLANTED CONTRADICTORY MOUTH.

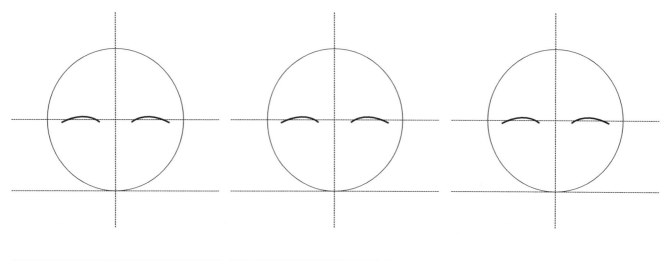

DUMBFOUNDED

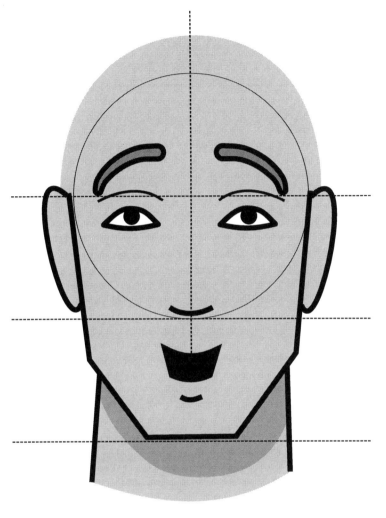

EYEBROWS
Use RAISED EYEBROWS.

EYES
Use NEUTRAL EYES.

NOSE
Use NEUTRAL NOSE.

MOUTH
Use NARROW OPEN SMILE.

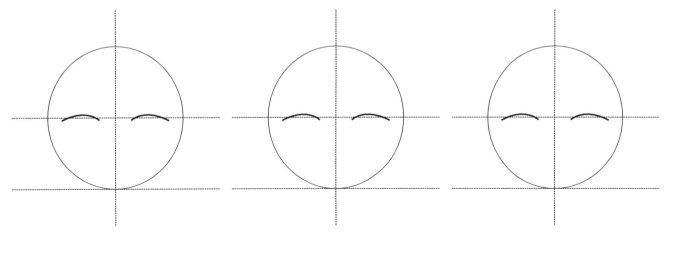

EAGER

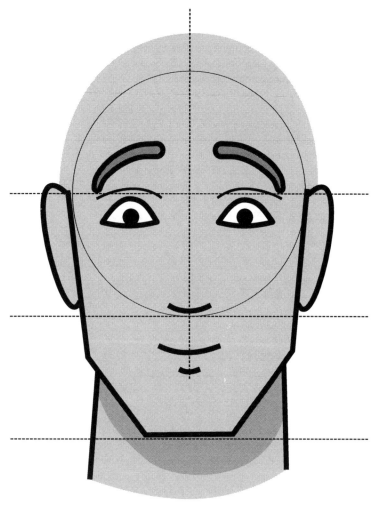

EYEBROWS
Use RAISED EYEBROWS.

EYES
Use UPPER-WIDE EYES.

NOSE
Use NEUTRAL NOSE.

MOUTH
Use CLOSED SMILE.

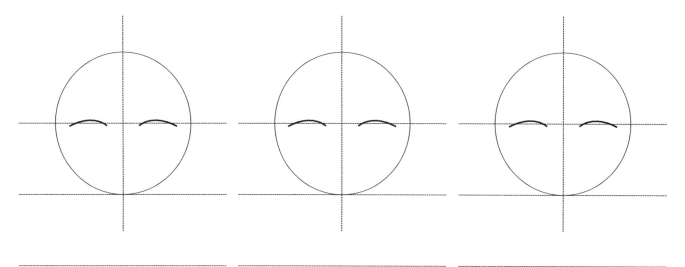

ECSTATIC

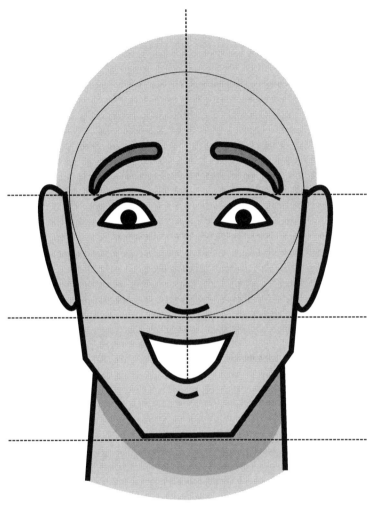

EYEBROWS
Use RAISED EYEBROWS.

EYES
Use UPPER-WIDE EYES.

NOSE
Use NEUTRAL NOSE.

MOUTH
Use TEETH OPEN GRIN.

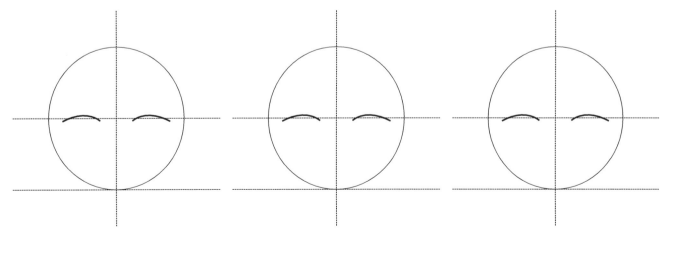

EMBARRASSED

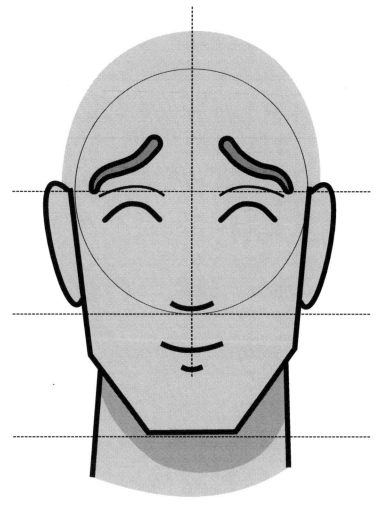

EYEBROWS
Use OUTWARD SLOPE EYEBROWS.

EYES
Use HIGH-UPWARD CLOSED EYES.

NOSE
Use NEUTRAL NOSE.

MOUTH
Use CLOSED SMILE.

EMPATHETIC

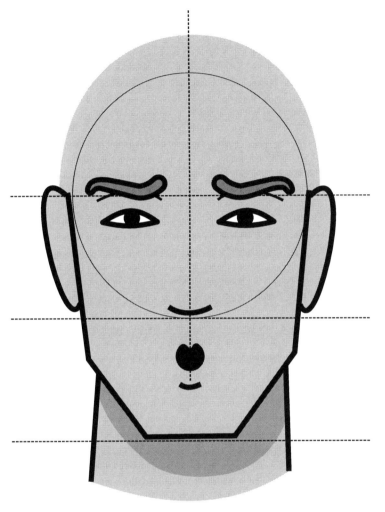

EYEBROWS
Use INWARD DROOP EYEBROWS.

EYES
Use NARROW EYES.

NOSE
Use NEUTRAL NOSE.

MOUTH
Use SMALL ROUNDED MOUTH.

ENRAGED

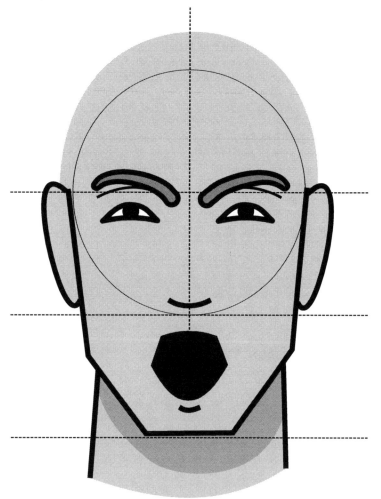

EYEBROWS
Use INWARD SLOPE EYEBROWS.

EYES
Use UPTURNED EYES.

NOSE
Use LIFTED NOSE.

MOUTH
Use ROARING MOUTH.

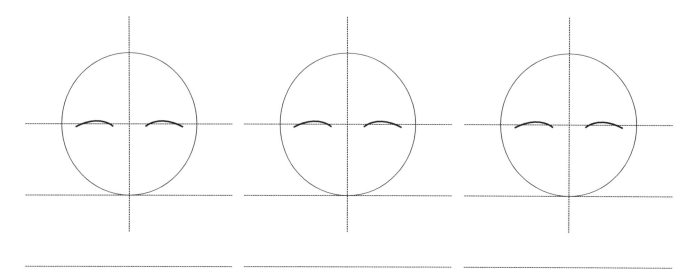

ENVIOUS

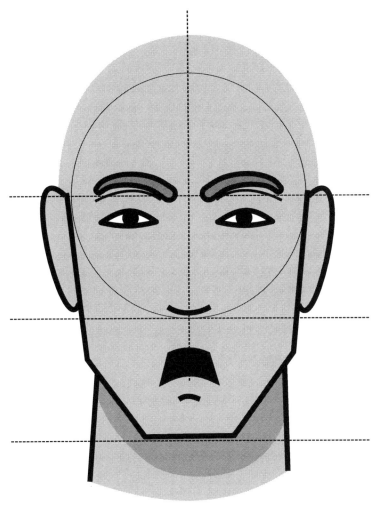

EYEBROWS
Use DIPPING EYEBROWS.

EYES
Use NARROW EYES.

NOSE
Use NEUTRAL NOSE.

MOUTH
Use NARROW OPEN FROWN.

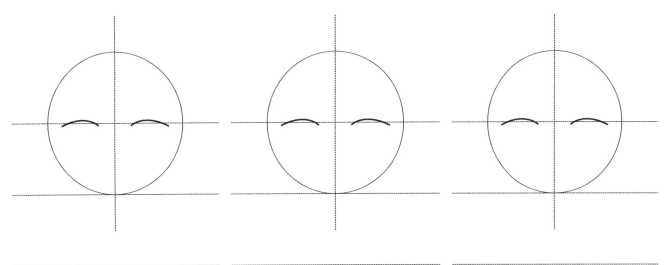

ENVISIONING

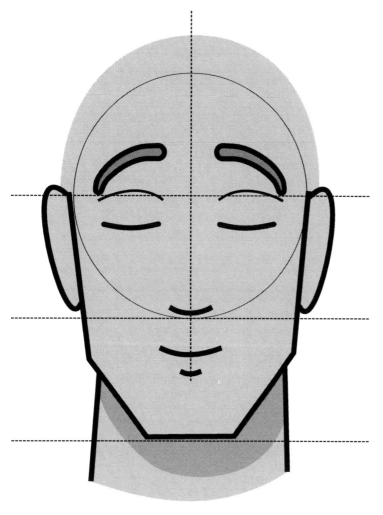

EYEBROWS
Use RAISED EYEBROWS.

EYES
Use DOWNWARD CLOSED EYES.

NOSE
Use NEUTRAL NOSE.

MOUTH
Use CLOSED SMILE.

EXCITED

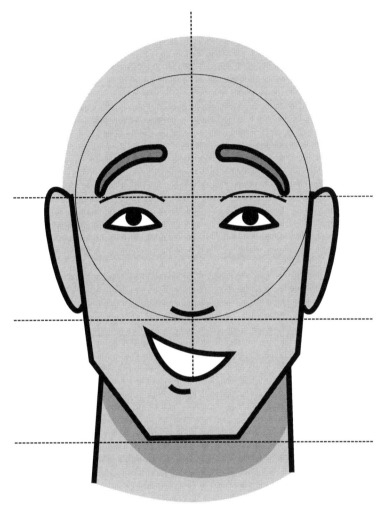

EYEBROWS
Use RAISED EYEBROWS.

EYES
Use NEUTRAL EYES.

NOSE
Use NEUTRAL NOSE.

MOUTH
Use SLANTED TEETH OPEN GRIN.

EXHAUSTED

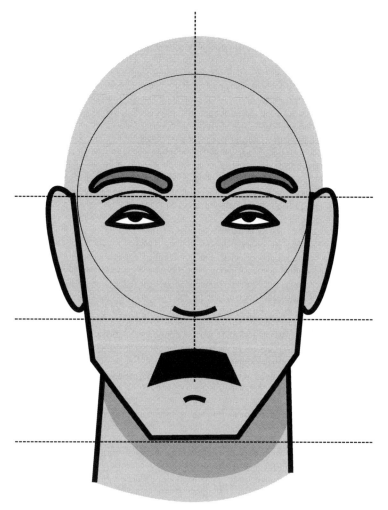

EYEBROWS
Use NEUTRAL EYEBROWS.

EYES
Use HALF-OPEN EYES with the circle tucked half hidden up underneath the upper eye lid.

NOSE
Use NEUTRAL NOSE.

MOUTH
Use OPEN FROWN.

FLABBERGASTED

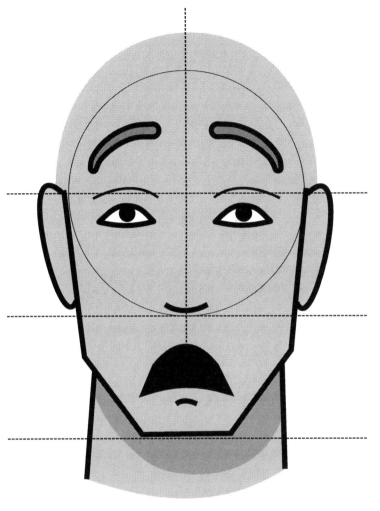

EYEBROWS
Use HIGH RAISED EYEBROWS.

EYES
Use NEUTRAL EYES.

NOSE
Use NEUTRAL NOSE.

MOUTH
Use GAPING FROWN.

FLIRTATIOUS

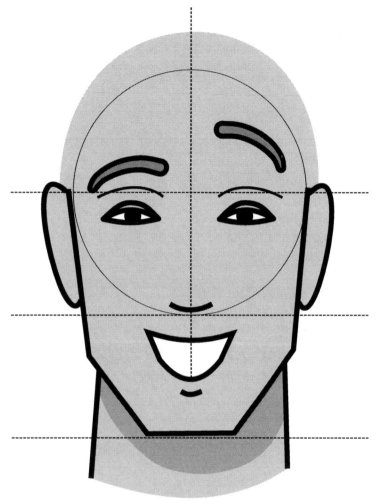

EYEBROWS
Use a SLIGHTLY RAISED EYEBROW on one side and a HIGH RAISED EYEBROW on the other.

EYES
Use HALF-OPEN EYES.

NOSE
Use NEUTRAL NOSE.

MOUTH
Use TEETH OPEN GRIN.

FOCUSED

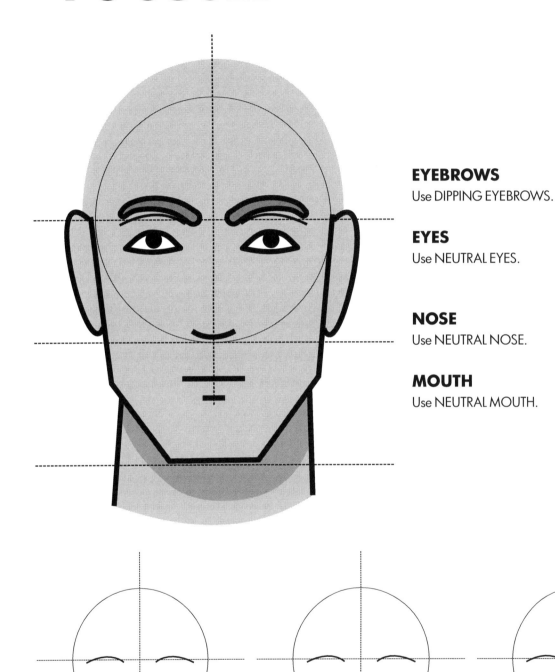

EYEBROWS
Use DIPPING EYEBROWS.

EYES
Use NEUTRAL EYES.

NOSE
Use NEUTRAL NOSE.

MOUTH
Use NEUTRAL MOUTH.

FORLORN

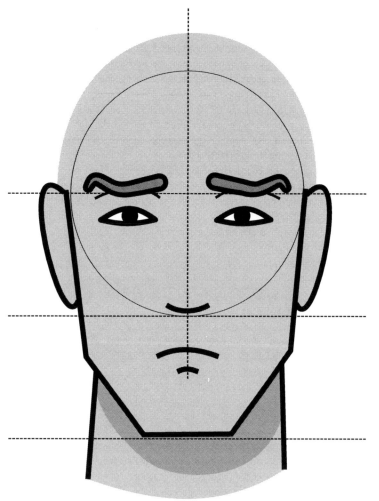

EYEBROWS
Use OUTWARD DROOP EYEBROWS.

EYES
Use NARROW EYES.

NOSE
Use NEUTRAL NOSE.

MOUTH
Use CLOSED FROWN.

FURIOUS

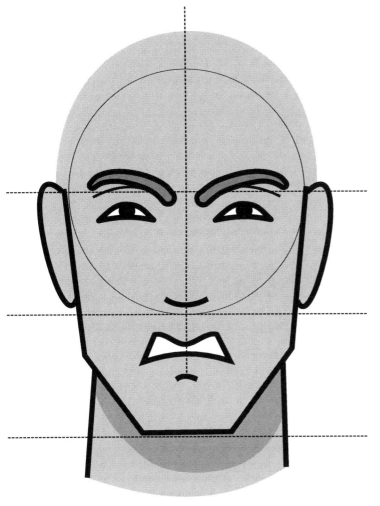

EYEBROWS
Use INWARD SLOPE EYEBROWS.

EYES
Use UPTURNED EYES.

NOSE
Use LIFTED NOSE.

MOUTH
Use TEETH GRIMACE.

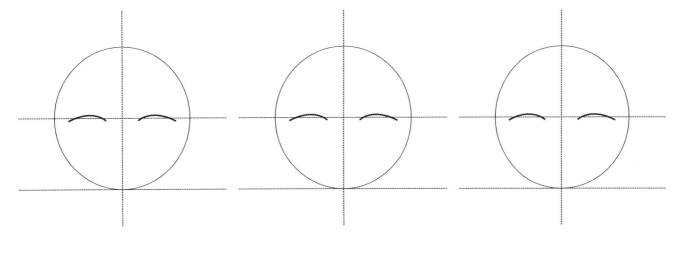

GALLED

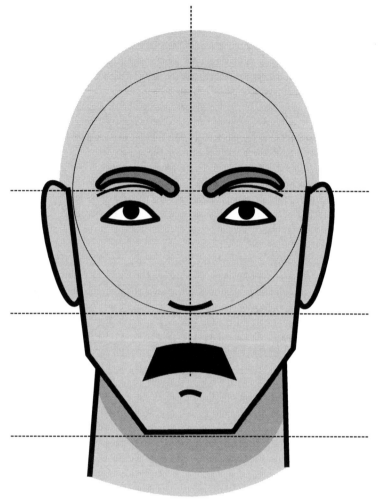

EYEBROWS
Use DIPPING EYEBROWS.

EYES
Use NEUTRAL EYES.

NOSE
Use NEUTRAL NOSE.

MOUTH
Use OPEN FROWN.

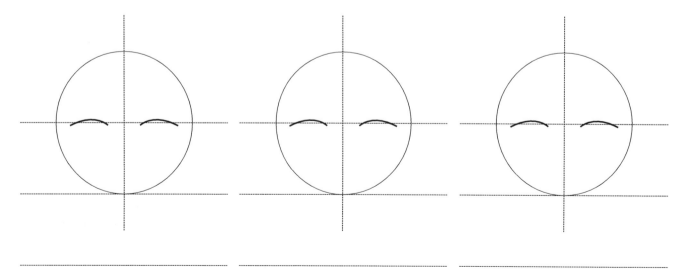

GIDDY

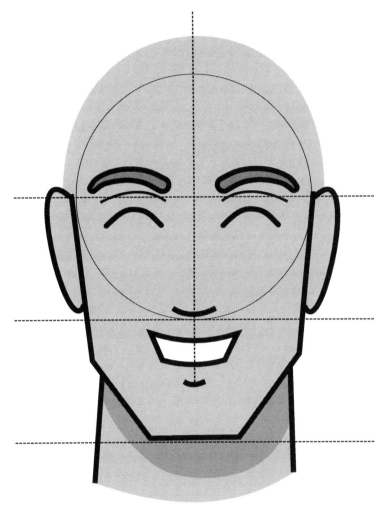

EYEBROWS
Use NEUTRAL EYEBROWS.

EYES
Use HIGH-UPWARD CLOSED EYES.

NOSE
Use NEUTRAL NOSE.

MOUTH
Use TEETH OPEN SMILE.

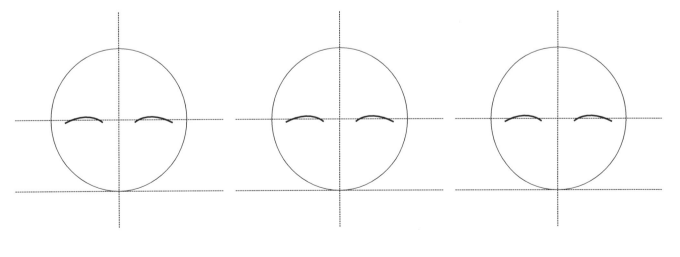

GLARING

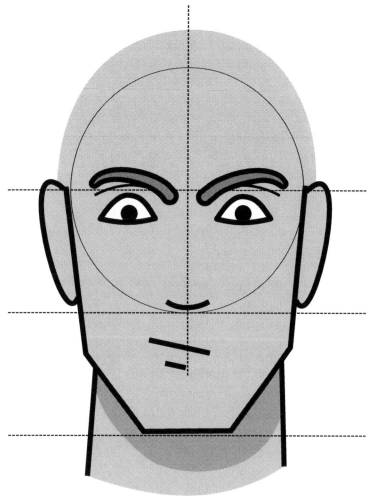

EYEBROWS
Use INWARD SLOPE EYEBROWS.

EYES
Use UPPER-WIDE EYES.

NOSE
Use NEUTRAL NOSE.

MOUTH
Use SLANTED NEUTRAL MOUTH.

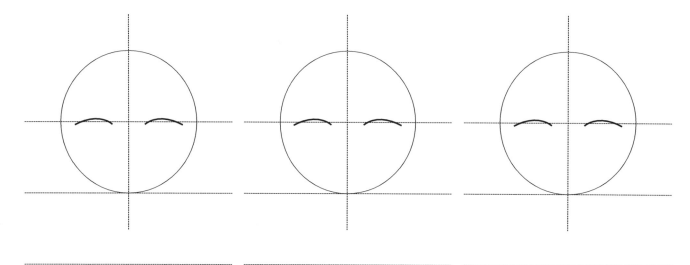

GOOFY

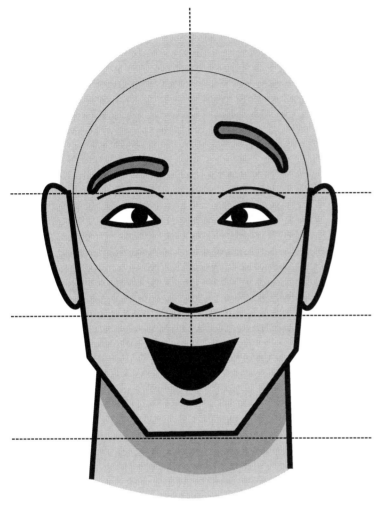

EYEBROWS

Use a SLIGHTLY RAISED EYEBROW on one side and a HIGH RAISED EYEBROW on the other.

EYES

Use NEUTRAL EYES looking inward towards one another.

NOSE

Use NEUTRAL NOSE.

MOUTH

Use OPEN GRIN.

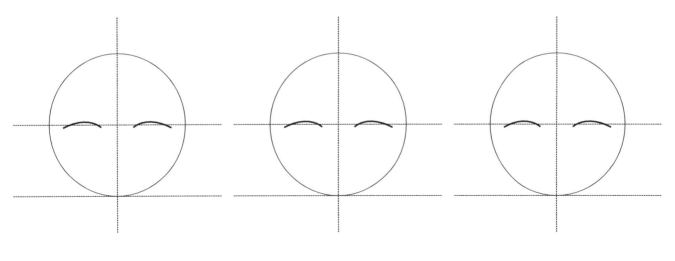

GRUMPY

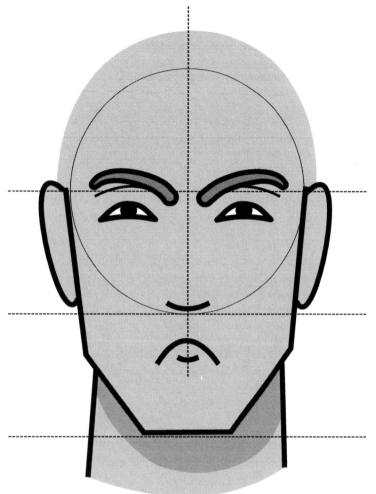

EYEBROWS
Use INWARD SLOPE EYEBROWS.

EYES
Use UPTURNED EYES.

NOSE
Use NEUTRAL NOSE.

MOUTH
Use DEEP CLOSED FROWN slightly raised with the smaller of the two lines flipped so the ends bend upward.

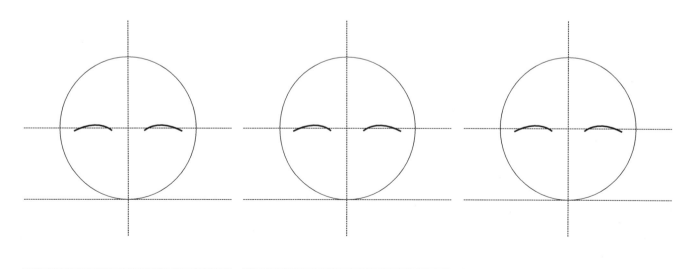

HAPPY

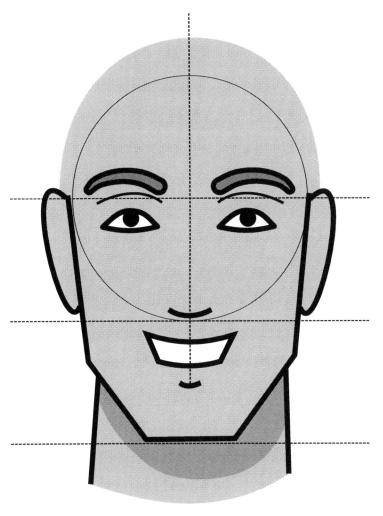

EYEBROWS
Use NEUTRAL EYEBROWS.

EYES
Use NEUTRAL EYES.

NOSE
Use NEUTRAL NOSE.

MOUTH
Use TEETH OPEN SMILE.

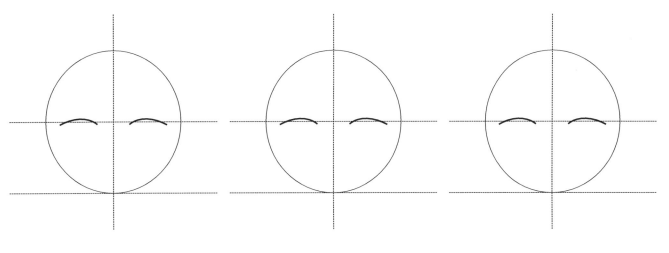

HEARTBROKEN

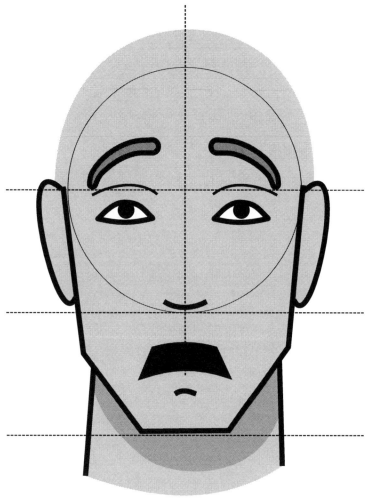

EYEBROWS
Use RAISED EYEBROWS.

EYES
Use NEUTRAL EYES.

NOSE
Use NEUTRAL NOSE.

MOUTH
Use OPEN FROWN.

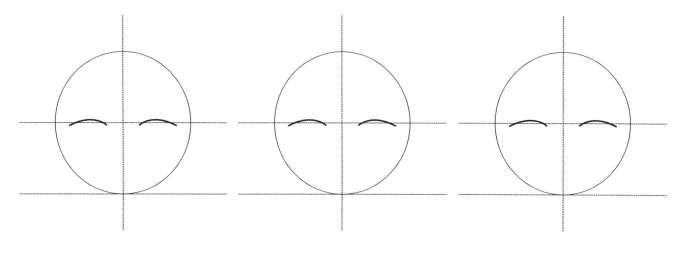

IMPRESSED

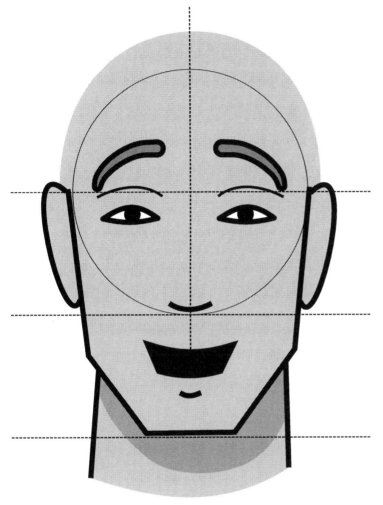

EYEBROWS
Use RAISED EYEBROWS.

EYES
Use NARROW EYES.

NOSE
Use NEUTRAL NOSE.

MOUTH
Use OPEN SMILE.

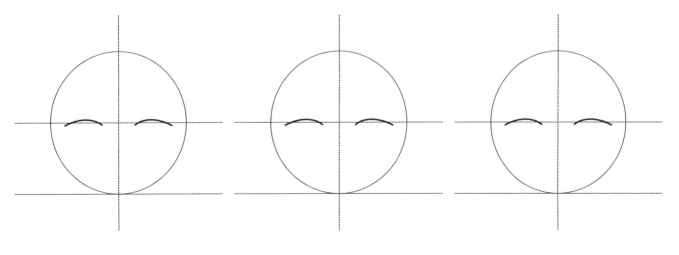

INTERESTED

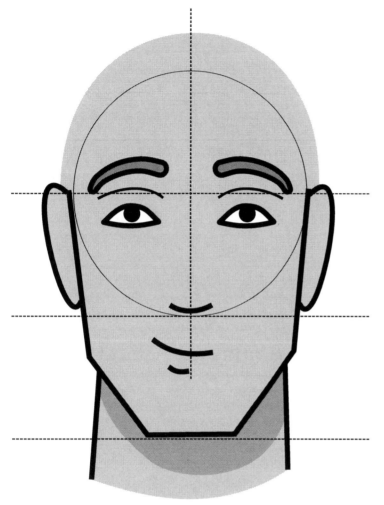

EYEBROWS
Use SLIGHTLY RAISED EYEBROWS.

EYES
Use NEUTRAL EYES.

NOSE
Use NEUTRAL NOSE.

MOUTH
Use SLANTED CLOSED SMILE.

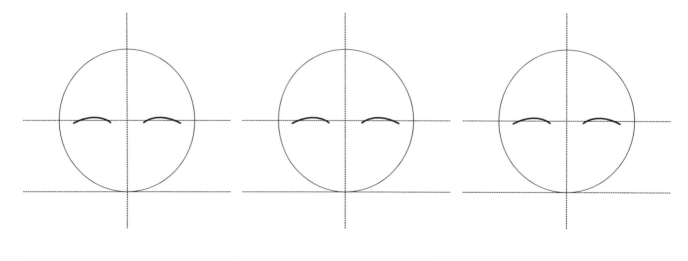

INTRIGUED

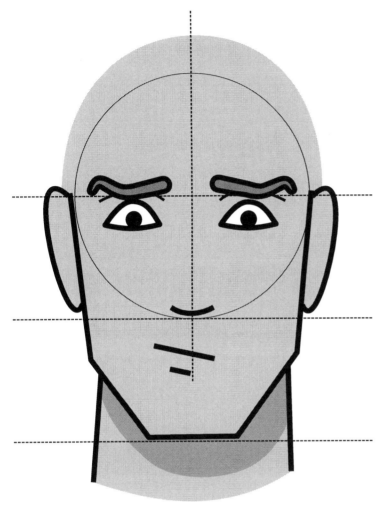

EYEBROWS
Use OUTWARD DROOP EYEBROWS.

EYES
Use UPPER-WIDE EYES.

NOSE
Use NEUTRAL NOSE.

MOUTH
Use SLANTED NEUTRAL MOUTH.

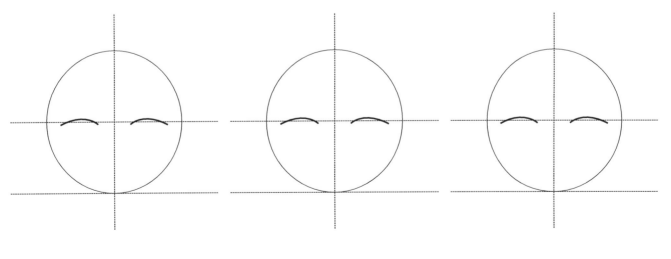

INTROSPECTIVE

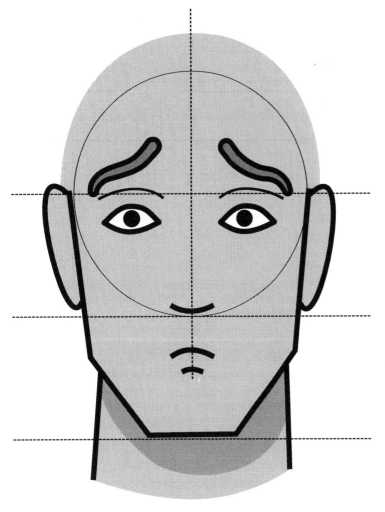

EYEBROWS
Use OUTWARD SLOPE EYEBROWS.

EYES
Use LOWER-WIDE EYES.

NOSE
Use NEUTRAL NOSE.

MOUTH
Use NARROW CLOSED FROWN.

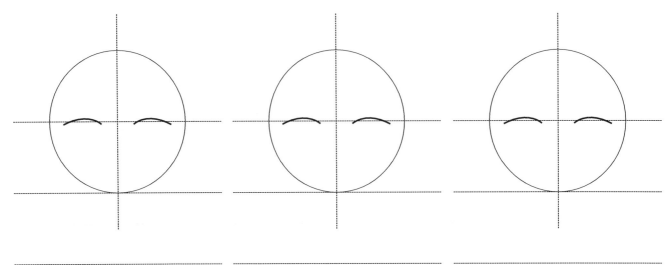

LOVESTRUCK

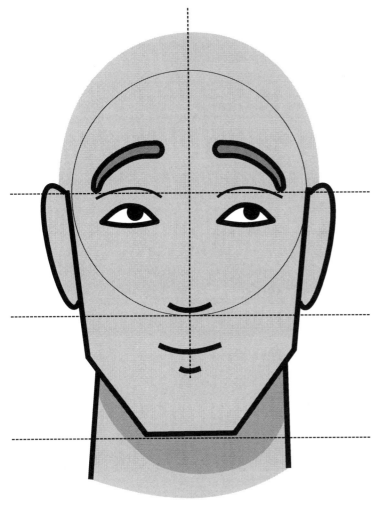

EYEBROWS
Use RAISED EYEBROWS.

EYES
Use NEUTRAL EYES looking up and off to one side.

NOSE
Use NEUTRAL NOSE.

MOUTH
Use CLOSED SMILE.

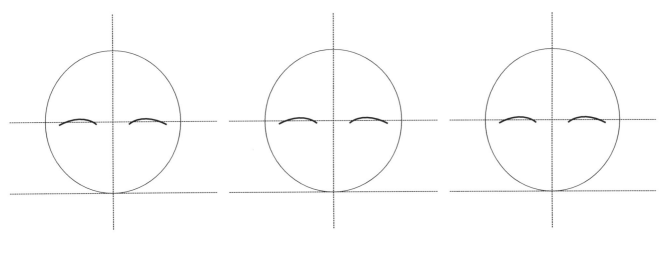

MAD

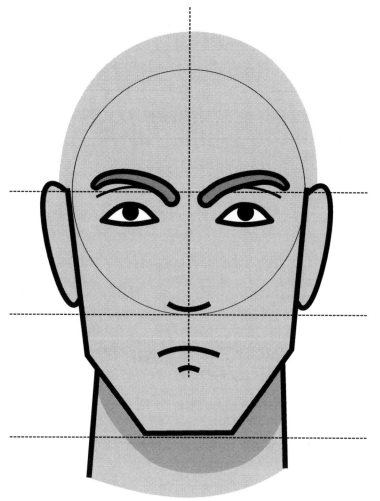

EYEBROWS
Use INWARD SLOPE EYEBROWS.

EYES
Use NEUTRAL EYES.

NOSE
Use NEUTRAL NOSE.

MOUTH
Use CLOSED FROWN.

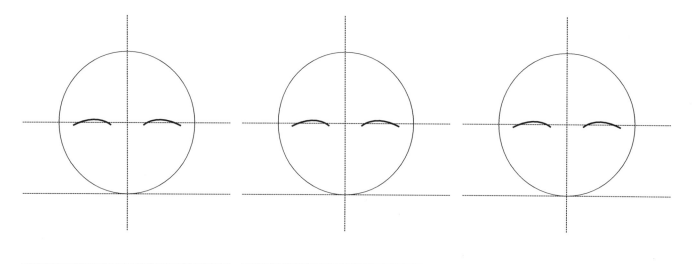

MEDITATING

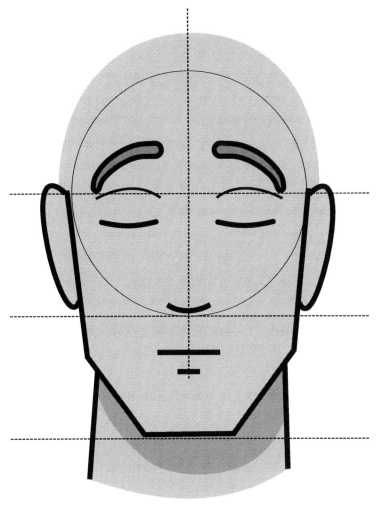

EYEBROWS
Use RAISED EYEBROWS.

EYES
Use DOWNWARD CLOSED EYES.

NOSE
Use NEUTRAL NOSE.

MOUTH
Use NEUTRAL MOUTH.

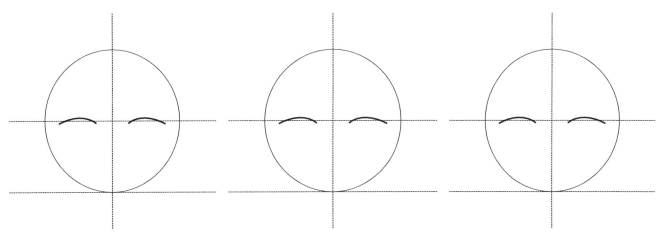

MELANCHOLY

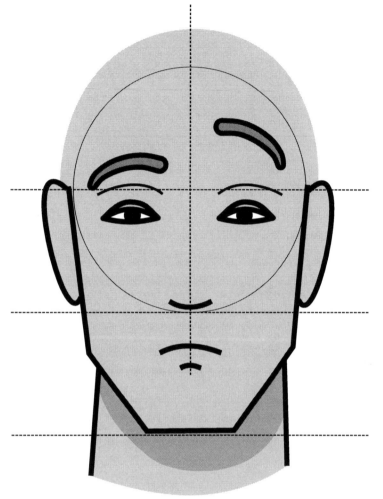

EYEBROWS
Use a SLIGHTLY RAISED EYEBROW on one side and a HIGH RAISED EYEBROW on the other.

EYES
Use HALF-OPEN EYES.

NOSE
Use NEUTRAL NOSE.

MOUTH
Use CLOSED FROWN.

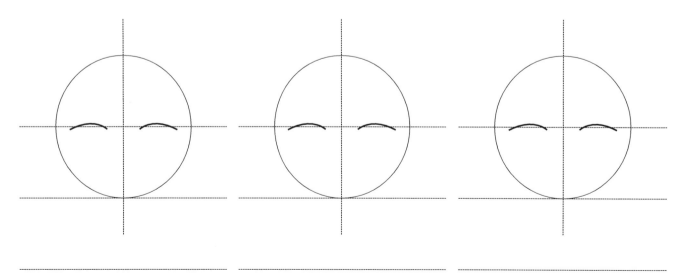

MIFFED

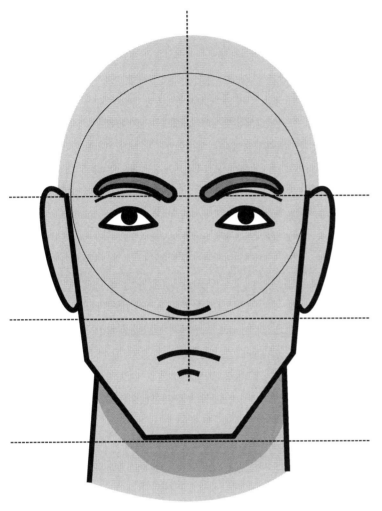

EYEBROWS
Use DIPPING EYEBROWS.

EYES
Use NEUTRAL EYES.

NOSE
Use NEUTRAL NOSE.

MOUTH
Use CLOSED FROWN.

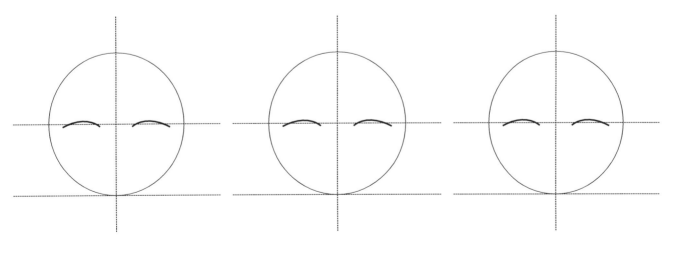

MIRTHFUL

EYEBROWS
Use SLIGHTLY RAISED EYEBROWS.

EYES
Use HIGH-UPWARD CLOSED EYES.

NOSE
Use NEUTRAL NOSE.

MOUTH
Use OPEN GRIN.

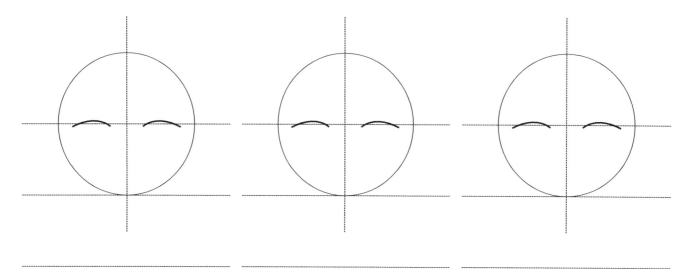

NEUTRAL

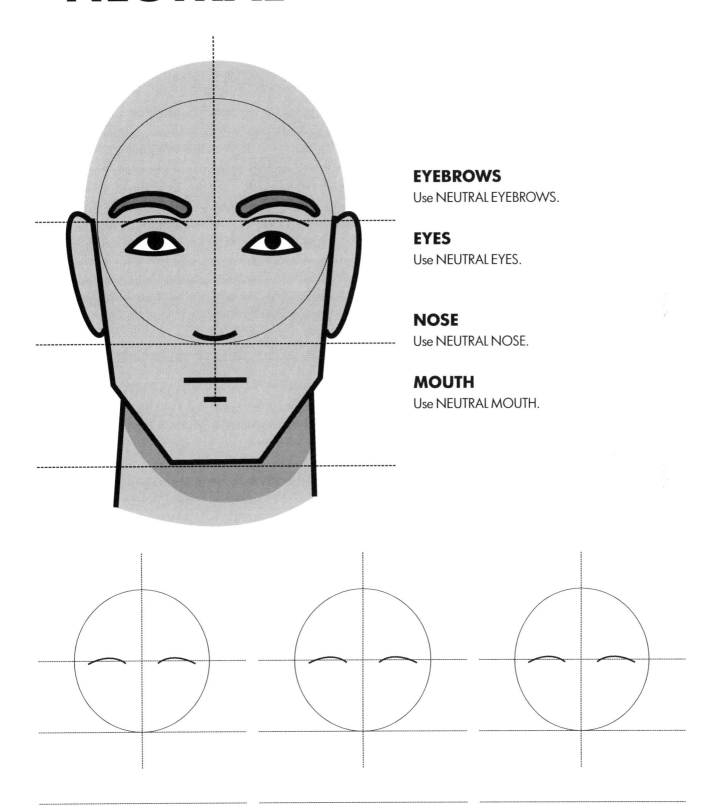

EYEBROWS
Use NEUTRAL EYEBROWS.

EYES
Use NEUTRAL EYES.

NOSE
Use NEUTRAL NOSE.

MOUTH
Use NEUTRAL MOUTH.

NURTURING

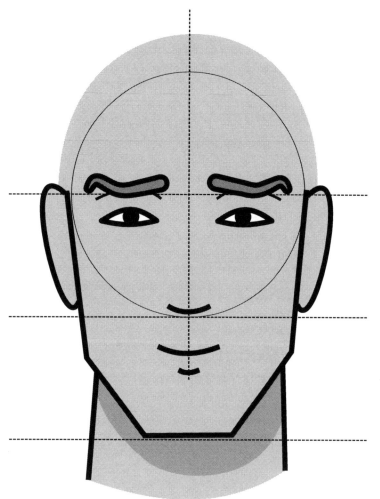

EYEBROWS
Use OUTWARD DROOP EYEBROWS.

EYES
Use NARROW EYES.

NOSE
Use NEUTRAL NOSE.

MOUTH
Use CLOSED SMILE.

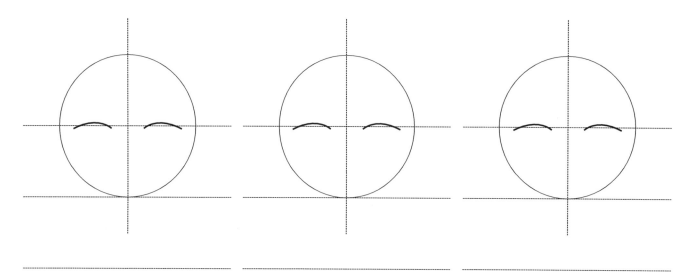

PETRIFIED

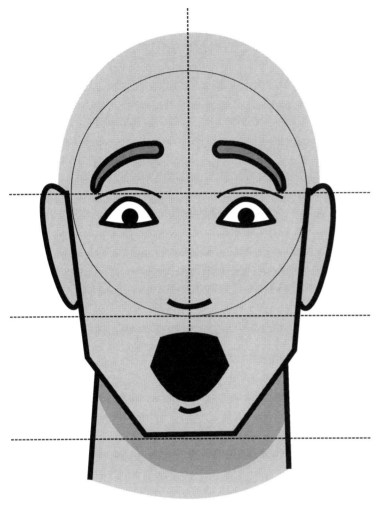

EYEBROWS
Use RAISED EYEBROWS.

EYES
Use UPPER-WIDE EYES.

NOSE
Use LIFTED NOSE.

MOUTH
Use ROARING MOUTH.

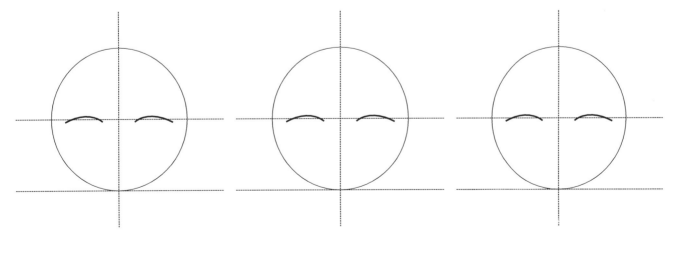

PITYING

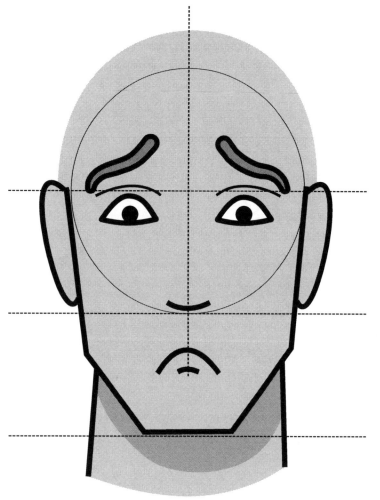

EYEBROWS
Use OUTWARD SLOPE EYEBROWS.

EYES
Use UPPER-WIDE EYES.

NOSE
Use NEUTRAL NOSE.

MOUTH
Use DEEP CLOSED FROWN.

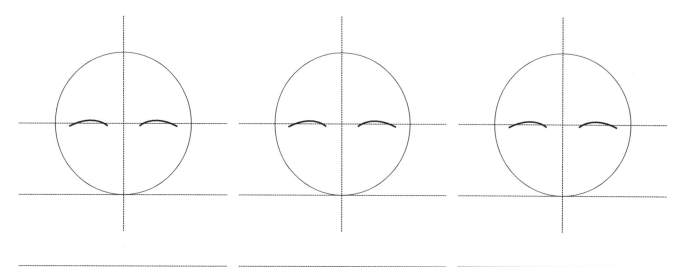

PLEASED

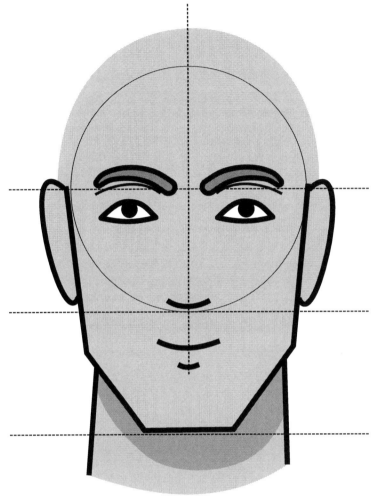

EYEBROWS
Use DIPPING EYEBROWS.

EYES
Use NEUTRAL EYES.

NOSE
Use NEUTRAL NOSE.

MOUTH
Use CLOSED SMILE.

PLEASURED

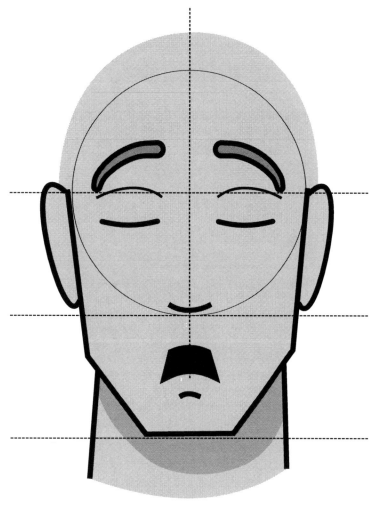

EYEBROWS
Use RAISED EYEBROWS.

EYES
Use DOWNWARD CLOSED EYES.

NOSE
Use NEUTRAL NOSE.

MOUTH
Use NARROW OPEN FROWN.

PONDERING

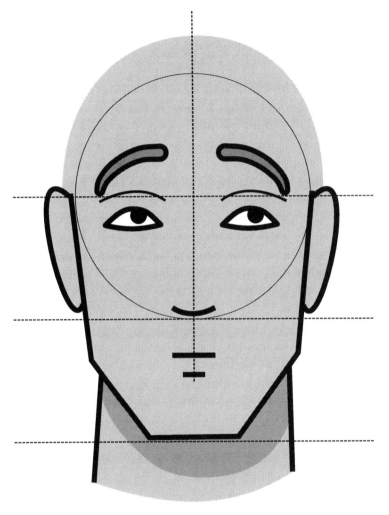

EYEBROWS
Use RAISED EYEBROWS.

EYES
Use NEUTRAL EYES looking up and off to one side.

NOSE
Use NEUTRAL NOSE.

MOUTH
Use NARROW NEUTRAL MOUTH.

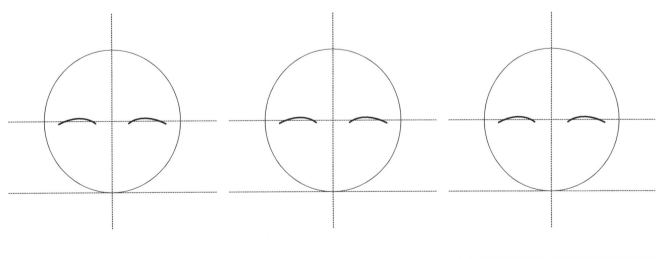

PROUD

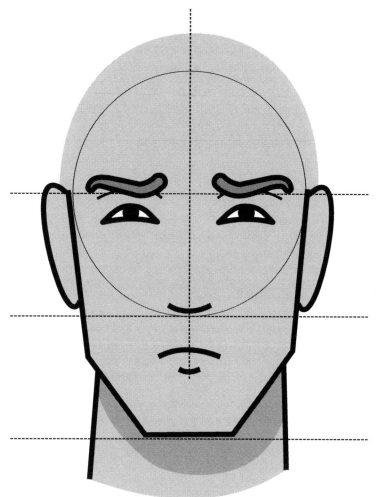

EYEBROWS
Use INWARD DROOP EYEBROWS.

EYES
Use UPTURNED EYES.

NOSE
Use NEUTRAL NOSE.

MOUTH
Use CLOSED FROWN with the smaller of the two lines flipped so the ends bend upward.

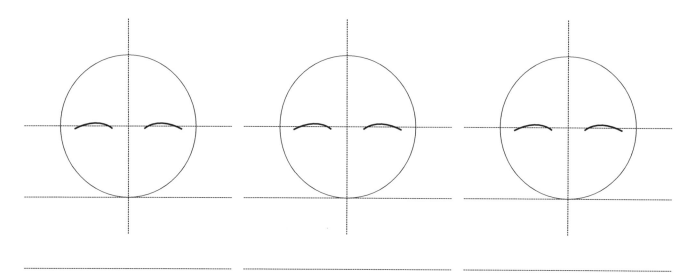

PUZZLED

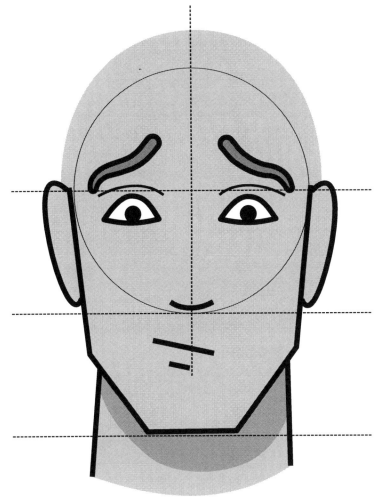

EYEBROWS
Use OUTWARD SLOPE EYEBROWS.

EYES
Use UPPER-WIDE EYES.

NOSE
Use NEUTRAL NOSE.

MOUTH
Use SLANTED NEUTRAL MOUTH.

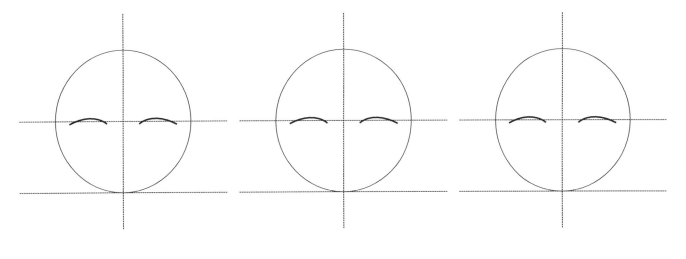

REGRETFUL

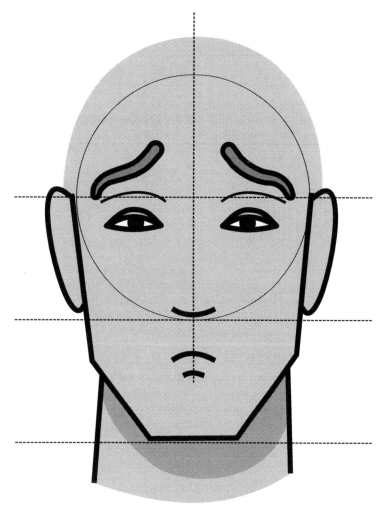

EYEBROWS
Use OUTWARD SLOPE EYEBROWS.

EYES
Use HALF-OPEN EYES.

NOSE
Use NEUTRAL NOSE.

MOUTH
Use NARROW CLOSED FROWN.

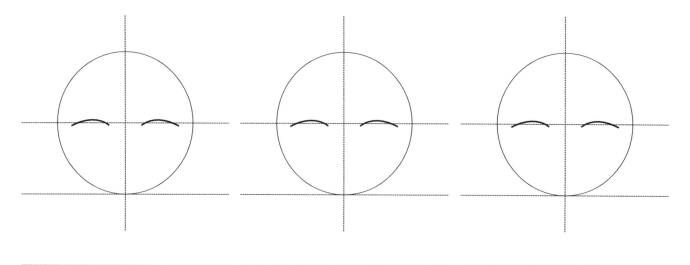

RELIEVED

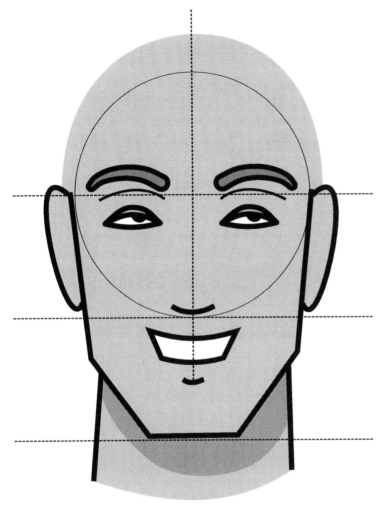

EYEBROWS
Use NEUTRAL EYEBROWS.

EYES
Use HALF-OPEN EYES looking off to one side with the circle tucked half hidden up underneath the upper eye lid.

NOSE
Use NEUTRAL NOSE.

MOUTH
Use TEETH OPEN SMILE.

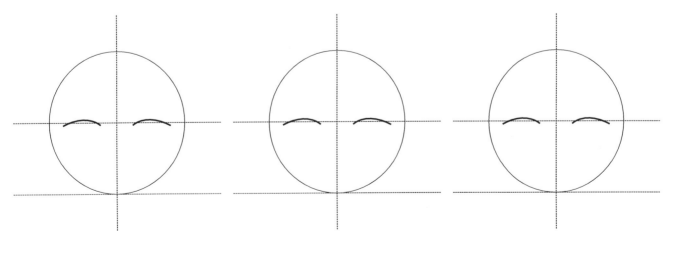

RELUCTANT

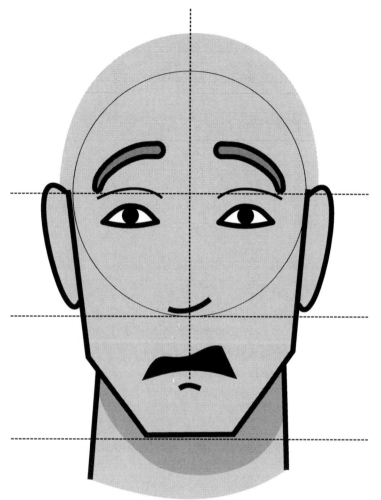

EYEBROWS
Use RAISED EYEBROWS.

EYES
Use NEUTRAL EYES.

NOSE
Use SLANTED NOSE lifted on the same side as the raised upper lip of the mouth.

MOUTH
Use LOPSIDED GRIMACE.

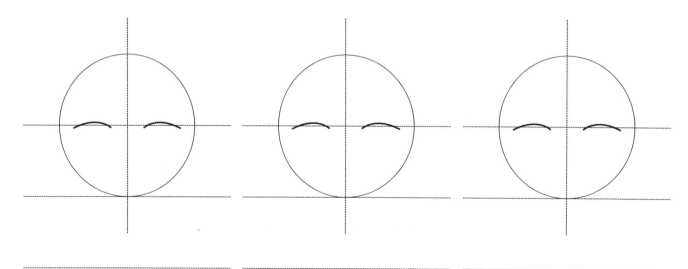

REMEMBERING

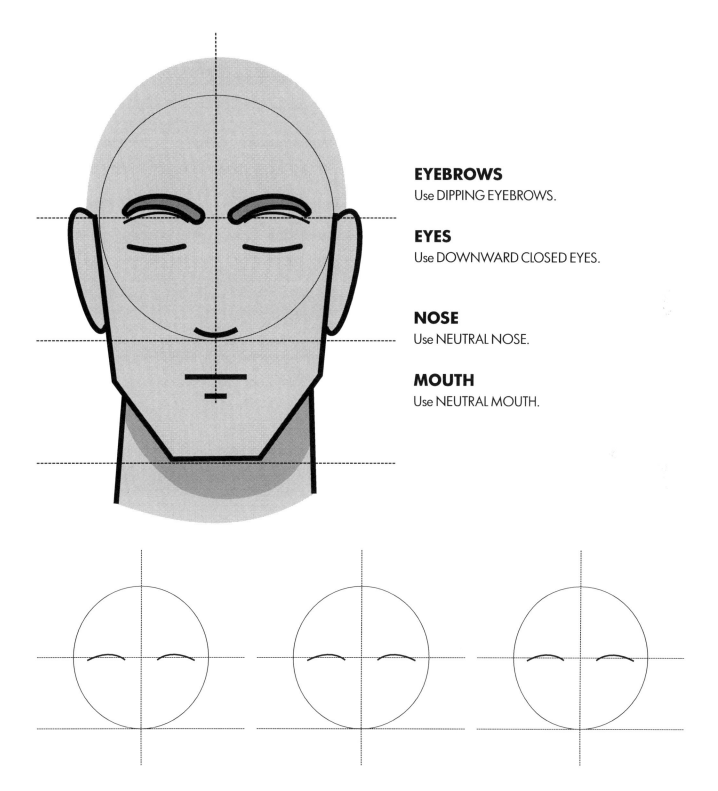

EYEBROWS
Use DIPPING EYEBROWS.

EYES
Use DOWNWARD CLOSED EYES.

NOSE
Use NEUTRAL NOSE.

MOUTH
Use NEUTRAL MOUTH.

RESENTFUL

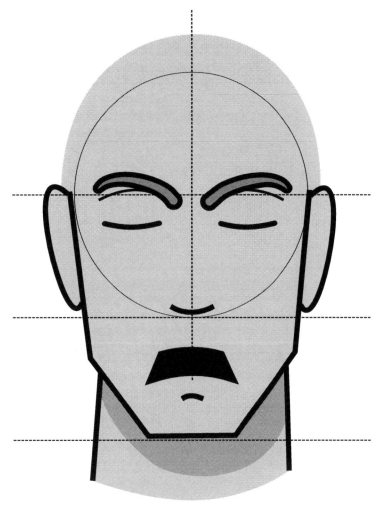

EYEBROWS
Use INWARD SLOPE EYEBROWS.

EYES
Use DOWNWARD CLOSED EYES.

NOSE
Use NEUTRAL NOSE.

MOUTH
Use OPEN FROWN.

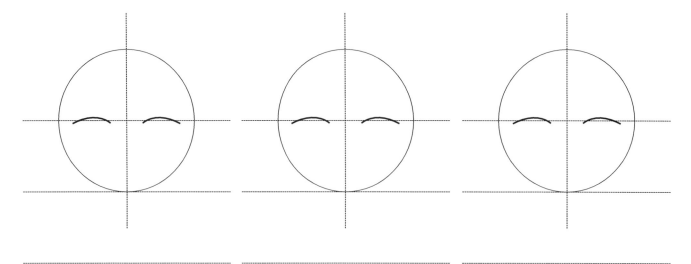

SAD

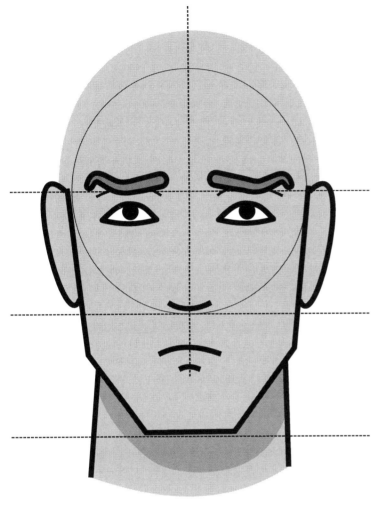

EYEBROWS
Use OUTWARD DROOP EYEBROWS.

EYES
Use NEUTRAL EYES.

NOSE
Use NEUTRAL NOSE.

MOUTH
Use CLOSED FROWN.

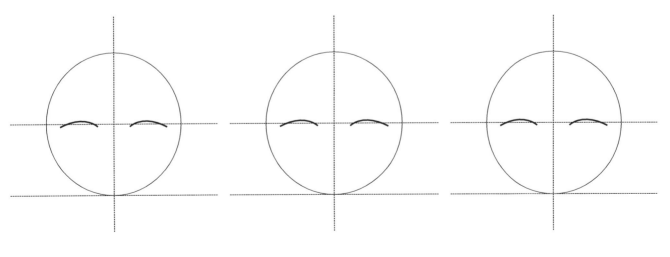

SCHEMING

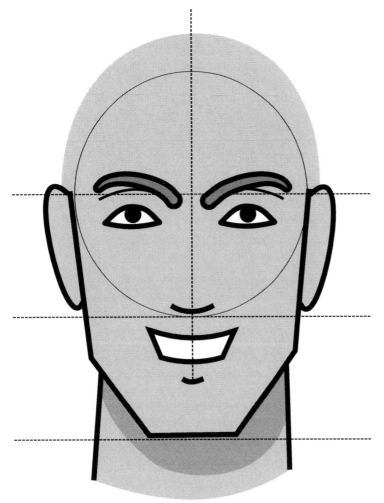

EYEBROWS
Use INWARD SLOPE EYEBROWS.

EYES
Use NEUTRAL EYES.

NOSE
Use NEUTRAL NOSE.

MOUTH
Use TEETH OPEN SMILE.

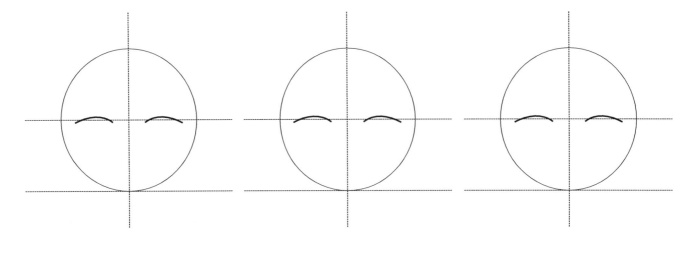

SERENE

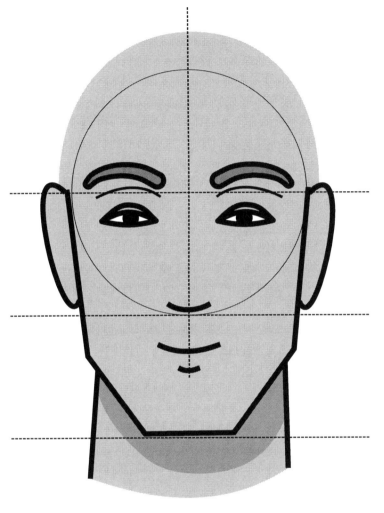

EYEBROWS
Use NEUTRAL EYEBROWS.

EYES
Use HALF-OPEN EYES.

NOSE
Use NEUTRAL NOSE.

MOUTH
Use CLOSED SMILE.

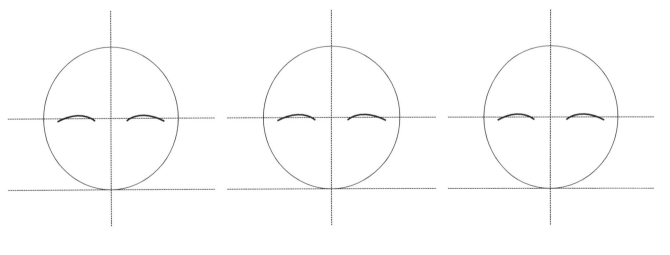

SERIOUS

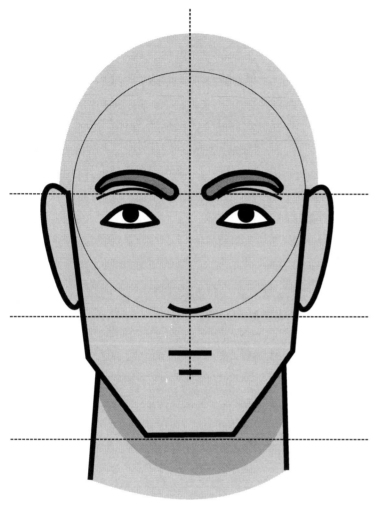

EYEBROWS
Use DIPPING EYEBROWS.

EYES
Use NEUTRAL EYES.

NOSE
Use NEUTRAL NOSE.

MOUTH
Use NARROW NEUTRAL MOUTH.

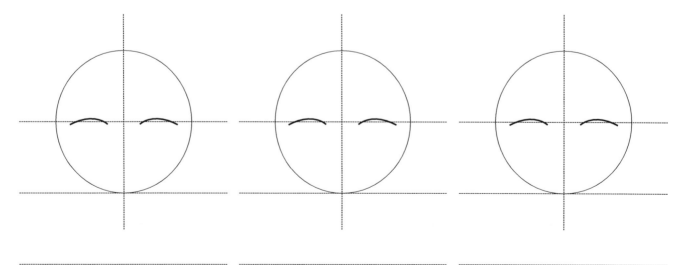

SHOCKED

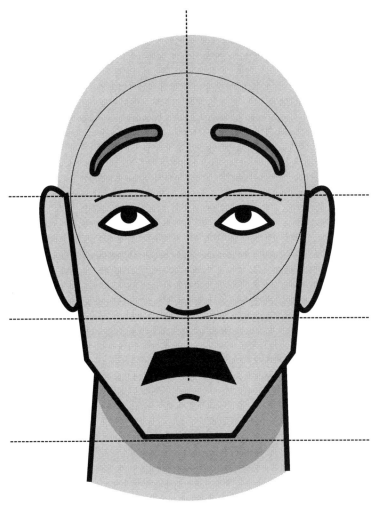

EYEBROWS
Use HIGH RAISED EYEBROWS.

EYES
Use LOWER-WIDE EYES.

NOSE
Use NEUTRAL NOSE.

MOUTH
Use OPEN FROWN.

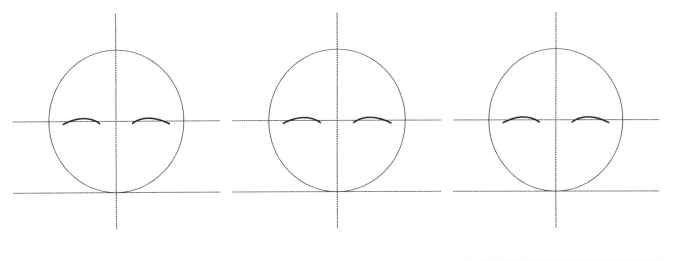

111

SHY

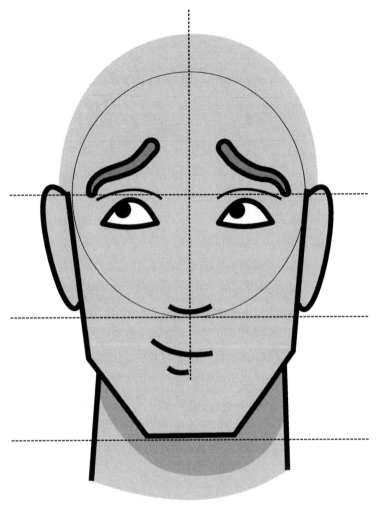

EYEBROWS
Use OUTWARD SLOPE EYEBROWS.

EYES
Use UPPER-WIDE EYES looking up and off to the side - the same side to which the mouth is shifted.

NOSE
Use NEUTRAL NOSE.

MOUTH
Use SLANTED CLOSED SMILE.

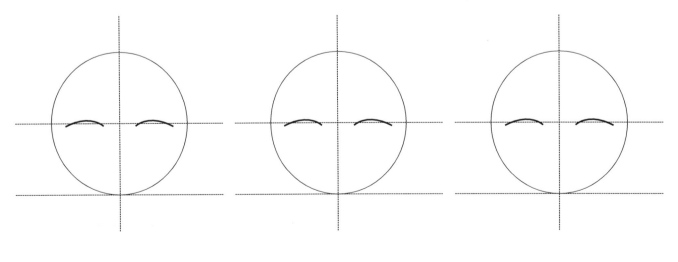

SINCERE

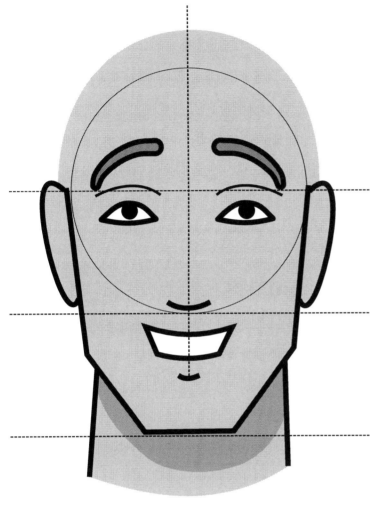

EYEBROWS
Use RAISED EYEBROWS.

EYES
Use NEUTRAL EYES.

NOSE
Use NEUTRAL NOSE.

MOUTH
Use TEETH OPEN SMILE.

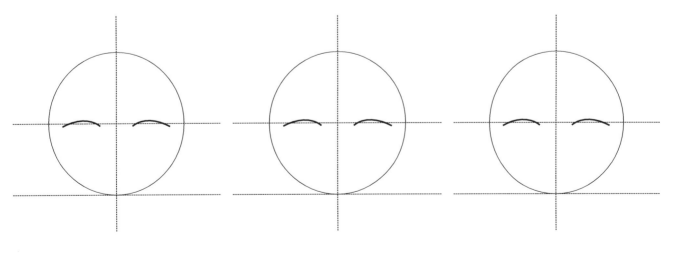

SLEEPING

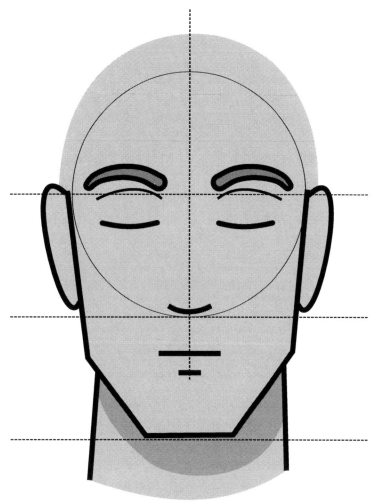

EYEBROWS
Use NEUTRAL EYEBROWS.

EYES
Use DOWNWARD CLOSED EYES.

NOSE
Use NEUTRAL NOSE.

MOUTH
Use NEUTRAL MOUTH.

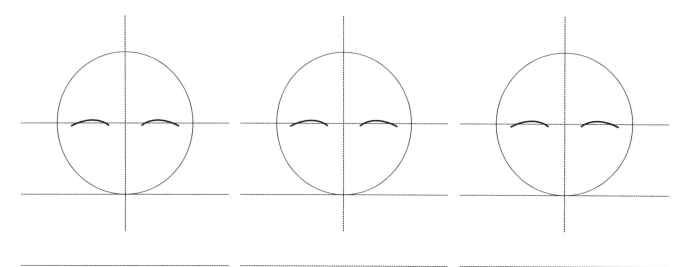

SLY

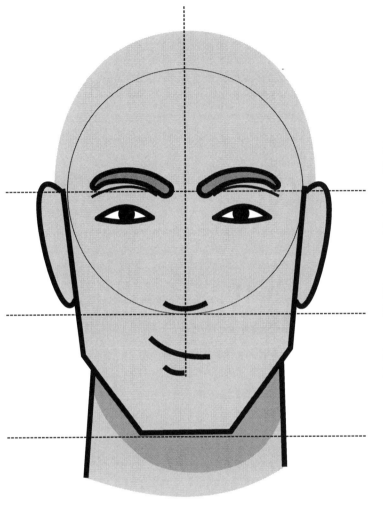

EYEBROWS
Use DIPPING EYEBROWS.

EYES
Use NARROW EYES.

NOSE
Use NEUTRAL NOSE.

MOUTH
Use SLANTED CLOSED SMILE.

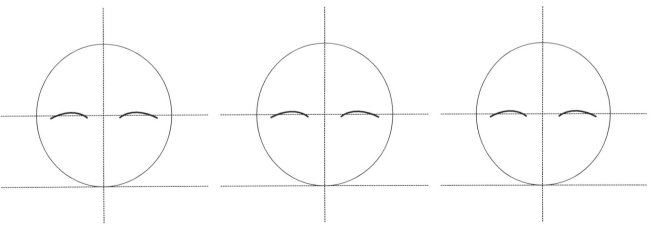

SMUG

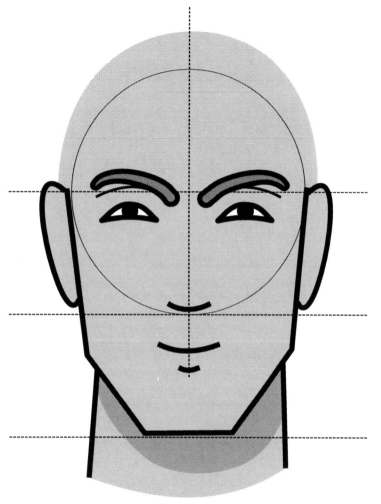

EYEBROWS
Use INWARD SLOPE EYEBROWS.

EYES
Use UPTURNED EYES.

NOSE
Use NEUTRAL NOSE.

MOUTH
Use CLOSED SMILE.

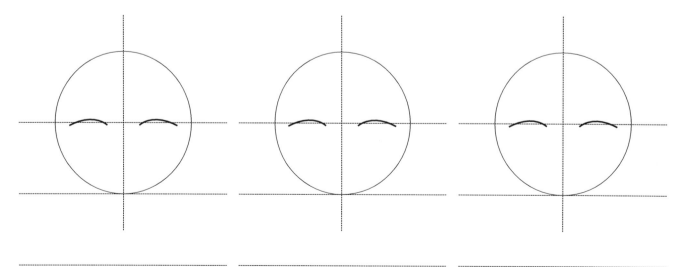

SNEERING

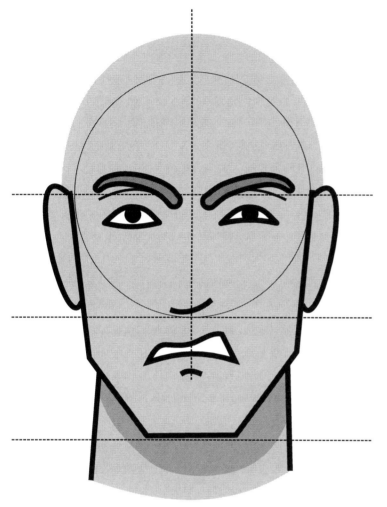

EYEBROWS
Use INWARD SLOPE EYEBROWS.

EYES
Use an UPTURNED EYE on the same side as the raised upper lip of the mouth and a NARROW NEUTRAL EYE on the other side.

NOSE
Use SLANTED NOSE lifted on the same side as the raised upper lip of the mouth.

MOUTH
Use LOPSIDED TEETH GRIMACE.

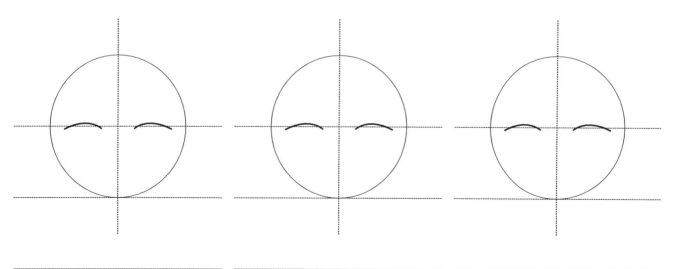

SNOBBY

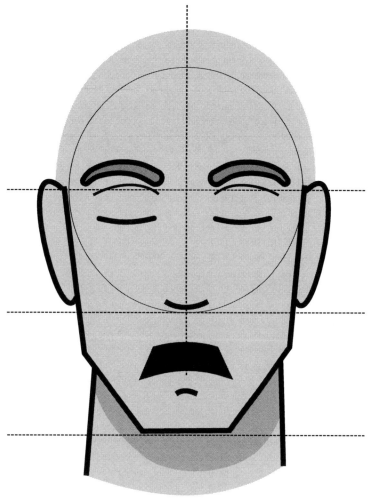

EYEBROWS
Use NEUTRAL EYEBROWS.

EYES
Use DOWNWARD CLOSED EYES.

NOSE
Use NEUTRAL NOSE.

MOUTH
Use OPEN FROWN.

SOMBER

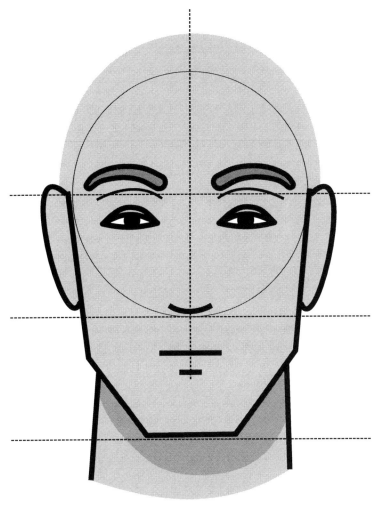

EYEBROWS
Use NEUTRAL EYEBROWS.

EYES
Use HALF-OPEN EYES.

NOSE
Use NEUTRAL NOSE.

MOUTH
Use NEUTRAL MOUTH.

SORRY

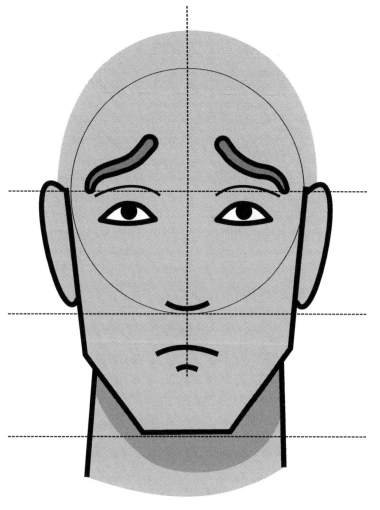

EYEBROWS
Use OUTWARD SLOPE EYEBROWS.

EYES
Use NEUTRAL EYES.

NOSE
Use NEUTRAL NOSE.

MOUTH
Use CLOSED FROWN.

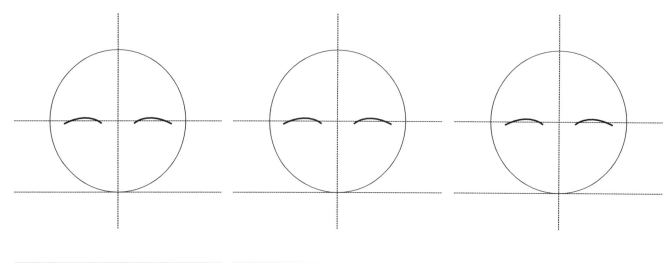

SPEECHLESS

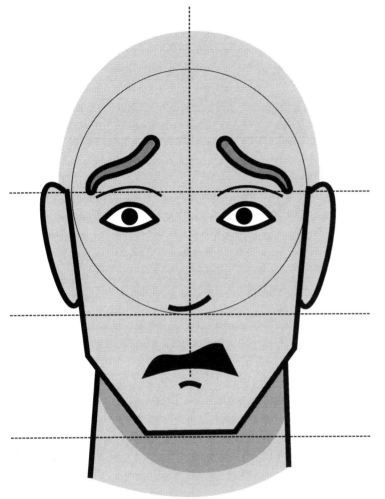

EYEBROWS
Use OUTWARD SLOPE EYEBROWS.

EYES
Use LOWER-WIDE EYES with the circle not touching the upper and lower eye lids.

NOSE
Use SLANTED NOSE lifted on the same side as the raised upper lip of the mouth.

MOUTH
Use LOPSIDED GRIMACE.

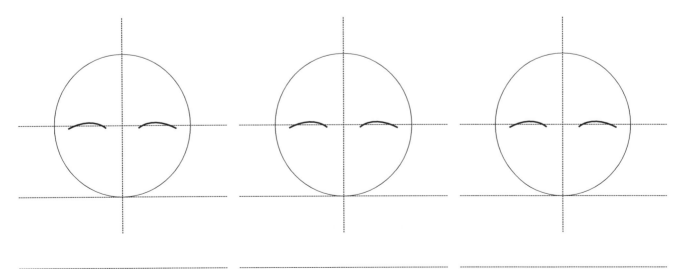

121

STARING

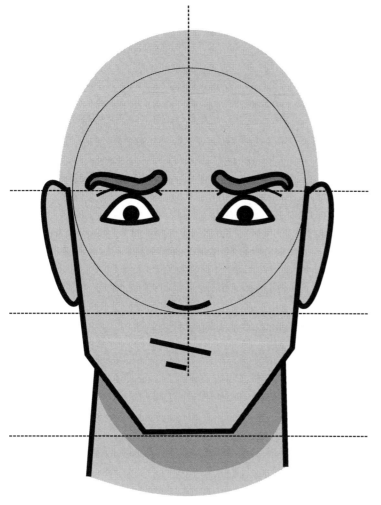

EYEBROWS
Use INWARD DROOP EYEBROWS.

EYES
Use UPPER-WIDE EYES.

NOSE
Use NEUTRAL NOSE.

MOUTH
Use SLANTED NEUTRAL MOUTH.

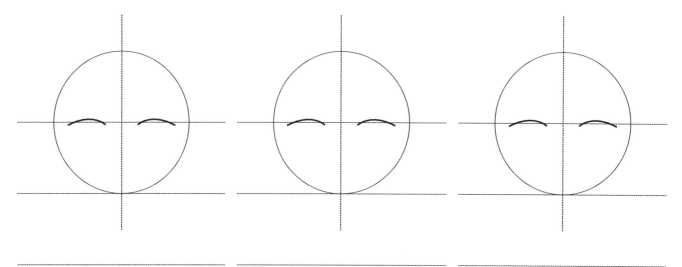

STARTLED

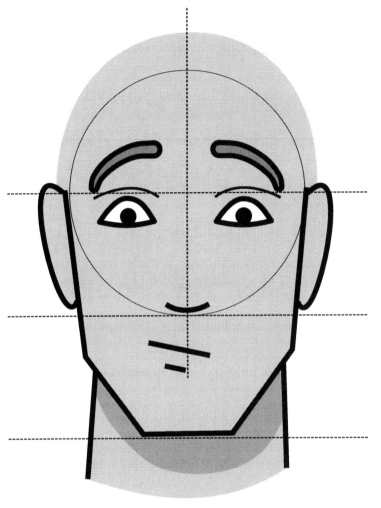

EYEBROWS
Use RAISED EYEBROWS.

EYES
Use UPPER-WIDE EYES.

NOSE
Use NEUTRAL NOSE.

MOUTH
Use SLANTED NEUTRAL MOUTH.

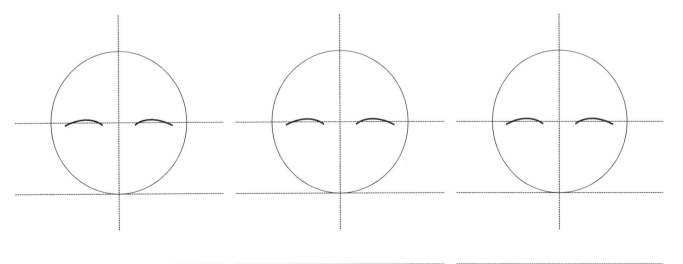

STERN

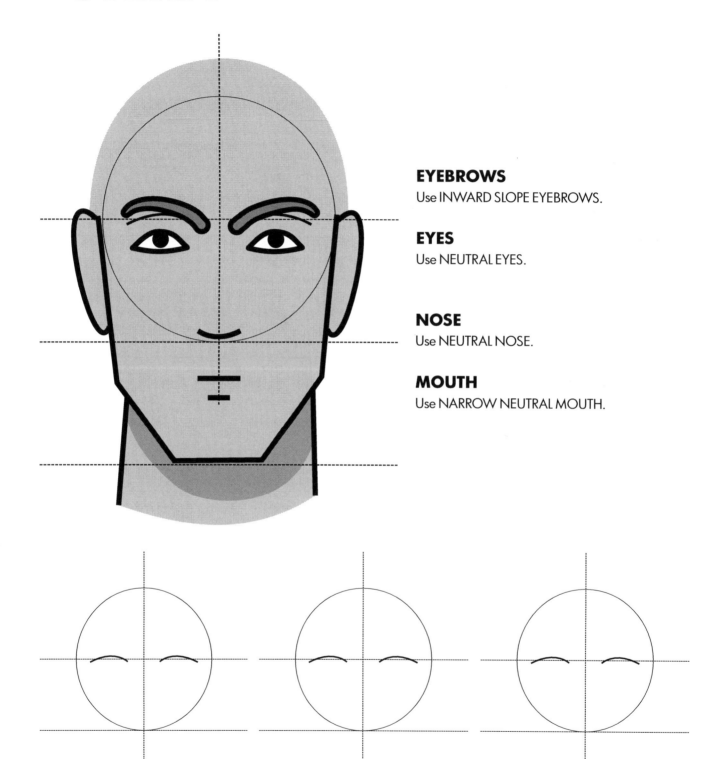

EYEBROWS
Use INWARD SLOPE EYEBROWS.

EYES
Use NEUTRAL EYES.

NOSE
Use NEUTRAL NOSE.

MOUTH
Use NARROW NEUTRAL MOUTH.

STOKED

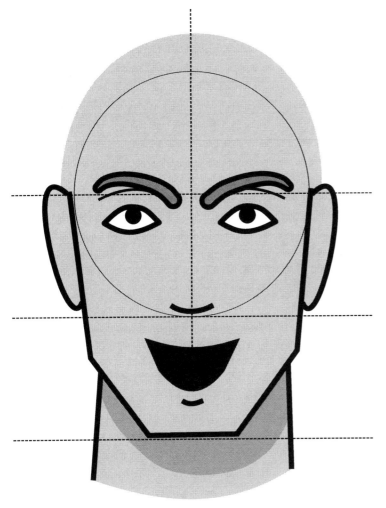

EYEBROWS
Use INWARD SLOPE EYEBROWS.

EYES
Use LOWER-WIDE EYES.

NOSE
Use NEUTRAL NOSE.

MOUTH
Use OPEN GRIN.

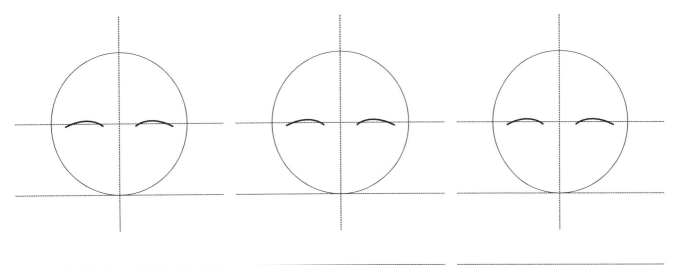

STUNNED

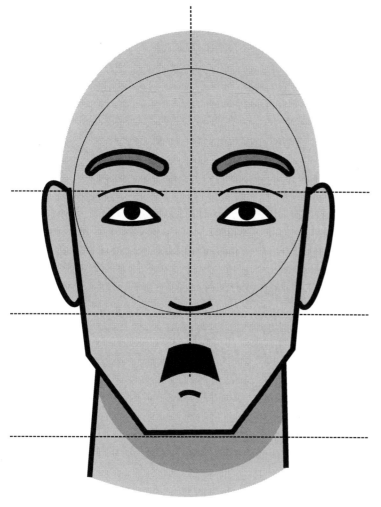

EYEBROWS
Use HIGH NEUTRAL EYEBROWS.

EYES
Use NEUTRAL EYES.

NOSE
Use NEUTRAL NOSE.

MOUTH
Use NARROW OPEN FROWN.

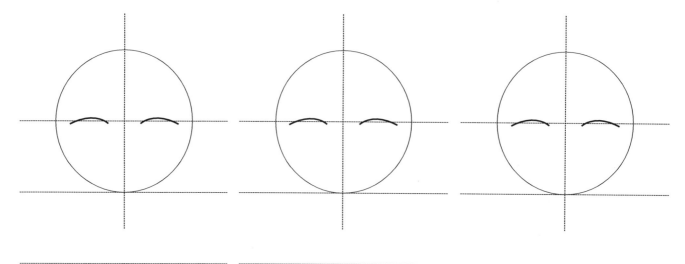

SUAVE

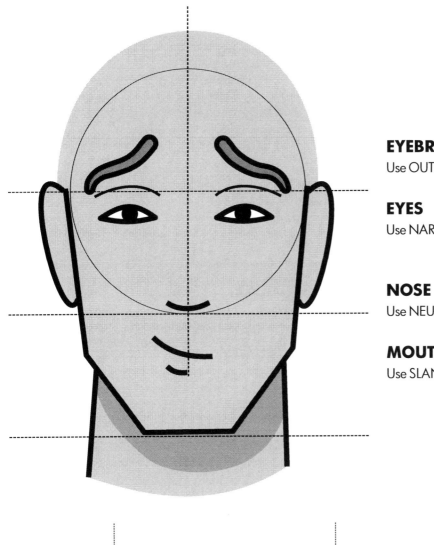

EYEBROWS
Use OUTWARD SLOPE EYEBROWS.

EYES
Use NARROW EYES.

NOSE
Use NEUTRAL NOSE.

MOUTH
Use SLANTED CLOSED SMILE.

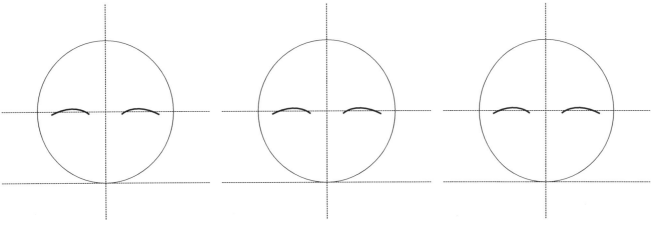

SUSPICIOUS

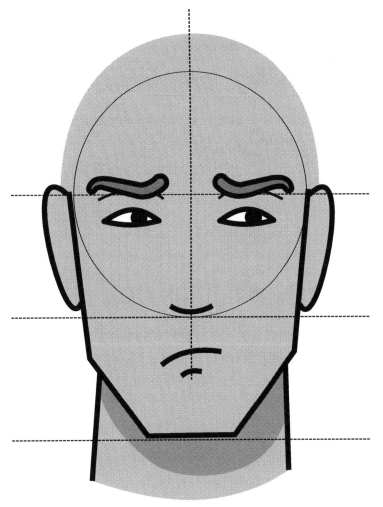

EYEBROWS
Use INWARD DROOP EYEBROWS.

EYES
Use NARROW EYES looking off to one side.

NOSE
Use NEUTRAL NOSE.

MOUTH
Use SLANTED CLOSED FROWN.

SYMPATHETIC

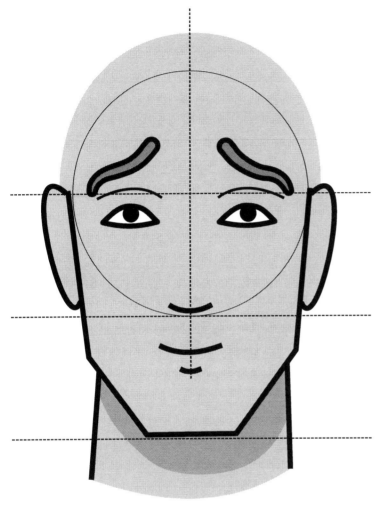

EYEBROWS
Use OUTWARD SLOPE EYEBROWS.

EYES
Use NEUTRAL EYES.

NOSE
Use NEUTRAL NOSE.

MOUTH
Use CLOSED SMILE.

TEASING

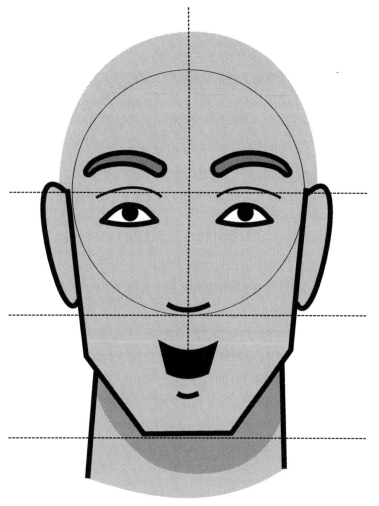

EYEBROWS
Use HIGH NEUTRAL EYEBROWS.

EYES
Use NEUTRAL EYES.

NOSE
Use NEUTRAL NOSE.

MOUTH
Use NARROW OPEN SMILE.

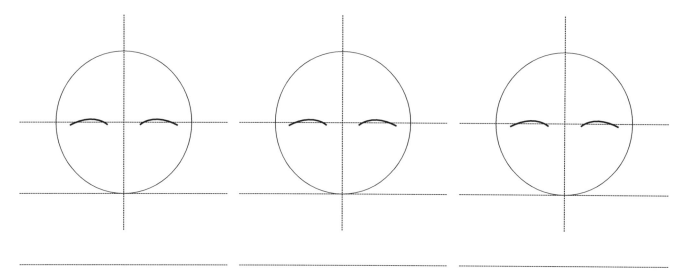

TERRIFIED

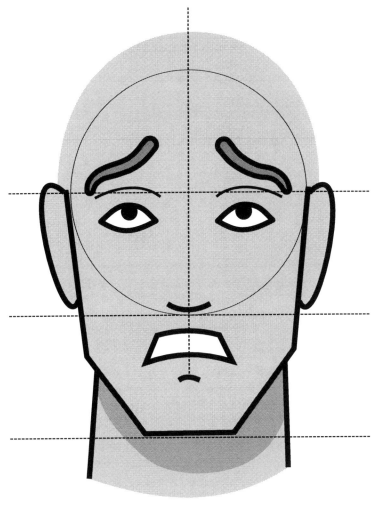

EYEBROWS
Use OUTWARD SLOPE EYEBROWS.

EYES
Use LOWER-WIDE EYES.

NOSE
Use NEUTRAL NOSE.

MOUTH
Use TEETH OPEN FROWN.

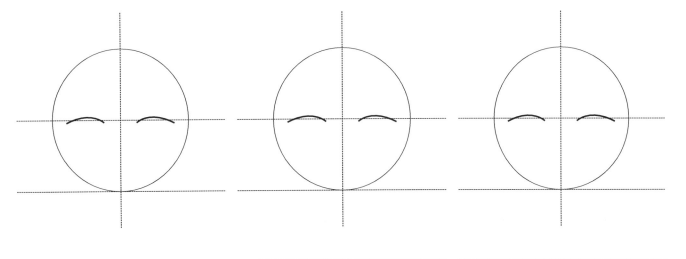

THANKFUL

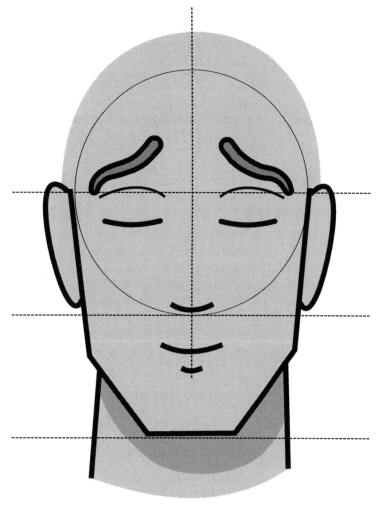

EYEBROWS
Use OUTWARD SLOPE EYEBROWS.

EYES
Use DOWNWARD CLOSED EYES.

NOSE
Use NEUTRAL NOSE.

MOUTH
Use CLOSED SMILE.

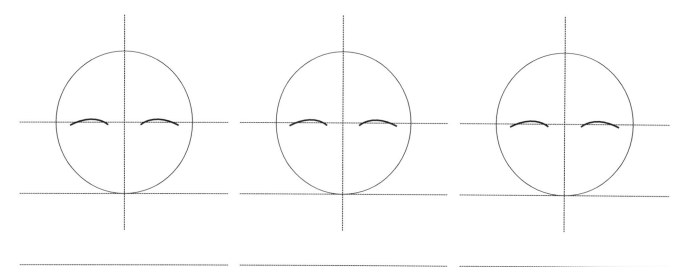

UNHINGED

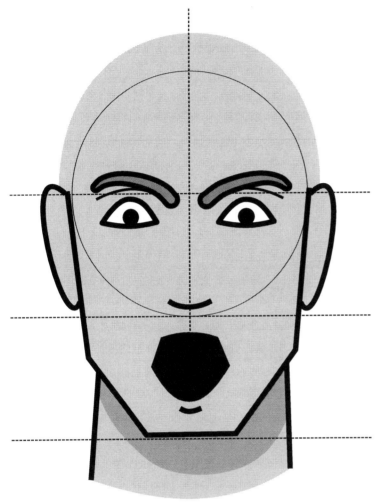

EYEBROWS
Use INWARD SLOPE EYEBROWS.

EYES
Use UPPER-WIDE EYES.

NOSE
Use LIFTED NOSE.

MOUTH
Use ROARING MOUTH.

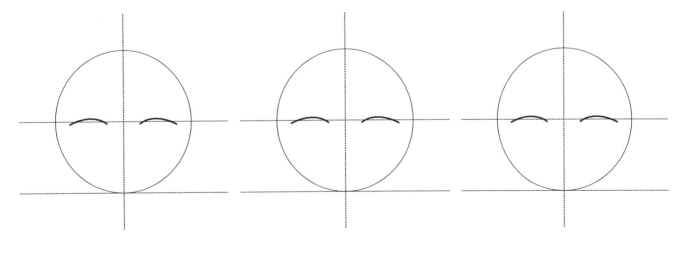

WEARY

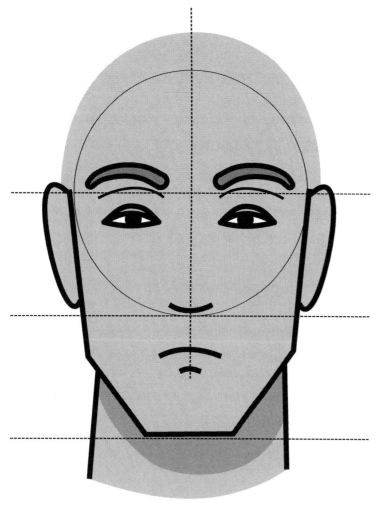

EYEBROWS
Use NEUTRAL EYEBROWS.

EYES
Use HALF-OPEN EYES.

NOSE
Use NEUTRAL NOSE.

MOUTH
Use CLOSED FROWN.

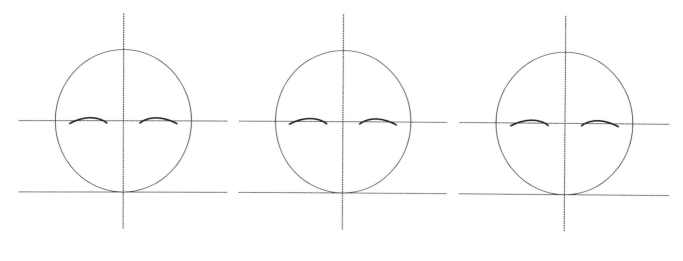

WINKING

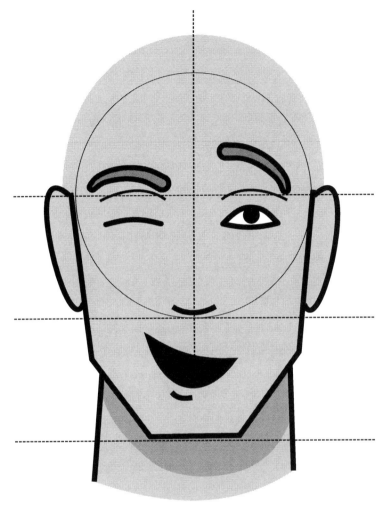

EYEBROWS
Use a NEUTRAL EYEBROW on the same side as the closed eye and a RAISED EYEBROW.

EYES
Use a LOW-UPWARD CLOSED EYE on the same side as the raised corner of the mouth and a NEUTRAL EYE on the other side.

NOSE
Use NEUTRAL NOSE.

MOUTH
Use SLANTED OPEN GRIN.

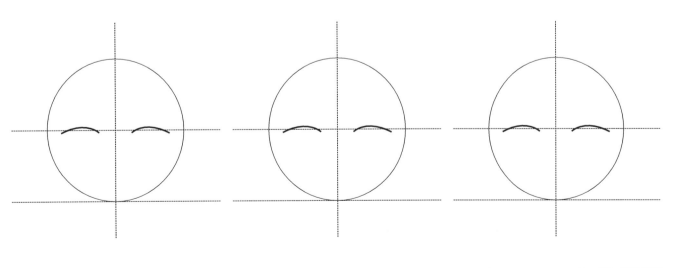

WORRIED

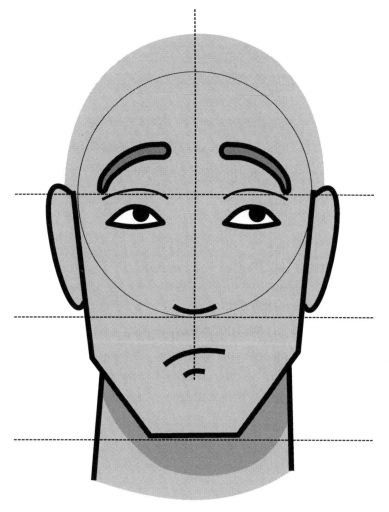

EYEBROWS
Use RAISED EYEBROWS.

EYES
Use NEUTRAL EYES looking up and off to one side.

NOSE
Use NEUTRAL NOSE.

MOUTH
Use SLANTED CLOSED FROWN.

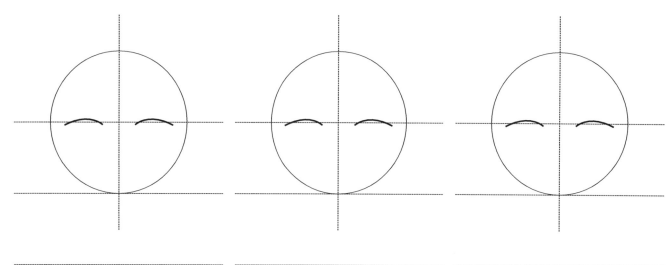

YAWNING

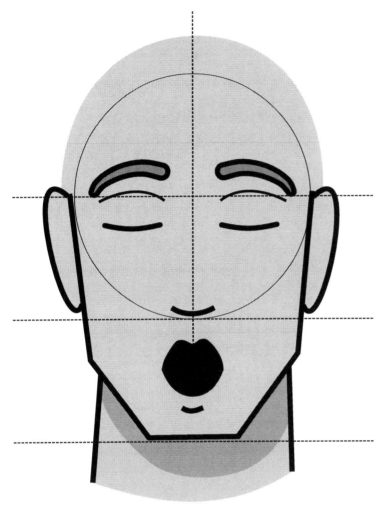

EYEBROWS
Use SLIGHTLY RAISED EYEBROWS.

EYES
Use DOWNWARD CLOSED EYES.

NOSE
Use NEUTRAL NOSE.

MOUTH
Use ROUNDED MOUTH.

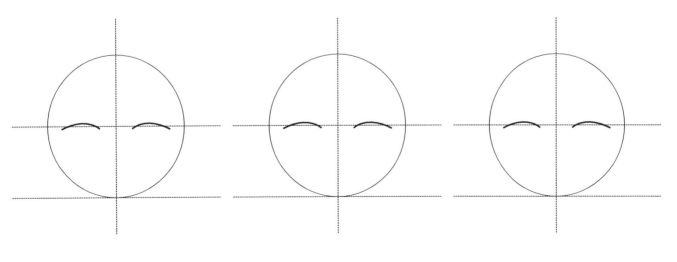

NECK

The type of neck depends on the gender of the face. On an average-weight individual a female neck is more slender than a male neck. Also a male neck shows a protruding lump (called the laryngeal prominence) in the front, centered below the chin. This lump is formed by the largest cartilage of the larynx (voice box). Female necks also have this lump. It is significantly smaller and usually concealed beneath the skin and not drawn on female necks. On male necks the lump is drawn as a single curve - a line that appears like the one drawn for the simple nose but at half the width and positioned slightly below the Chin Guideline.

An adult male neck will be wider than the distance between the outer corners of the eyes. An adult female neck will be equal to or less wide than the distance between the outer corners of the eyes. Teenagers are still growing into their skin. A teenage male neck will be equal to the distance between the outer corners of the eyes, while a teenage female neck will be less than the distance between the outer corners of the eyes. Pre-Teen female and male necks are the same as teenage necks, but the Eye Guideline is lowered.

Eye Guideline Original Position →
Eye Guideline Pre-Teen Position →

Position the Eye Guideline for Pre-Teens so it sits a quarter of the way down based on the distance between its original position and the Nose Guideline. This will reduce the height of the ears and alter the placement of the eyes and eyebrows accordingly.

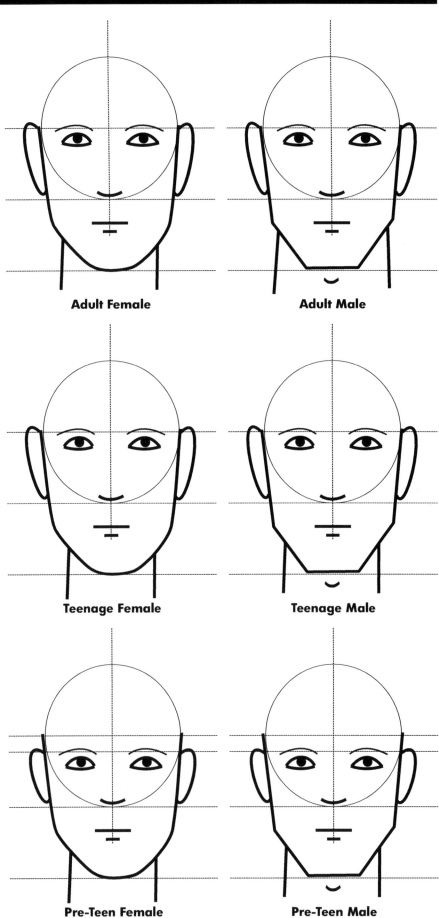

Adult Female **Adult Male**

Teenage Female **Teenage Male**

Pre-Teen Female **Pre-Teen Male**

138

JAW

The jawline can be customized. The key is to keep the feature symmetrical, so draw one side of the Center Guideline (the left or the right) and then mirror it on the other side to make it balanced.

Use a jawline from the next pages. You can use it unchanged, modify it, or create an original one. One thing to consider when creating your own is the width of the chin. It can be narrow, moderate, or wide. Also consider the shape of the chin. It can be gently curved, squared off, abruptly curved, and so forth. A chin can be smooth or can have a minor or major cleft. Think about the length of the jaw - whether and how much it rests above, on, or below the Chin Guideline. The jawline can be taut, trim, and angled or it can mildly to profoundly droop on the sides or even droop under the chin.

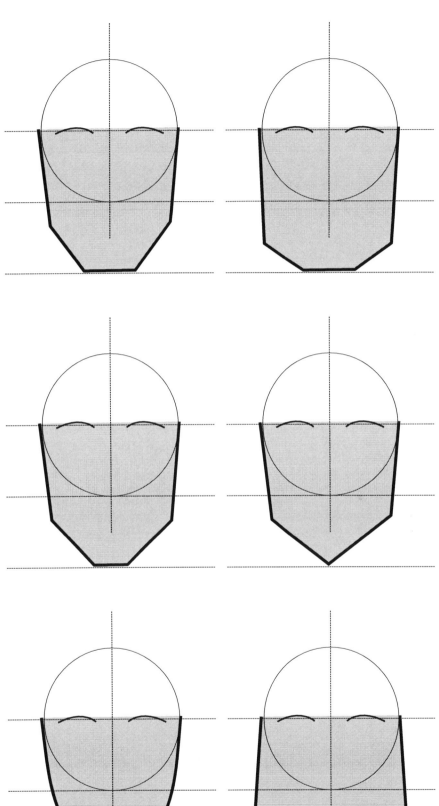

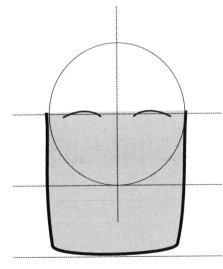
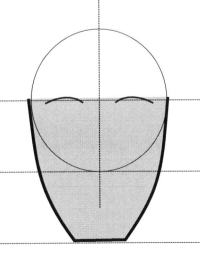

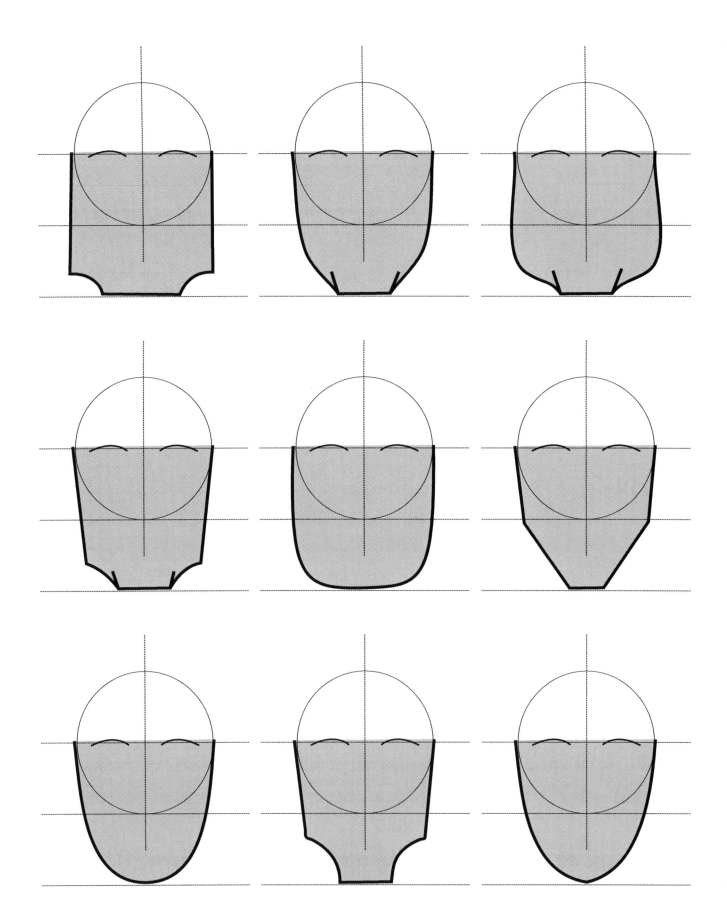

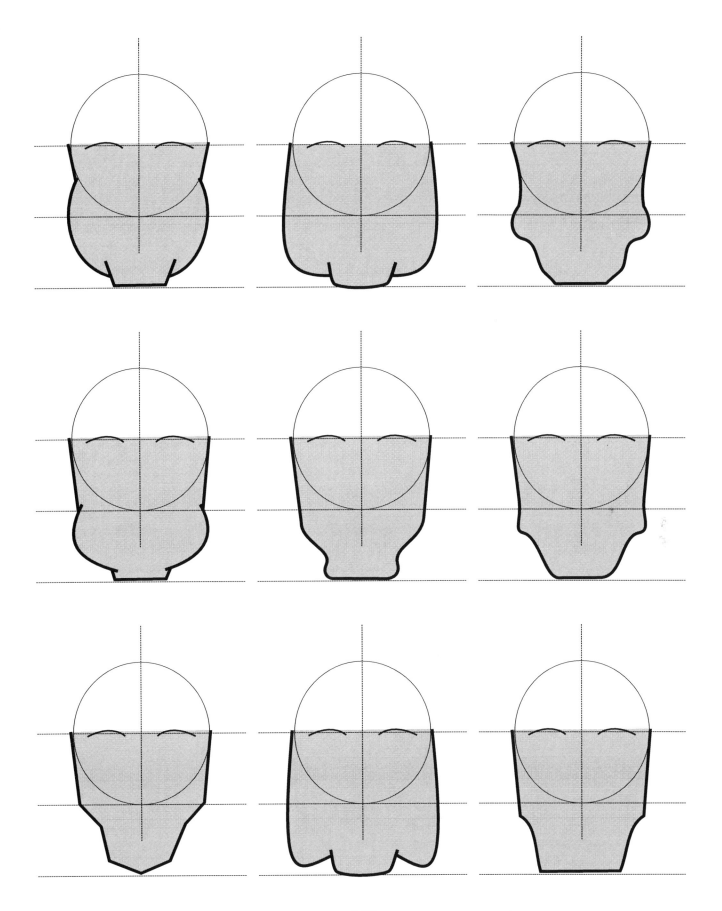

141

EARS

Ears can be drawn with a single curved line or with more detail. You can depict them at any stage shown here - step 1, 2, 3, 4, or 5 - depending on your personal style.

Regardless of which step you stop at, first decide how much the ears stick out from the rest of the head. Humans have a wonderful variety of ears - and how much they jut out or are closer to the head is part of that diversity. You may want to draw the ears flush (top row), partially-protruding (middle row), or protruding (bottom row). At its widest point, a flush ear is equal to a third the width of an eye, a partially-protruding ear is half the width of an eye, and a protruding ear is two-thirds the width of an eye. A reminder of these equivalencies has been added to step 1 above the right eye and ear.

An ear has an outer and an inner ridge. Step 2 shows the thickness of the outer ridge, while step 3 introduces the curved inner ridge. The bottom tip of the line added in step 3 ends at the jaw above the Nose Guideline a quarter of the way to the Eye Guideline.

Note the lines from step 2 and step 3 do not meet at their upper tips. The line from step 2 extends past the line from step 3 just a bit because they are parts of two different ear structures - the outer ridge and the inner ridge. The inner ridge resembles a curved letter Y, which appears in step 4 when the small V-shape and tiny half-oval are added to the inside of both ears. Notice the outer ridge appears to go behind the Y-shaped inner ridge on the flush ear (top row), while on the partially-protruding and protruding ears (middle and bottom rows), the outer ridge remains farther from the head than the Y-shaped inner ridge.

A quarter of the way up each ear the outer ridge can be pinched inward a bit to create the ear lobes, as shown in step 5. The lobes often appear as they do in the example but can be shaped as desired, but should generally mirror each other. Heavy jewelry hung from lobes causes them to lengthen as they sag from the weight.

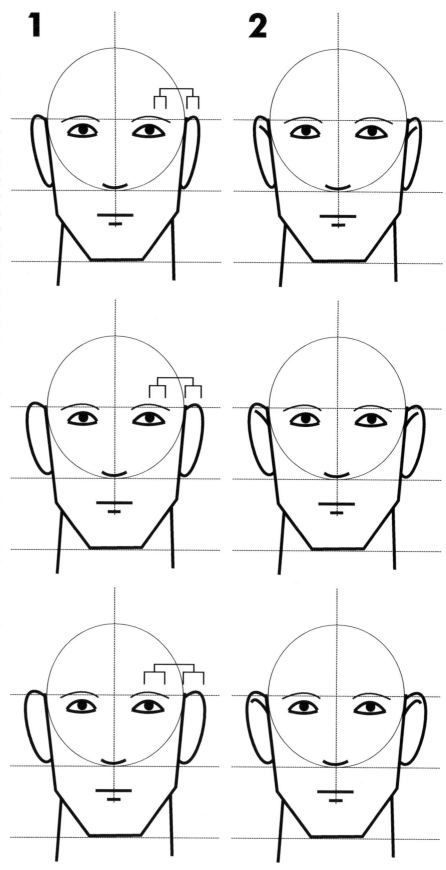

1 **2**

3 **4** **5**

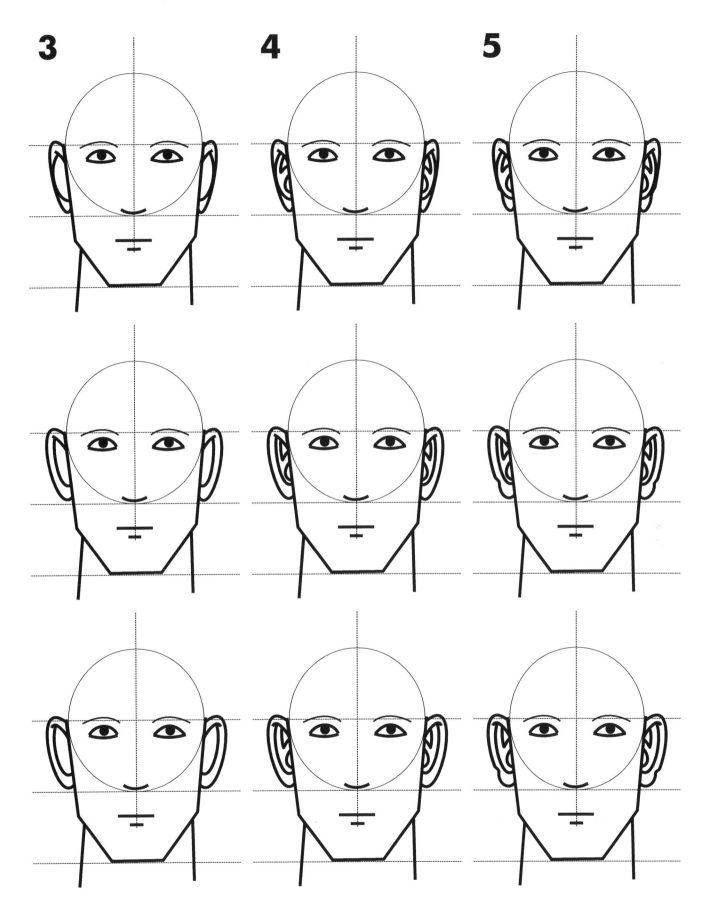

CROWN

When adding a crown, the top of the bald head touches the Center Guideline above the Circle Guideline a distance equal to a third of the way between the Eye Guideline and the top of the Circle Guideline. Also very important is the back of the head, which is larger than the front, so the crown must be drawn wider than the Circle Guideline. The points where the crown nears the Eye Guideline on both sides should be drawn roughly an amount equal to the width of a third of an eye away from the Circle Guideline.

If you create a hairstyle that remains close to the head shape along one or both sides such as a crewcut, buzz cut, slicked back or pulled back into a bun or a ponytail, then remember this means you have to position the hair on the sides to provide for the wider back of the head. The hair must be drawn out enough away from the Circle Guideline to properly provide for the wider back of the head plus however much thickness the hairstyle would add to the sides, so at least a third of an eye away from the Circle Guideline.

CONTOURS

The human head has contours to reflect the parts of the face that recede and protrude. These contours also help an artist create hairstyles by delineating the sides of the head from the front.

The topmost curves start at the very top of the head and travel down to define the edges of the forehead. Next are outward bumps - curves that show the outer edges of the brows behind the eyebrows. Then there are the eye dents, an inward curve showing the outer edge of the recessed socket surrounding each eye. Below those dents are outward bumps commonly called the cheekbones. They slope down the face and point towards the tops of the mouth contours - the outward curves flanking, but not touching, the corners of the mouth. These bowed furrows lead down to the chin contours, which show the edges where the front of the chin meets the sides of the chin.

Mouth contours are flexible, shifting inward or outward to react to lip movement. Mouth contours never touch any lines of the mouth itself. They maintain their distance from the corners. Their movement influences nearby contours. The bottom of the cheek contours above and the top of the chin contours below shift accordingly in response to any changes to the mouth contours.

HAIRSTYLE

Before starting on any hair, decide the look of the jaw and the neck as well as whether or not all or part of one or both ears will show based on the hairstyle you are aiming to produce. Draw these requisite features first after creating guidelines and then move on to the lines of the hair. If you ultimately discover the hairstyle will block any part of these initial features from view, erase the affected area of the feature.

Add the remaining facial features (eyes, eyebrows, etc.) once you are satisfied with the hair. This ensures you can easily make subtle or drastic hairstyle changes before committing to a specific expression. These final features may disappear in whole or in part behind hair.

TYPE 1 HAIRSTYLES

The simplest-to-draw hairstyles have two sections - an inner line and an outer line. Always start with the inner line. The inner line connects to the jaw or neck at some point and together they frame the inner facial features (eyes, nose, mouth). In a Type 1 Hairstyle, the inner and outer lines might touch at the tips but otherwise they do not cross over one another.

Three examples are shown on the opposite page. In the top example the hair droops down, while the hair is short in the middle and bottom examples. When hair is short or pulled back, the hairline crossing the forehead typically appears a third of the way down from the top of the Circle Guideline to the Eye Guideline.

Remember to review the contours of the head. These inform you of where the inner line represents the hair at the front of the face compared to where it represents the hair on the sides of the head (the upper sides of the crown, at the temples on the lower sides of the crown, at the sideburns in front of the ears, down along the cheeks and the sides of the neck).

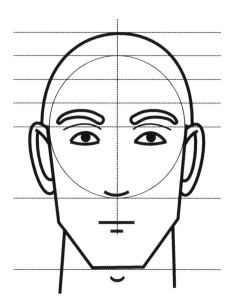

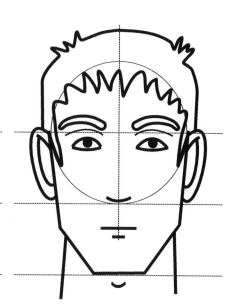

1 **2** **3**

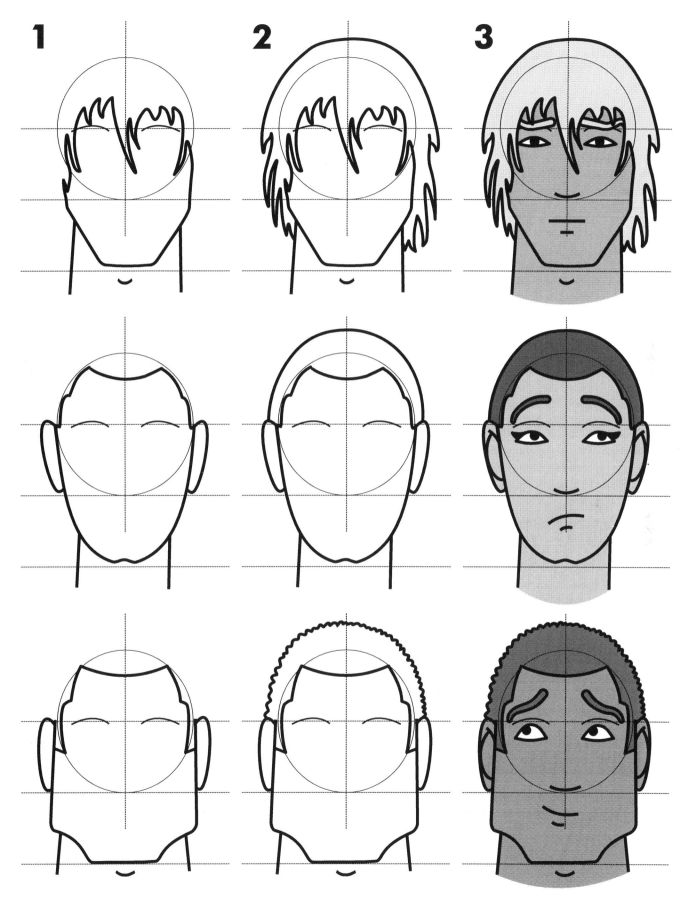

145

TYPE 2 HAIRSTYLES

These hairstyles are a bit more complex. They also start with two common sections - an inner line and an outer line - but also introduce one or more back lines. Once again, always start with the inner line (*see drawings in column one to the right*). The inner line crosses or connects to the lines of the jaw or neck at some point. Together all of these lines frame the inner facial features (eyes, nose, mouth).

Next apply the outer line (*see drawings in column two to the right*), representing the upper and outermost hair at the front of the head. In a Type 2 Hairstyle, inner and outer lines might touch (for example, at the tips) but otherwise they do not cross over one another.

Next apply the back lines (*see drawings in column three to the right*), which represent the hair at the back of the head. These often appear to show hair below, surrounding, or covering the ears. They also are used to show hair at the top of the head behind any hair structure at the front (such as bangs). The bottom example shows back lines at the top of the head and back lines at the sides of the head extending around and down past the ears eventually ending at the neck to complete the hairstyle.

Make any final adjustments or tweaks to your design before applying an expression to your face (*see drawings in column four to the right*). Although you add it only after creating the hair, decide the expression beforehand so you can take it into account in determining the appropriate hairstyle.

A character may shift styles to fit their mood or personality. For instance, a woman may wear her long hair gathered back behind her head when she is happy, blown out with lots of body when she is seductive, partially covering her face when she is shy, tucked behind her ears when she is concentrating, and so forth. A frustrated man may have frantically run his hands through his normally-well-kept hair so now it appears disheveled. A shocked person may have their hair standing on end. A stern individual may keep their hair short to match their idea of a proper appearance, while a carefree type may let their hair grow long so it can flow with the wind. A well-to-do person may have an expensive-looking hairstyle while a thrifty individual may have a do-it-yourself haircut.

Circumstance also plays a role in determining hair. A motorcyclist who spent hours on the road will have their hair stuck to their head from wearing a helmet or blown-back if riding without one. Wet hair also loses volume, clumps, and sticks to skin. Someone standing in the rain, swimming in a lake, or stepping freshly out of the shower will have their hair reflect those characteristics.

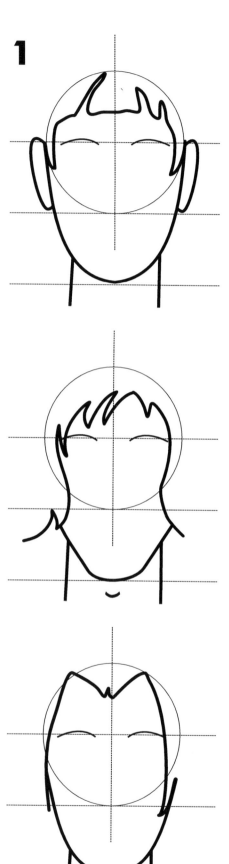

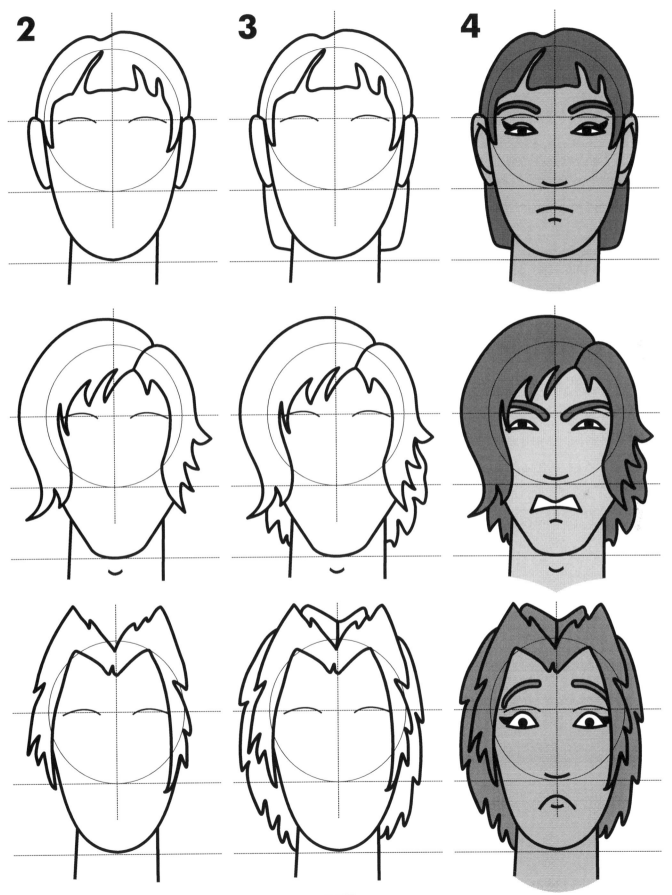

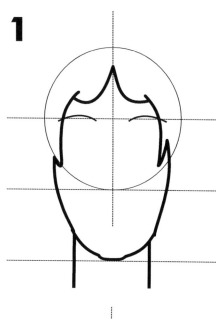

TYPE 3 HAIRSTYLES

In Type 3 Hairstyles, inner and outer lines are made of one or more overlapping lines rather than being comprised of only single continuous lines. This adds to the depth of the hair - such as accentuating bangs at the front of the head (see the top example).

Sometimes the lines of a chunk of hair overlap an existing hair line in more than one spot (see steps 1 and 2 of the middle example). To complete the appearance of the overlap, a segment of the underlying line is erased (the dotted segments in step 2 of the middle example).

Overlapping in succession adds even more depth. Look at the shark-fin-like segments used to create the back outer line in the bottom example. Segments further from the Center Guideline overlap the segments closer to the Center Guideline, and the two closest segments do not overlap because they represent the farthest hair at the back of the head and are equidistant from the viewer.

Once you decide how many lines in your hairstyle will overlap, you have to determine the extent of the overlap. How much lines overlap is a matter of personal choice. They can overlap just a tiny bit or they can substantially overlap. If you are uncertain,

start out with just a little bit of overlap and return to add more to those lines until you reach the desired look. The amount of overlap can be uniform or vary throughout a hairstyle. Remember that overlap is simply an option in a hairstyle. *Only introduce overlap if it strengthens the hairstyle.* Reduce or remove any overlap that clutters the overall appearance. Regardless of the type of hairstyle, you are aiming for a solid style that you like - one that enhances the character you want to portray to the viewer.

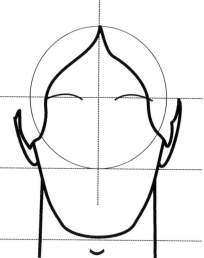

HAIR CHECK

Run a little check after you think you have finished your hairstyle. Check to see that the hair extends far enough outside the left and right sides of the Circle Guideline. Is it far enough to make it believable that a bald crown sits under the hair? If the ears are covered, is the hair really far enough out to cover ears completely? Or should part or all of one or both ears be drawn?

Never hesitate to make adjustments to the hair until you are satisfied. You will readily build up a mental library of styles as you practice creating your own original styles as well as breaking down into lines the hair you spot in photographs, on television, in movies, on web sites, and so forth.

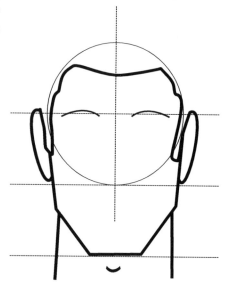

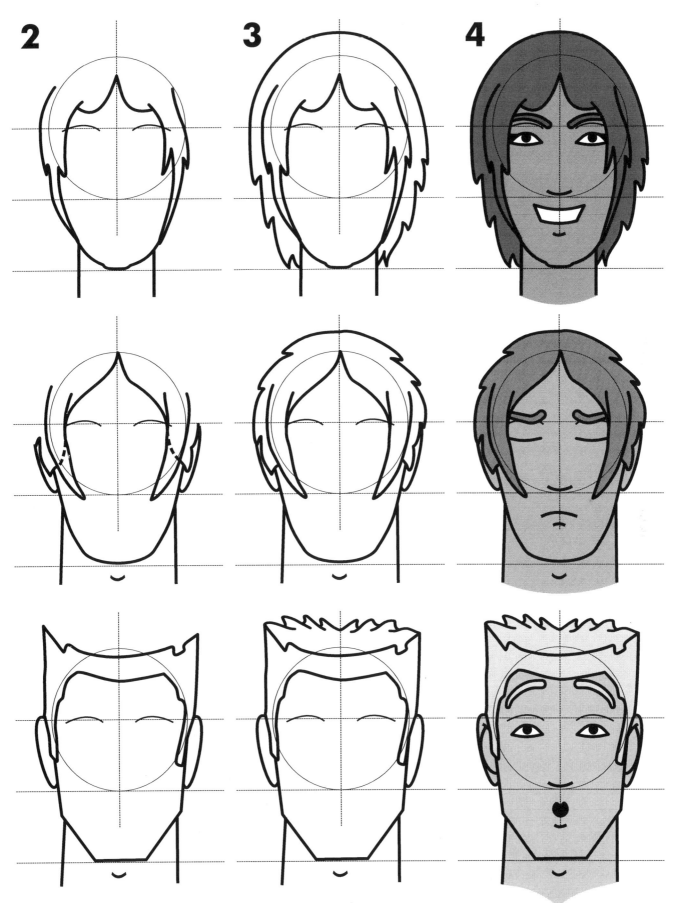

SHADING

Hue describes the type of pure color such as red, yellow, golden brown, peach, moss green, steel blue, etc. If you add white to any hue, you create *tints* of that color. If you add black to any hue, you create *shades* of that color. The amount of tint or shade is the overall *value* of a color - also known as its *brightness*. Lighter values fall towards white, while darker values fall towards black. *Pure white* is the lightest of all colors, values, and tints. *Pure black* is the darkest of all colors, values, and shades. *Pure grays* fall between white (100% value) and black (0% value).

Saturation of a color describes how much hue is mixed into it compared to the amount of white, gray, or black. Pure hues without any added white, gray, or black have the highest saturation, while colors containing added white, gray, or black have lower saturation. Pure white, pure black, and pure grays have no saturation whatsoever; in other words, they are completely un-saturated colors - not mixed with any hue.

Contrast of a drawing describes the value range within the image. *Low contrast* means values are similar across the whole image - all lighter values, all mid-range values, or all darker values. *High contrast* means a wide range of values in the image (a mix of lighter and darker values, with or without mid-range values).

The main hue of an object is known as its *base* color, or its *mid-tone*, while lighter regions are *highlights* and darker regions are *shadows*.

Some surfaces also contain *reflections* of the surroundings such as nearby objects, terrain, or dominant light sources. Reflections can be sharp or blurred. Metallic or glass jewelry, the faceplate of a helmet, reading glasses, and sunglasses are some examples of items on a face that can hold reflections.

PICK A PLAN

Pick a plan for how you want to approach shading a particular drawing. If you are creating a series of related drawings for a project, your plan will keep them consistent so they appear to originate from the same story universe. Below are five plans broken down into their distinct elements or create your own plan. Test out different plans to see which appeals to your sense of style or which fits your project best. The elements of the five plans are described hereafter.

BASE WITH OR WITHOUT CONTOURS
Select an overall approach for coloring the head by deciding whether you want to A) use a base, or B) use a base with contours.

In the first option, you apply a base color across the entire head (including the neck) before applying any other type of shading. If you include a hairstyle, select a uniform hair color to apply to the entire style.

In the second option, you can make use of contours to define the left side, right side, and front of the head by placing the base color on the front, a tint of that color on the side with the light source, and a shade of the base color on the side opposite the light source. Apply the base color to the neck, a strip of tint along the side of the neck with the light source, and a strip of shade along the side of the neck opposite the light source. If you include a hairstyle on your drawing, repeat the same process you used on the head by adding a base hair color to the front of the hair, a tint on the light side, and a shade on the shadow side. Use the contour lines on the head underneath the hair to define the different sides of the hair - left side, front, and right side.

EYE LIGHTS
Eyes have a special reflection called *eye lights*. These eye lights are easily drawn as a tiny off-center white circle within the black circle of the eye and represent the reflection of surroundings back at the world. They do not mirrored each other. Instead they appear in the same spot of each eye. So if you

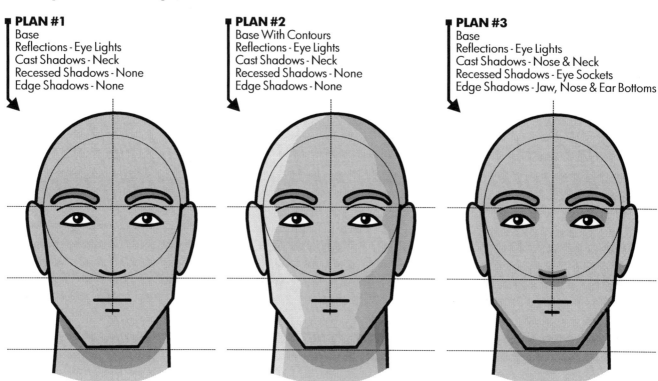

PLAN #1
Base
Reflections - Eye Lights
Cast Shadows - Neck
Recessed Shadows - None
Edge Shadows - None

PLAN #2
Base With Contours
Reflections - Eye Lights
Cast Shadows - Neck
Recessed Shadows - None
Edge Shadows - None

PLAN #3
Base
Reflections - Eye Lights
Cast Shadows - Nose & Neck
Recessed Shadows - Eye Sockets
Edge Shadows - Jaw, Nose & Ear Bottoms

draw them in the upper left corner of one eye, draw them in the same spot on the other eye. You can include more than one eye light in an eye, but the same number should appear in both eyes and in the same location within both eyes. Eye lights, like all reflections, will fade and disappear from view if the subject is drawn at a far distance.

CAST SHADOWS

These shadows are produced by one part of the face and projected onto another. The most readily-seen cast shadow is produced when overhead light hits the head and casts a shadow onto the neck underneath. Draw on the same side as the overhead light, slightly below where the neck meets the jaw, and curve the line down and then up over to the other side of the neck to end twice the distance of the starting point below where the neck meets the jaw. The curve should be off-center and lean away from the starting side (i.e. the side with the source light). A light that happens to be directly overhead would mean the shadow should have a uniform, balanced (i.e. non-leaning) curve that starts and stops on both sides at spots equally below where the neck meets the jaw. The shadow should fall below the jaw line an distance equal to the distance from a Neutral Nose to the top line of a Neutral Mouth.

Another cast shadow is produced by the protruding nose and falls onto the region above the mouth. This shadow starts at one end of the curving nose line and ends at the other end. Like the shadow on the neck, this nose shadow curves so that it leans away from the source light. If the overhead light is found on the left, the curving shadow leans towards the right. If the light source sits directly overhead, then the nose shadow curves in a smooth arc that does not lean in either direction. How far down you let the nose shadow dip before it comes back up depends on how much you consider the nose to be protruding - longer noses have shadows that dip further down the face. An average nose will have a shadow that is the same height as the distance between the top and bottom lines of a Neutral Mouth.

EDGE SHADOWS

Curved surfaces do not abruptly change the way that right-angled surfaces do. A sphere transitions from its "sides" to its "bottom" while a cube suddenly goes from one to the other. Edge shadows are used to indicate this transitional property of curved surfaces. These shadows appear in three primary areas on a face - along the front and lower sides of the jaw line, along the bottoms of the ears, and along the bottom edge of the nose (note: this is a shadow on the surface of the nose, making this shadow

different than the previously-discussed cast shadow that falls below the nose). These edge shadows appear above the jaw line (at the front and lower sides), above and inside the line that forms the bottom of the ear, and above the nose line. The tops of these edge shadows should droop in the middle and head upward at each end.

RECESSED SHADOWS

When facial features are set back from the main plane of the face into sockets or holes, a recessed shadow appears to fill in the cave-like space. The most readily-seen recessed shadows sit in the concave area under each Ridge Guideline, extending down to top of each eye. These eye socket shadows can be subtle or strong depending on the prominence of the brows and how far back the eyes sit in their sockets.

OTHER FACTORS

These other factors impact every drawing, whether of a face or any other subject. They control the overall appearance of objects so consider them before you start shading a drawing. If the situation surrounding your subject changes in a new drawing of that same subject (time of day, its distance, etc.), then reevaluate how these factors apply.

AMBIENT LIGHT CONDITIONS

In bright conditions such as sunny outdoors or well-lit chambers, high contrast applies to an image which causes strong highlights, deep shadows, and solid reflections. During dim conditions such as overcast weather or moonlit nighttime, low contrast applies to an image, which results in dull highlights, weak shadows, and diffused reflections.

DISTANCE

Distance impacts the appearance of all objects by causing them to gradually lose contrast, saturation, and details. As a result, objects lose highlights, shadows, and reflections.

ATMOSPHERIC PERSPECTIVE

Atmospheric perspective affects hue as you place more air between the viewer and an object. On a clear day distant objects take on a blue or grayish-blue tinge - the result of water droplets in the air. In smoggy, hazy, smoky, foggy, or polluted air, distant objects take on a orange, brown, gray, or purple tinge from dust and other airborne particulates.

▌ PLAN #4
Base With Contours
Reflections - Eye Lights
Cast Shadows - Nose & Neck
Recessed Shadows - Eye Sockets
Edge Shadows - None

▌ PLAN #5
Base With Contours
Reflections - Eye Lights
Cast Shadows - Nose & Neck
Recessed Shadows - Eye Sockets
Edge Shadows - Jaw, Nose & Ear Bottoms

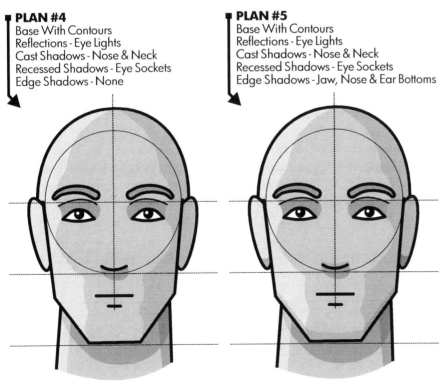

EYE CLOSE-UP DETAILS

STEP 1. You already know about placing four dots for the corners of the eyes.

STEP 2. Place a lightly drawn guideline half way between each pair of dots.

STEP 3. Subdivide the four halves of the eyes into thirds with lightly-drawn guidelines. Each eye should now be divided into sixths - the two corners dots along with the five guidelines you added. For reference sake, the innermost guideline will be referred to as guideline #1, then #2, #3, #4 on out to the outermost guideline #5. So the outermost guideline on both eyes is called guideline #5.

STEP 4. Place a dot on guideline #1 of each eye.

STEP 5. For each eye, draw the upward-arcing upper-eyelid line that curves from one corner of the eye to its other corner.

STEP 6. For each eye, draw the downward-arcing first segment of the lower eyelid from the outer corner of the eye to the dot you added to guideline #1.

STEP 7. For each eye, draw the second segment of the lower eyelid as a slightly-upward-arcing line from the dot you placed on guideline #1 to the inner corner of the eye.

STEP 8. For each eye, draw an outward-arcing line connecting the upper and lower lid at the halfway point between guideline #5 and outer corner. These are the outer edges of the eyeballs, which rest behind the lids.

STEP 9. For each eye, draw an inward-arcing line connecting the upper and lower lid along guideline #1. These are the inner edges of the eyeballs behind the eyelids.

STEP 10. For each eye, draw the iris as a circle that is one-third the width of the overall eye from corner-to-corner. For easy measuring, use guidelines #2 and #4 to determine its circular diameter when the iris is "centered". *This positioning actually sets the irises slightly inward-looking to avoid an unnatural doll-like appearance if the irises were both dead-center.* Part of an iris typically floats underneath one or both lids depending on the direction of an eye.

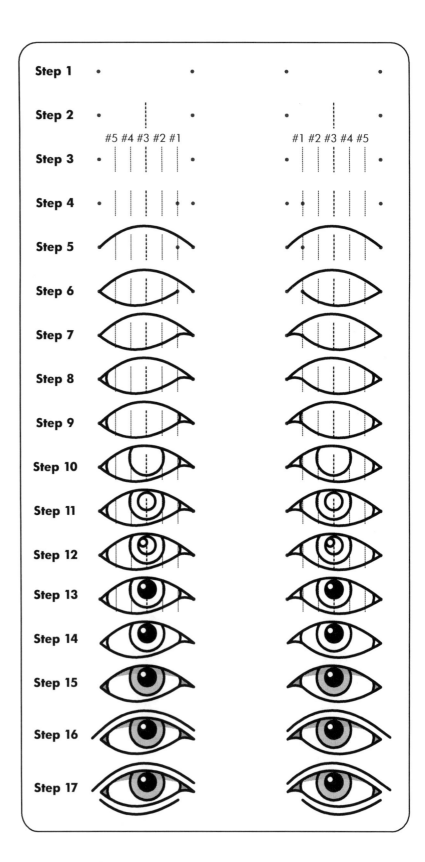

STEP 11. For each eye, draw a pupil. It is centered inside the iris. Its size is variable. This is very important. In darker conditions it stays as its maximum size, which is half the diameter of the iris. In bright conditions the pupil shrinks until it reaches its minimum size, which is a quarter the diameter of the iris. Because the pupil takes in the light for seeing, the mechanics of the eye naturally attempt to keep the pupil of the eye from slipping under any lid unless the eye closes completely or the eyes roll up into the head.

STEP 12. Pupils reflect a bit of light back into the world. These eye lights are drawn as a tiny circle inside the pupil. These lights copy each other for location in the pupils rather than mirror each other, so wherever you place the light in one pupil will dictate the exact same position for the other pupil. You can add more lights if you wish, but they should be the same in both eyes.

STEP 13. Fill the rest of both pupils black.

STEP 14. Erase the guidelines.

The next three steps are optional.

STEP 15. Add shading or color to the iris of each eye as well as to the triangular areas of tissue found in the corners of each eye. Since the spherical eyeballs sit behind the eyelids, under regular lighting conditions the upper lids cast a slim shadow upon the curved surface just under the lid.

STEP 16. When eyes go to close, it is the bottom of the upper lid and the top of the lower lid (two lines that are already drawn) which move to shut the eye. You may wish to add the top of the upper lid, which is actually a crease in the lid. This crease line remains stationary as the eye closes. Draw an upward-arcing line slightly above the already-existing bottom of each upper lid, and make the arc extend outward a bit from the outer corner of the eye.

STEP 17. If you have added the top line of the upper lid, you may also wish to add the bottom line of the lower lid. This line is a crease that remains stationary when the eye closes. Draw a downward-arcing line slightly below the downward arc of the already-existing top of each lower lid. The new curve should extend from below the inner edge of the eyeball to the outer corner of the eye - in other words, stretching from guideline #1 outward to the dot you initially put at the outer corner of the eye.

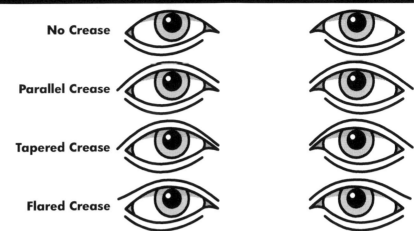

No Crease

Parallel Crease

Tapered Crease

Flared Crease

CREASES
The creases in human eyes show some great variation. Some people have no upper crease at all above one or both eyes. When an eye does have an upper crease, the crease can be parallel, tapered, or flared. Parallel creases run equidistant to the upward curve of the bottom line of the upper lid. Tapered creases bend down close to, but do not touch, the bottom line of the upper lid as the crease approaches the inner corner of the eye. Flared creases gently lift up away from the upward curve of the bottom line of the upper eyelid above the outer corner of the eye.

WIDE EYES
Upper-Wide Eyes have the lines of the top and bottom of the upper lid merge into a single line at the top of each arc (the bottom line stretches up to the highest point of the arc of the top line. Study the Upper-Wide Eyes illustration).

Lower-Wide Eyes follow the same procedure as Upper-Wide Eyes for the upper lid, while the lines of the top and bottom of the

lower lid merge into a single line at the bottom of each arc (the top line stretches to the lowest point of the arc of the bottom line).

UPTURNED EYES
Upturned Eyes have the same upper lid lines as Neutral Eyes. The top of the lower lid is drawn as a nearly-flat horizontal line from one corner of the eye to the other with an ever-so-slight upward arc that prevents it from being a straight line as it crosses the spherical eyeball.

HALF-OPEN EYES
Half-Open Eyes have the same lower lid lines as Neutral Eyes. The bottom of the upper lid is drawn as a nearly-flat horizontal line from one corner of the eye to the other with an ever-so-slight upward arc that prevents it from being a straight line as it crosses the spherical eyeball.

NARROW EYES
Narrow Eyes have less arc in the bottom of the upper lid line and the top of the lower lid line, bringing the lids closer together.

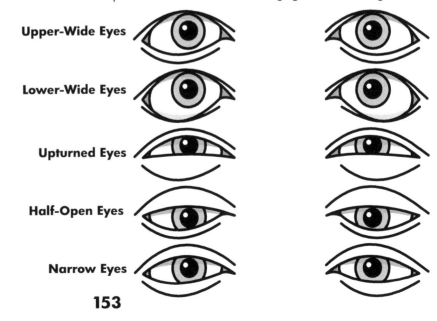

Upper-Wide Eyes

Lower-Wide Eyes

Upturned Eyes

Half-Open Eyes

Narrow Eyes

IRIS & PUPIL MOVEMENT & SHAPE

The edges of the iris routinely disappear behind the lids as eyes look around. The eye however automatically attempts to keep the pupil from going under the lids. As the eyes close or narrow the pupil adjusts accordingly so the eye can still see. Eventually the pupil disappears under the lids when they close completely. If a person rolls an eye such as expressing disbelief or pretending to be a zombie, the pupil may vanish partially beneath the lid, but will bounce back into full view when the person stops deliberately forcing the eye movement or otherwise changes to a new expression.

The eyeball is a sphere. The iris and pupil sit on that sphere. When the iris and pupil are directly facing a viewer they are circular. As soon as they veer off in any direction other than straight at the viewer, the iris and pupil shape are impacted by sitting on a sphere and slowly become more oval-shaped the more off-center from the viewer they become. For example, if the person is facing the viewer but that person looks off to the left or right, the iris and pupil keep their height but lose some width as they turn on the eyeball sphere, becoming vertical ovals. Likewise, if the person looks directly up or down, the iris and pupil

maintain their width and lose some height, becoming horizontal ovals. The compression axis always lies perpendicular to an imaginary line drawn from the center of the pupil to the center point (of the eyeball) that directly faces the viewer. In other words, if the face were turned but with its eyes still looking directly at the viewer, the iris and pupils would remain circles and would only become ovals if the eyes looked off in any direction except directly at the viewer. So regardless of the direction of the face, the iris and pupil become ovals any time they are not looking directly at the viewer.

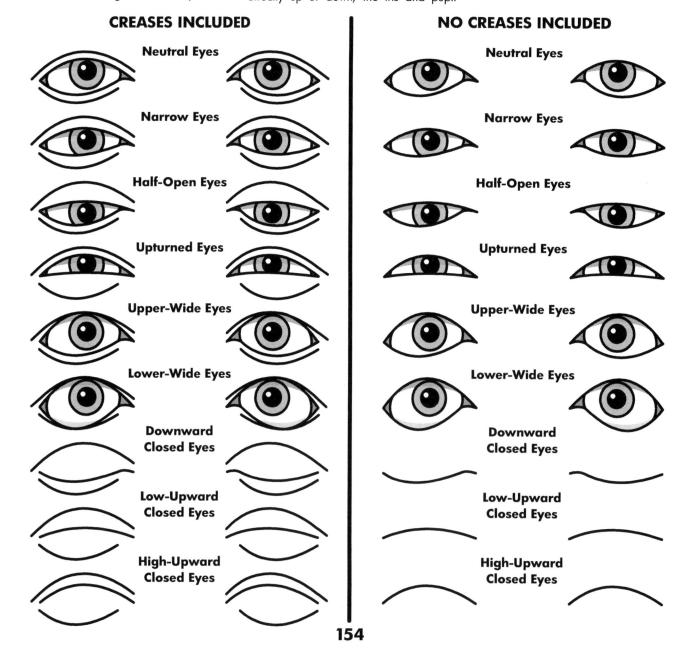

CREASES INCLUDED

NO CREASES INCLUDED

Neutral Eyes

Narrow Eyes

Half-Open Eyes

Upturned Eyes

Upper-Wide Eyes

Lower-Wide Eyes

Downward Closed Eyes

Low-Upward Closed Eyes

High-Upward Closed Eyes

NOSE CLOSE-UP DETAILS

Simplified noses are presented as a single curved line that represents its bottom edge.

Depicting a more advanced nose requires a basic understanding of its parts. By breaking them into sections, the parts become easy to master and manipulate in your drawings. There are two different nose outlines to consider, which you can use in whole or in part.

The outer nose outline starts at the inner corners of the eyes and moves down along the edges that touch the cheeks, then curves around the nostrils to the underside, ending at the midway point under the nose where skin separates the nostrils.

The inner nose outline begins at the Ridge Guidelines, moves down atop the bridge, travels along the nasal ridge, and encircles the protruding tip of the nose.

When drawn directly facing the viewer, the outer outline is the parts of the nose farthest away from the viewer, while the inner outline represents the parts nearest the viewer.

You can include all of the lines from the upper, middle, and lower nose sections (Example A) or simply pick and choose just some of the lines (Example B) that you feel will best enhance your particular drawing.

NOSTRILS
The section of skin that separates the nostril

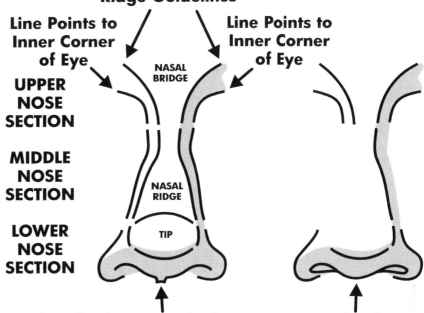

EXAMPLE A **EXAMPLE B**

Lines Point to Eye Ridge Guidelines

Line Points to Inner Corner of Eye

Line Points to Inner Corner of Eye

UPPER NOSE SECTION

MIDDLE NOSE SECTION

LOWER NOSE SECTION

NASAL BRIDGE

NASAL RIDGE

TIP

Skin dividing nostrils shows on noses that have an upturned tip (Example A). Otherwise the skin is hidden behind the bottom of the tip (Example B).

openings is called the columella. It can be narrow or broad. It can be seen on noses that have an upturned tip (Example A). Otherwise the columella is hidden behind the bottom of the nose tip (Example B).

Nostrils have three characteristics - shape, direction, and tilt. Shape often resembles that of a kidney bean or of a rough, squashed oval. Direction indicates which way the nostrils blow - downward at the mouth or off

to both sides diagonally. Tilt is the angle of the nostril towards the viewer, revealing less or more of the opening.

The section of skin that covers a nostril is called an ala. The two alae flank the tip of the nose and mirror each other in their general shape on either side of the Center Guideline of the face. Their appearance ranges from inverted question marks to fins to more-squared-off bracket-like forms.

NOSTRILS ANGLE & TILT

	No Angle	Slight Angle	Medium Angle	Major Angle
No Tilt				
Minor Tilt				
Major Tilt				

ALAE SHAPES

Inverted Question Marks

Slopes

Brackets

Sideways Fins

Alae have height and width characteristics, ranging from tall to short as well as narrow to broad. An ala will share the same height and width as the ala on the other side.

NASAL RIDGE

The nasal ridge makes up the middle nose section, and can have as much impact on the overall impression of the nose as the lower nose section. The shape of the ridge varies from slender and delicate to wide and solid. It can gently slope into the lower nose or it can abruptly fall or even waver to reveal a bump in the nose. Typically the top of the ridge resides farther away from the viewer than the bottom of the ridge, which extends out towards the viewer to meet the tip in the lower nose section.

The Nasal Ridge Shapes illustration on this page shows some of the possibilities. Each shape example shows the two lines of the outer outline and the two lines of the inner outline. The outer outline and inner outline may be similar to each other (e.g. Pinched, Sloping, Bell, Bump) or the outlines may be dissimilar (e.g. Vase), which reflects that the protruding part of the ridge (represented by the inner outline) may possess its own shape that developed independently from the shape of where the nose blends with the cheeks (represented by the outer outline).

Noses can become broken from sustaining an impact from either the left or right side, which shows up as a complete distortion to the ridge in the middle nose section. Other than initial temporary swelling, the upper and lower nose sections are not altered in a broken nose. Any shape of nasal ridge can be broken. The broken ridge shape illustrated alongside the unbroken ones at the bottom of this page happens to be a Sloping shape that took an impact from the right. This damage resulted in all four lines of the outer and inner outlines being drawn as distorted to the left. However a broken nose only impacts the depiction of the ridge in the middle nose section. Otherwise the ridge remains attached to the upper and lower nose sections, so the tips of the ridge lines in a broken nose must still end up properly connected to these non-distorted adjacent sections.

A crooked nose is a natural trait. It has a left or right distortion only in the lines of the inner outline of the nasal ridge. However, optionally, the lower nose section (containing the nostrils, alae, etc.) of a crooked nose can be drawn displaced horizontally off-center from the Center Guideline so it becomes asymmetrical on the face. If you decide to slightly shift the entire lower nose section, then the lines of the outer outline of the nasal ridge in the middle nose section must be adjusted to connect up properly with the lower nose section. In other words, the lines of the outer outline of the nasal ridge must still blend into the lines forming the alae to complete the crooked nose.

TIP

The nose tip appears at the lower end of the nasal ridge. It typically sticks out the most of any facial structure. A nose tip ranges from tall to short in height, relative to the overall

TIP SHAPES

length of the nose, and from narrow to broad in width. A tip can have a circular, oval, or rounded block-like form. Some tips have a centered, vertical crease (e.g. lower row of the illustration of tip shapes) that appears from the bottom and can be short or travel all the way to the top of the tip, visually splitting it into left and right sides. A transverse nasal crease might also extend down below the tip - even as far as through any visible columella between the nostrils.

The bottom of the tip is drawn as part of the outer outline and relative to the bottom of the alae which flank either side. It will either be raised above, level to, or fall below the bottom of the adjacent alae. When it lies above the bottom of the alae, the columella that separates the nostrils becomes visible and is drawn so that it blends upward into the bottom of the nose tip. Also, a raised bottom of the nose tip blocks less of the nostrils, so tilted nostrils are more visible and drawn accordingly. When the bottom of the nose tip is level to or falls below the bottom of the alae, the columella is often not drawn because it is hidden behind the bottom of the nose tip.

NASAL RIDGE SHAPES

Pinched **Sloping** **Bell** **Bump** **Vase** **Broken**

156

BOTTOM OF NOSE TIP ABOVE BOTTOM OF ALAE

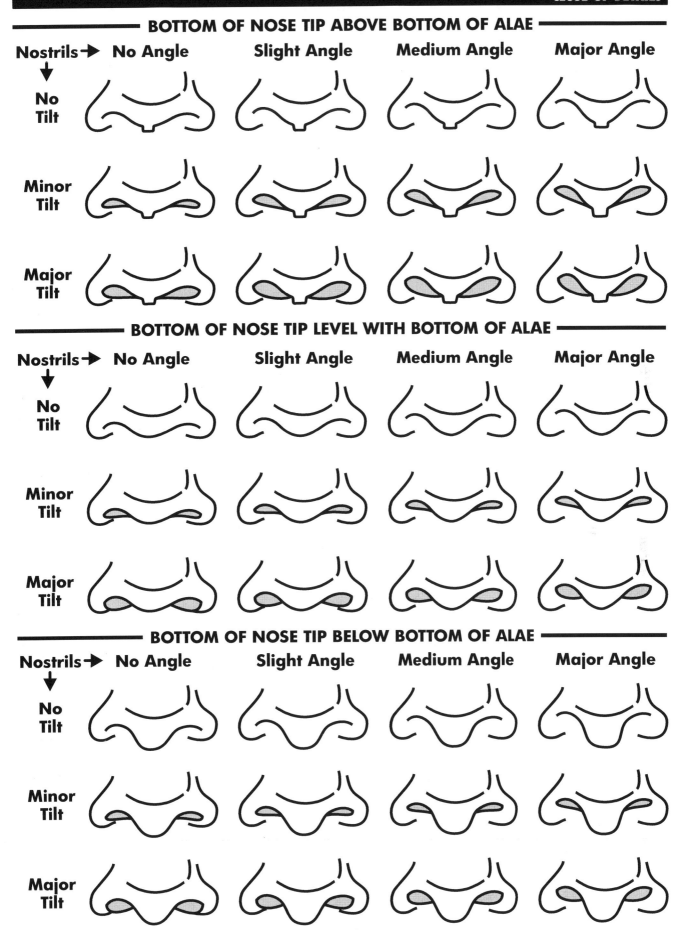

Nostrils ➤ No Angle Slight Angle Medium Angle Major Angle

No Tilt

Minor Tilt

Major Tilt

BOTTOM OF NOSE TIP LEVEL WITH BOTTOM OF ALAE

Nostrils ➤ No Angle Slight Angle Medium Angle Major Angle

No Tilt

Minor Tilt

Major Tilt

BOTTOM OF NOSE TIP BELOW BOTTOM OF ALAE

Nostrils ➤ No Angle Slight Angle Medium Angle Major Angle

No Tilt

Minor Tilt

Major Tilt

157

WIDTH OF NOSE BASE

Add the widths of the left ala, the bottom of the nose tip, and the right ala to determine the overall width of the lower nose section. Regardless of the proportions of the tip or the alae, the overall width of the base of a nose typically falls between the width of the space separating the inner corners of the eyes to the width of the space between the centers of the eyes (i.e. the space between the guideline #3 of each eye).

NASAL BRIDGE

The upper nose section contains the nasal bridge, which simply bridges the ridges above the eyes with the nasal ridge found in the middle nose section.

The nasal bridge consists of four lines that curve down and inward towards the Center Guideline. The lines of the inner outline of the bridge connect the Ridge Guidelines to the lines of the inner outline of the nasal ridge below. The lines of the outer outline of the bridge flow from the inner corners of the eyes down to the lines of the outer outline of the nasal ridge.

A nasal bridge can be broad, average, or narrow, which dictates its width as it drops down into the nasal ridge beneath it. As a result, you will need to adjust the lines of the nasal ridge in the middle nose section - making them wider or narrower - so they match up properly with the incoming lines of the bridge above.

COMBINATIONS

The sample combinations illustrated to the right demonstrate how different widths of nasal bridges affect the lines of the varied ridges below them, which in turn affect the lower section (tip, columella, nostrils, alae) at the bottom to create a smoothly connected whole when the lines from each section are aligned. The sections in the sample combinations are shown broken apart to display where one section runs into the next. Merge the lines when you draw them.

Practice drawing the parts of noses. Create combinations of upper, middle, and lower nose sections to acquaint yourself with the variety available to use on your faces. Mix different shapes. Vary the inner and outer outlines. Study how that affects the overall appearance of the nose. Draw all the lines of a nose for some of your designs. Then draw just some of the lines to see how that alters your perception of your nose design.

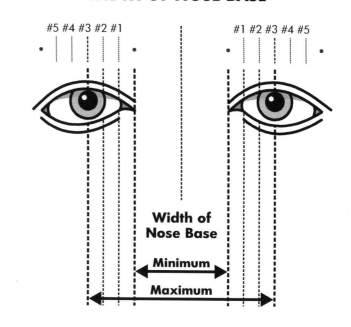

WIDTH OF NOSE BASE

#5 #4 #3 #2 #1 #1 #2 #3 #4 #5

Width of Nose Base

Minimum

Maximum

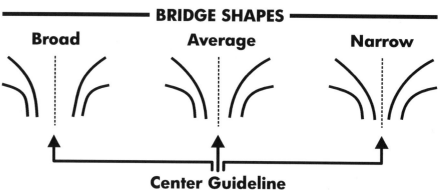

BRIDGE SHAPES

Broad Average Narrow

Center Guideline

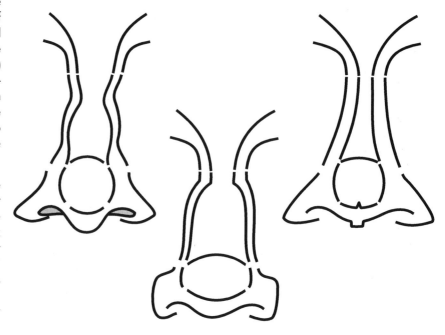

SAMPLE COMBINATIONS

158

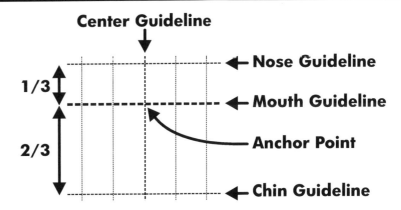

MOUTH CLOSE-UP DETAILS

A mouth shares some traits with an eye. First, the corners are set back farther from the viewer than the center. The top and bottom can open to reveal what lies beneath - in this case, teeth and tongue rather than an eyeball. Second, what lies underneath can also change appearance. An eyeball can look left and right as well as up and down, while teeth (at least the lower ones) and the tongue can also move side to side and up and down. To easily recall this relationship between an eye and a mouth, remember "lips" is just "lids" with the "d" rotated to create a "p".

When drawing an *open* eye, you have to think about the appearance and positioning of not only the lids but also of the eyeball behind them. When constructing an *open* mouth, you must think about the appearance and positioning of not only the lips but also of the teeth behind them. When creating a *closed* eye or mouth, you only have to draw the lids or lips, respectively, since they conceal the eyeball or teeth.

Unlike a moving eyeball behind lids, the movement of teeth behind lips will influence the shape of the lips.

TEETH
Twelve teeth - six on the top and six on the bottom - are the most common ones seen since they appear at the front of the mouth just behind the lips. These twelve teeth are revealed to varying degrees based on the positioning of the lips. Sometimes they are invisible, such as when the mouth is closed, while at other times they are fully visible, such as during a toothy smile. Upper and lower teeth can appear at the same time, or only one row appears - just the upper teeth or the lower teeth. Upper and lower teeth can be clamped together or they can be separated by some space. This space is

caused by the lower row of teeth moving downward. The upper row of teeth are firmly attached to the skull above them and therefore do not move independently of the skull. Since everything else about a mouth (lips, tongue, lower teeth, even cheeks) are movable, the row of upper teeth provide a set Anchor Point upon which to draw all the varied configurations of the mouth while keeping the overall facial feature properly and consistently positioned relative to the remainder of the face.

The special Anchor Point is specifically the center point of the bottom line of the upper teeth. This point happens to line up with the center point of the line formed between lips when lips are relaxed and closed. In other words, it lines up with the center point of the upper line of a Neutral Mouth. So even when you cannot see the upper teeth, you still know where to find the special Anchor Point, which falls on the Center Guideline, a third of the way down from the Nose Guideline to the Chin Guideline.

A useful, important characteristic of teeth is that, *even though the width of individual teeth may vary, the overall width of the row of upper teeth matches the overall width of the row of lower teeth.* And, barring any dental variation such as damage, the rows of teeth mirror themselves horizontally on either side of the Center Guideline, so the left-side teeth mirror the right-side teeth (but individual upper and lower teeth do not necessary mirror one another vertically).

LIPS & INNER PERIMETER
Lips have a wonderful range of variation in human beings. They can be lusciously thick, wispy thin, or somewhere in-between, but they share a general appearance - one that stretches and contorts into varied forms to express different meanings. The more lips

stretch outward from their neutral position the more slender they temporarily become.

Because lips are not only malleable but also have different thickness and thinness characteristics in each individual, drawing a mouth is based around first creating the inside shape formed by the lips rather than the outer perimeter shape of the lips. The inside shape remains constant regardless of the inherent plumpness of the surrounding lips. In other words, *a thin-lipped and thick-lipped mouth have the same inner perimeter between the lips, while the outer perimeter is variable* since it will reflect the overall plumpness of the upper and lower lips of the individual.

The inner perimeter is divided into an upper line and a lower line; these combined lines form the shape between the lips. Start by placing a dot at both corners of the mouth where the upper and lower lines meet. Be careful to position the dots properly then draw the lower and upper lines. A grid for each mouth type shows only the Combined Lines so you can study how they are placed relative to the Center, Nose, Mouth, and Chin Guidelines.

Some mouth types share the same inner perimeter shape so their upper and lower lines are identical. Their placement on the guideline grid, however, will be different, so pay extra attention to where they fall on the face. Mouth types with closed lips have the upper and lower lines overlap one another, which reflects the protruding lips coming together. Each mouth type includes a face with Neutral Eyes and Neutral Eyebrows to reveal mouth placement relative to these features as well as any required changes to the position of the bottom of the chin for mouth types with teeth apart as a result of the lower jaw being dropped.

Neutral Mouth

Narrow Neutral Mouth

Combined Lines

Upper Line

Lower Line

Combined Lines

Upper Line

Lower Line

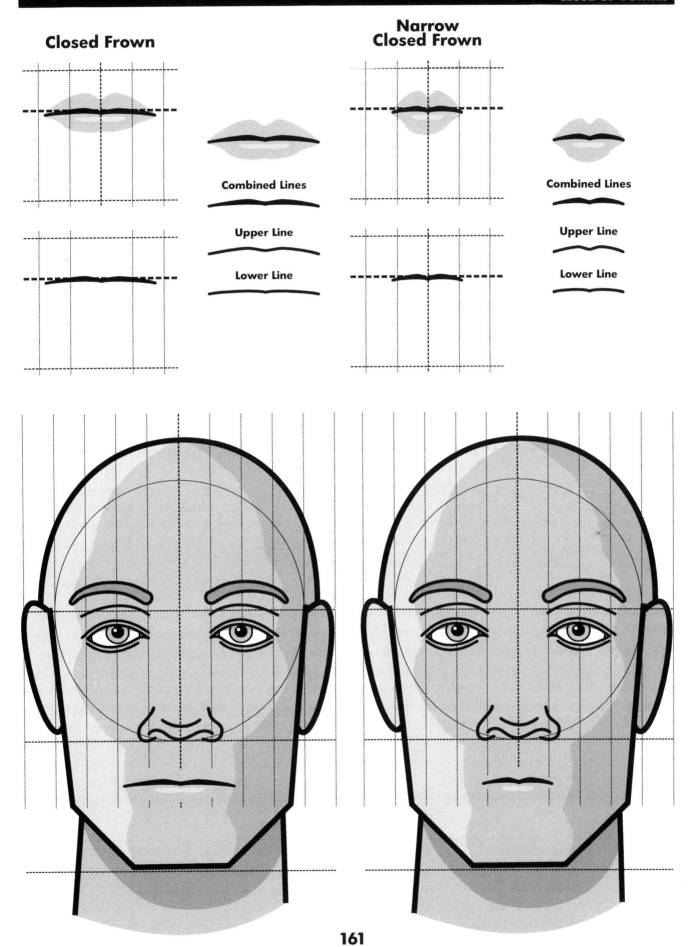

Closed Frown

Narrow Closed Frown

Combined Lines

Upper Line

Lower Line

161

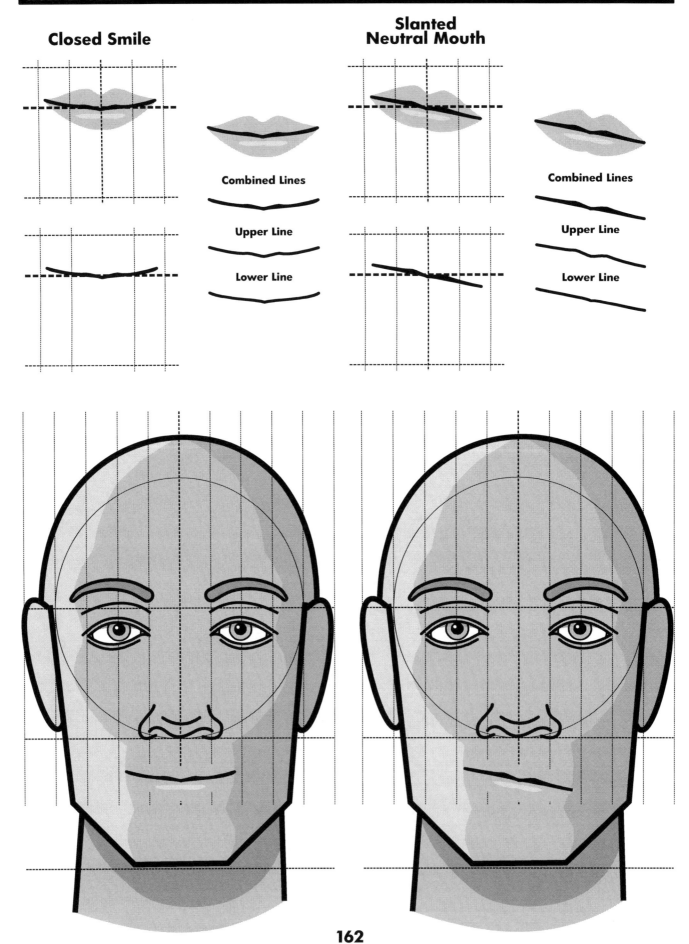

Closed Smile

Slanted Neutral Mouth

Combined Lines

Upper Line

Lower Line

Slanted Contradictory Mouth

Slanted Closed Smile

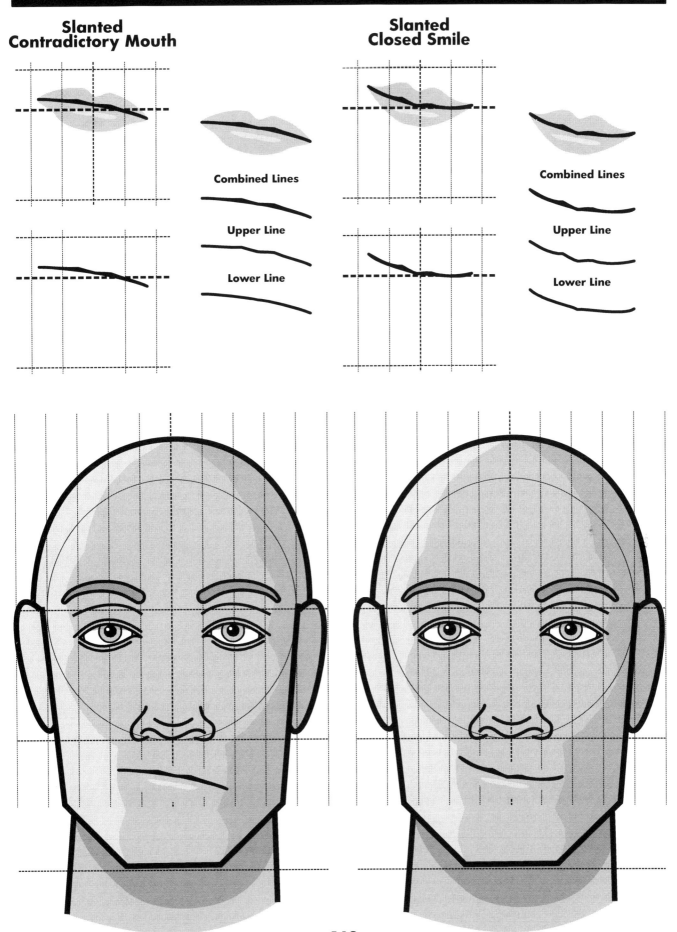

Combined Lines

Upper Line

Lower Line

Combined Lines

Upper Line

Lower Line

Slanted Closed Frown

Deep Closed Frown

Combined Lines

Upper Line

Lower Line

Combined Lines

Upper Line

Lower Line

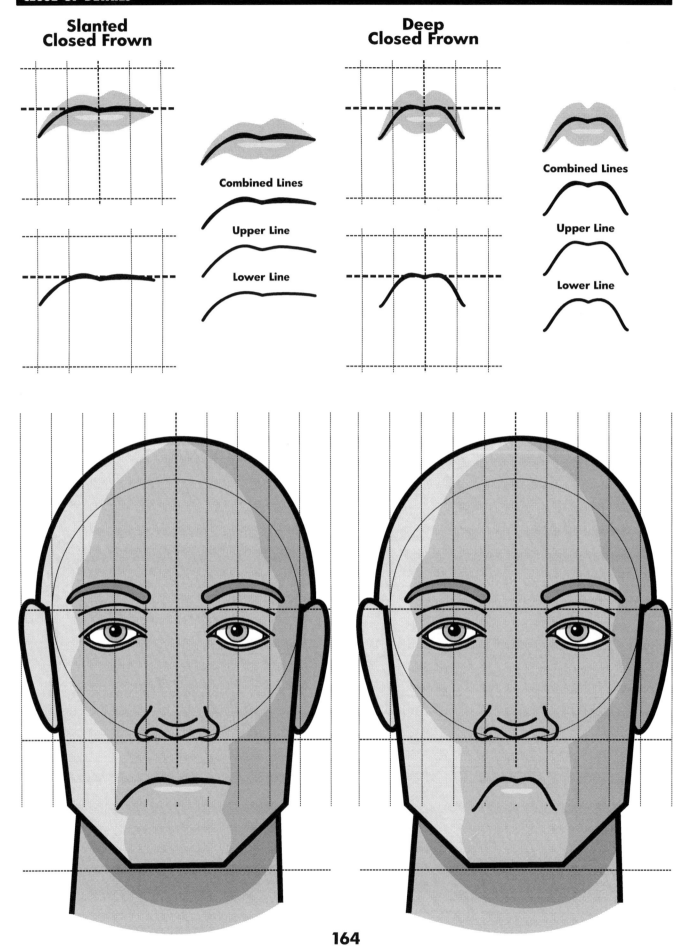

164

**Teeth
Open Smile**

**Teeth
Open Frown**

Combined Lines

Upper Line

Lower Line

Combined Lines

Upper Line

Lower Line

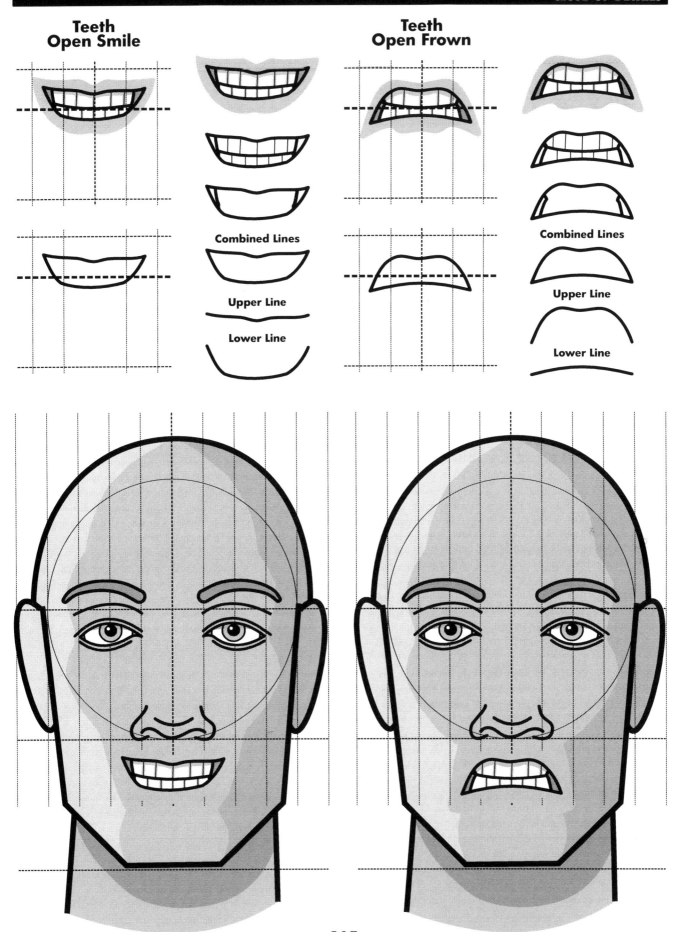

165

Open Smile

Open Frown

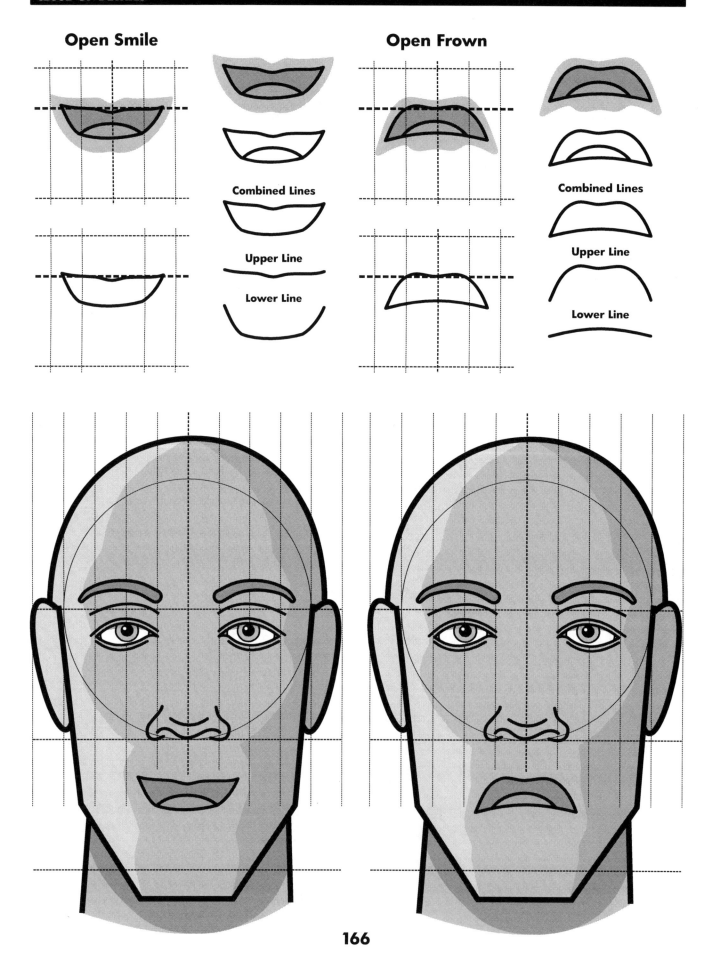

Combined Lines

Upper Line

Lower Line

166

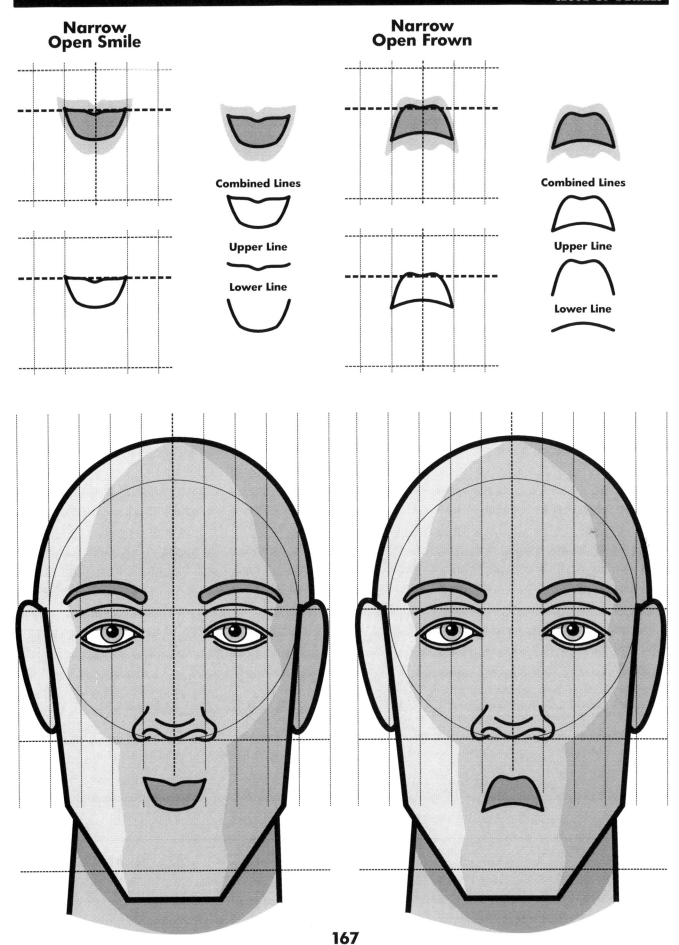

**Narrow
Open Smile**

Combined Lines

Upper Line

Lower Line

**Narrow
Open Frown**

Combined Lines

Upper Line

Lower Line

167

Teeth Grimace

Combined Lines

Upper Line

Lower Line

Lopsided Teeth Grimace

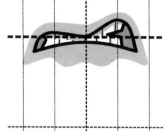

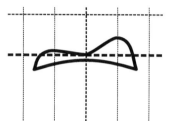

Combined Lines

Upper Line

Lower Line

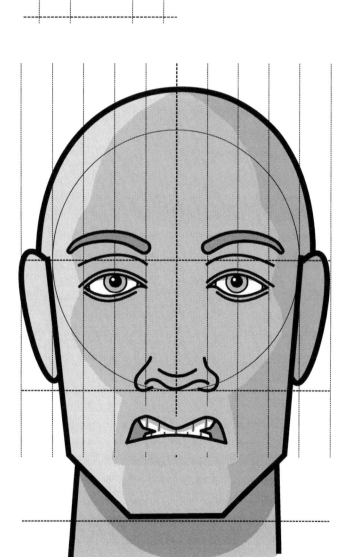

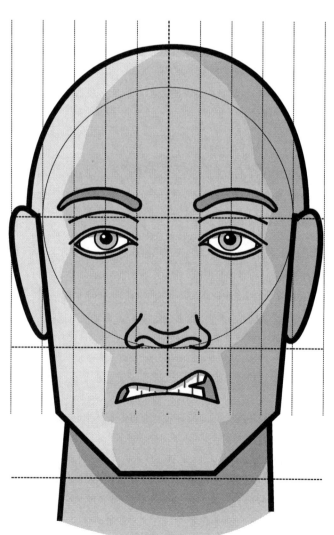

Grimace

Lopsided Grimace

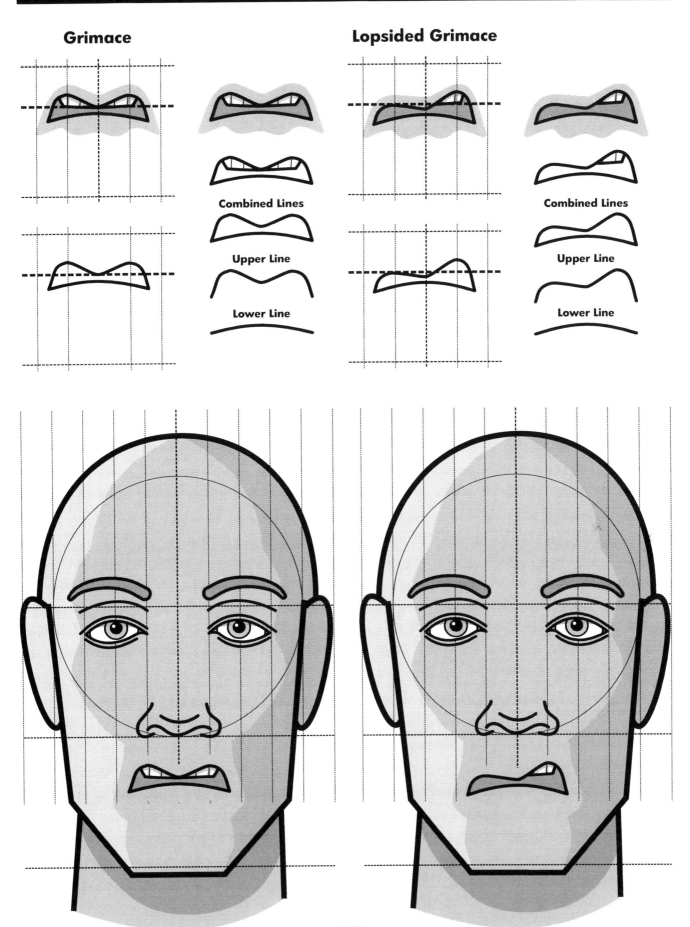

Combined Lines

Upper Line

Lower Line

169

Rounded Mouth

Small Rounded Mouth

Combined Lines

Upper Line

Lower Line

Combined Lines

Upper Line

Lower Line

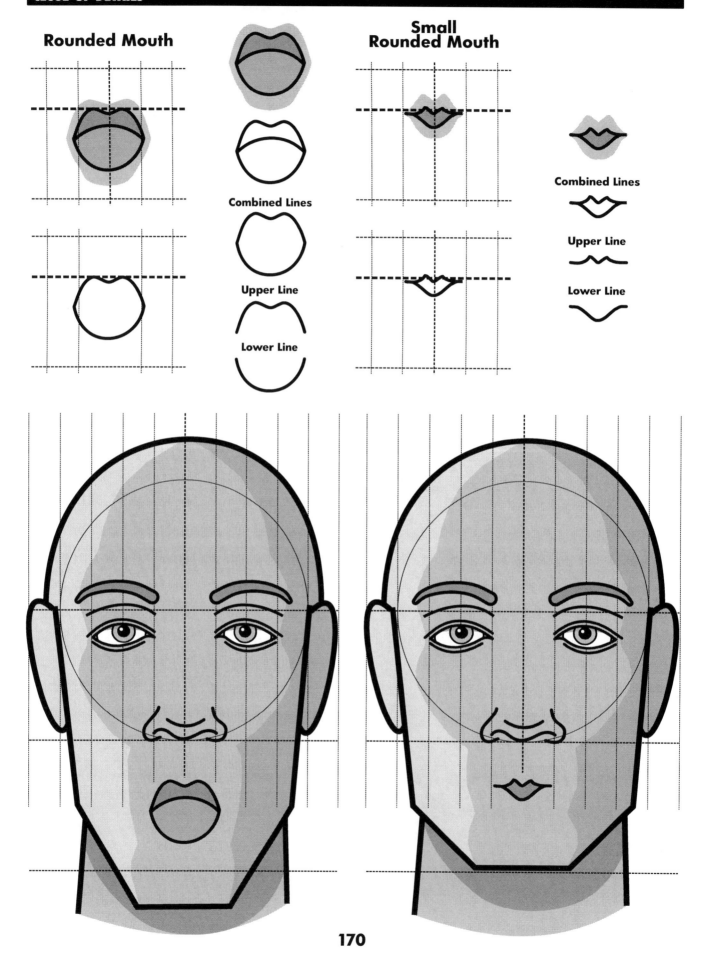

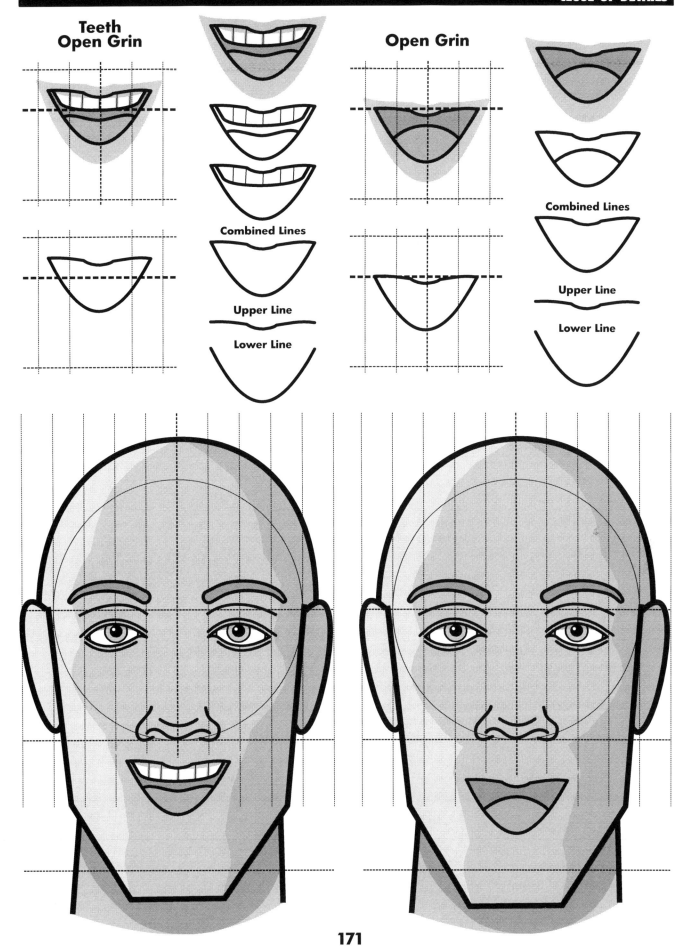

**Teeth
Open Grin**

Open Grin

Combined Lines

Upper Line

Lower Line

Combined Lines

Upper Line

Lower Line

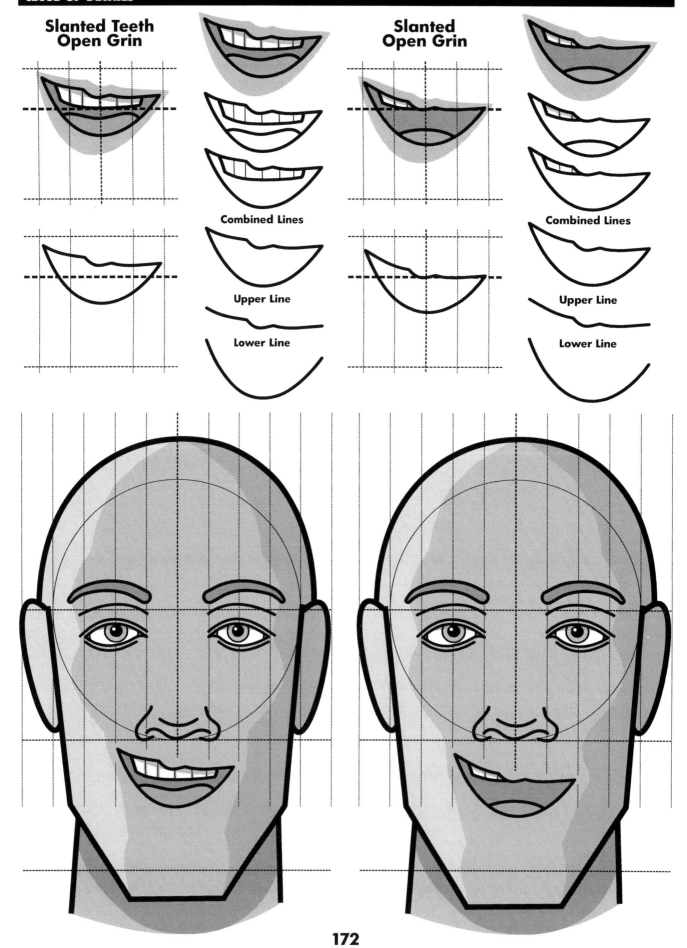

Slanted Teeth Open Grin

Slanted Open Grin

Combined Lines

Upper Line

Lower Line

Combined Lines

Upper Line

Lower Line

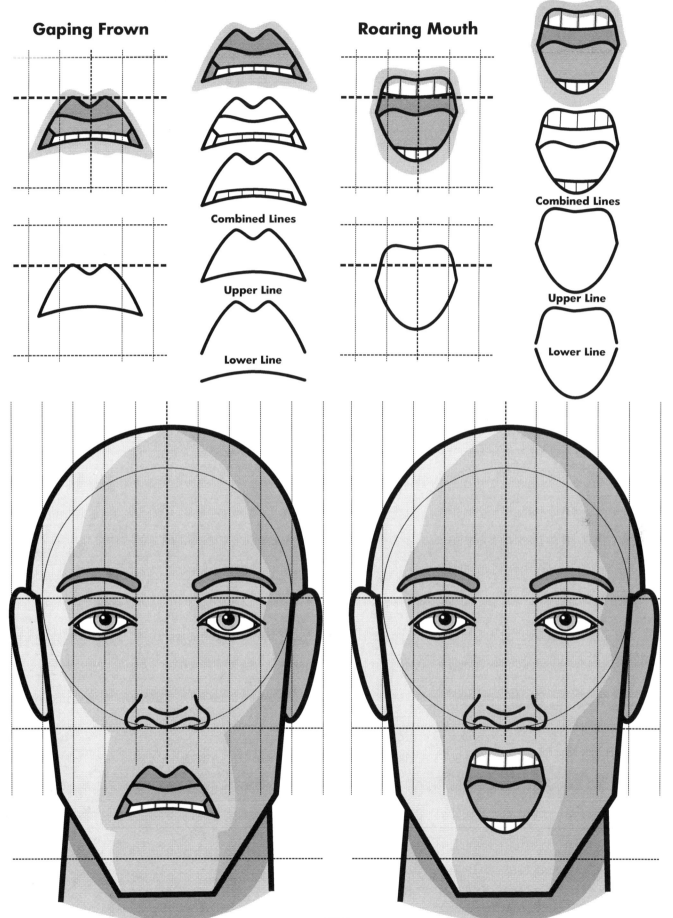

Gaping Frown

Combined Lines

Upper Line

Lower Line

Roaring Mouth

Combined Lines

Upper Line

Lower Line

173

1

2

3

4

5

6

7

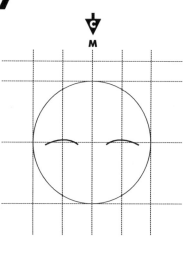

8

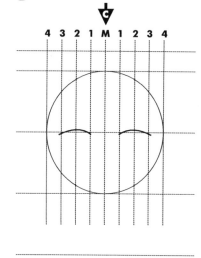

9

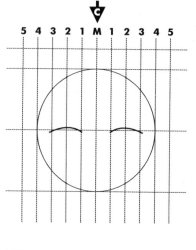

VARIATION

Before you begin this section, make certain you have read everything up to this point in the book and have created at least 100 faces with expressions so you have a solid grasp of the fundamental concepts covered so far. Do a quick review of the following sections: drawing guidelines for creating a neutral face; crown; contours; close-up details for eye, nose, and mouth.

HEAD TURN

GUIDELINES

The basic guidelines - Circle, Center, Eye, Nose, and Chin Guidelines - are also used for a head turn with the addition of a few lines. These expanded guidelines appear on the opposite page starting with the basic setup you already know (illustration #1) followed by the additions.

The first is a horizontal line at the top of the Circle Guideline for positioning reference (illustration #2). The second is a horizontal Crown Guideline (illustration #3) that passes through the point where the top of a crown touches the Center Guideline on a forward-facing head (i.e. directly facing the viewer). So from top to bottom, the horizontal Guidelines are: Crown, Top of Circle, Eye, Nose, and Chin. The two Ridge Guidelines remain on the Eye Guideline.

The vertical lines are the Center Guideline, which appears heading down the center of the circle. However, center actually refers to the center of the face, which just happens to also be the center of the Circle Guideline in a forward-facing head. As a head turns, the center of the face changes position, so the Center Guideline changes as well. To indicate this change the large black arrows in each illustration (a down and up arrow) always point to the Center Guideline to show the center of the face (illustration #4).

Since for head turns we still need to know the horizontal middle of the Circle Guideline, a vertical Middle Guideline is marked with a capital letter M. In a forward-facing head and a backward-facing head (i.e. facing directly away from the viewer), the Center Guideline and the Middle Guideline sit at the same spot (illustration #5). As the head turns to either side, the Center Guideline (marked by the large arrows) drifts away

from the Middle Guideline until eventually the head turns completely to one side.

Vertical Guidelines are spaced at a distance equal to a quarter of the way from the center of the Circle Guideline to the left and right edges of the Circle Guideline. Place a vertical line at the left and right edges of the Circle Guideline (illustration #6). Draw a vertical line half way between the Middle Guideline and lines at the edges (illustration #7). Then place a vertical line on either side of the midway ones you just drew, also set midway in the available space between the existing lines (illustration #8). You end up with four vertical lines evenly spaced on both sides of the Middle Guideline. These lines are numbered starting with 1 as they move away from the Middle Guideline, so the second line on either side of the Middle Guideline is Vertical Guideline 2, the third line is Vertical Guideline 3, and so forth. For lines beyond the left or right edge of the Circle Guideline, space the Vertical Guidelines the same distance as the ones drawn inside the Circle Guideline (illustration #9).

RELATIVE ROTATION SPEED

Find some room. Hold your arm directly out to the side, palm down and parallel with the floor. Keep your arm straight and slowly move it in an arc so it extends directly out in front of you still parallel to the floor. While you carefully move your straightened arm from the side to your front, watch three parts of it - your shoulder, your elbow joint, and the tips of your fingers. Now slowly move your arm back to the side following that same arc while observing those three body parts. Repeat the movement a few more times. This activity illustrates that objects closer to the point of rotation move less distance in the arc than those farther from the pivot point. In this case, your shoulder moves the least amount, your fingertips move the greatest distance, and your elbow joint moves a moderate amount relative to the others during any amount of rotation along the arc - front-to-side or side-to-front.

On a head, treat the Circle Guideline as a three-dimensional sphere with the pivot point for rotation inside the sphere at its center. Since movement speed along the arc is impacted by proximity to the pivot point, the eyes move the least distance, the tip of the nose travels the greatest distance, while the protruding brows and ridges

move a moderate amount, regardless of the degree of rotation along the arc - front-to-side or side-to-front.

SHIFTING SHAPE OF EDGES

Because the head can turn left or right, the changes to the shape of some features can occur on either side of the face and head, so features on a turned head will be described as *near* and *far* with respect to the viewer. For instance, the near corner of the near eye is the closest corner to the viewer while the far corner of the far eye is the farthest corner, regardless of whether the head is turned to the left or the right.

The contours - from bottom to top - are the Chin, Mouth, Cheek, Eye, and Brow, above which the contours are shown running up and along the typical hair part all the way to the back of the head to show the transition from the sides of the head to the top as well as the back of the head. The Chin, Mouth, Cheek, Eye, and Brow contours define the front of the face. When the head turns, these front contours become more prominent. Meanwhile the features on the far side of the head (including the far ear and far lower back jaw) gradually become hidden from view, only to be replaced by the contours which shift in the direction of the turn to become the visible left or right edge of the head. In other words, the far front contours (i.e. the ones on the same side as the direction of the turn) become the edge of the head once the head turns enough. Eventually this contour edge will also disappear from view once the head turns completely sideways.

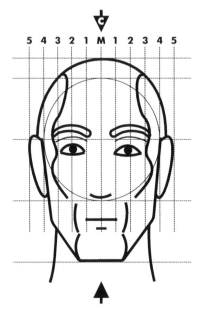

NOSE

As the head turns, the inner nose outline on the far side connects the far Ridge Guideline to the far end of the basic nose line (which represents the bottom of the tip). If you include nostrils on your nose, the far nostril will be blocked by the nose tip as the head turns. The basic nose line starts out centered on the Center Guideline for a forward-facing head, but the basic nose line drifts slowly towards the far side of the Center Guideline as the head turns to reflect the changing angle of the nose. Eventually the nose appears in profile when the head turns sideways to the viewer, and the nose shrinks until it disappears as the head turns away from the viewer. The tip of the nose protrudes more than the nasal bridge directly between the eyes, so while the nasal bridge remains centered on the Center Guideline regardless of head position, the nose tip is drawn more and more on the far side of the Center Guideline until it reaches profile on the sideways head.

EYES AND MOUTH

The eyes and the mouth (lids and lips) are similar to each other. Remember why? Their middles protrude from the head farther than their corners. As a result, when the head turns, the bulging middles of these facial features eventually block the view of the far corner.

In the case of eyes, the spherical roundness of the eyeball becomes the shape of the far side of the eye, instead of the pointed shape of the far corner, which disappears behind the jutting eyeball. This rounding of the far corner happens first to the far eye and eventually to the near eye once the far eye disappears entirely as a result of the head turning completely sideways.

The more a head turns, the closer the far eye is drawn to the Center Guideline. The near corner of the far eye vanishes behind the nasal bridge before the far eye disappears on a sideways head.

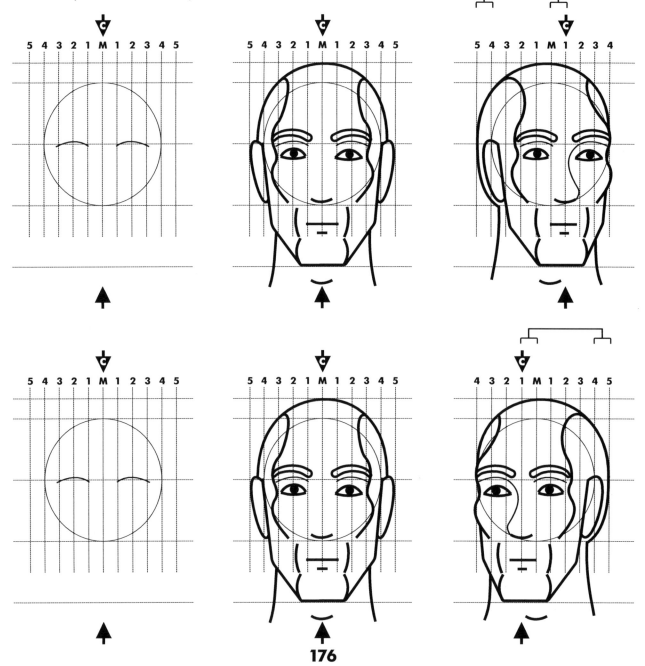

In the case of the mouth (a closed mouth), the protruding lips block the far corner so as the head turns the mouth loses length on its upper line on the far side of the mouth. The near corner of the mouth remains visible and unchanged, while the jutting shape of the lips becomes more apparent and the lines keep shortening horizontally on the far side (slowly slipping from view) until finally the head turns sideways.

Drawing different mouth types on a turned head is covered later, but for now practice creating a dozen or more turned heads with Neutral features (as illustrated below and on the next two pages) before tackling other expressions that incorporate various mouth types.

BACK OF THE HEAD
The back of the head is related to the front of the head whenever the head turns. The distance from the Middle Guideline to the Center Guideline is the same distance the back of the head sticks out from the edge of the Circle Guideline at the Eye Guideline. A reminder of this correlation between back and front is shown by the connected brackets above each illustration. The neck meets the back of the head at the Nose Guideline.

EYEBROWS
Draw eyebrows based on their positioning relative to the spot where the Eye Guideline meets the Center Guideline. The more the head turns away from facing the viewer the more the far eyebrow drifts away from the Center Guideline and the more the near eyebrow drifts towards the Center Guideline. As the head turns, the far side of the far eyebrow slowly disappears behind the Brow Contour and vanishes completely when the head turns sideways. The Ridge Guidelines, which represent the bottoms of the protruding brows, slowly drift the same way the eyebrows do as the head turns.

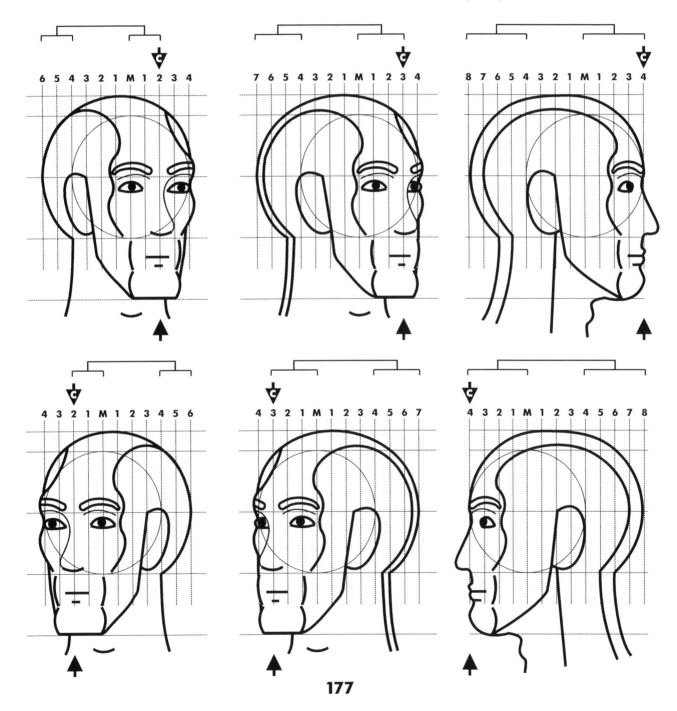

EDGE CONTOURS ONLY

The illustrations below hold the same information as the previous two pages but contain only the contour lines that comprise edges of the head. The remainder of the contour lines have been removed. Flip back and forth between these examples and those on the previous two pages to study the differences. You will often draw faces as they appear here on this page and the opposite one. Learning to visualize where all of the contour lines should go, even when you are not including them, helps you properly space and position features. Also, you can optionally include just pieces of removed contours (e.g. a bit of missing cheek contour) for effect to hint at their existence.

EARS

Ears come in a variety of shapes and sizes. They can be pointed or smooth, large or small, with tiny lobes or big ones, so the key to drawing ears in a head turn is to have a consistent anchor point for them. This Ear Anchor Point is the spot where the top front of the ear attaches to the head.

The Ear Anchor Point always sits on the Eye Guideline. On a head facing the viewer, the Ear Anchor Point sits where the Eye Guideline meets the Circle Guideline. If the space between any two vertical guidelines is a whole step, then the Ear Anchor Point moves along the Eye Guideline towards the

Middle Guideline a half step (inside the Circle Guideline) for each whole step the Center Guideline sits from the Middle Guideline. When the Center Guideline of a turned head sits at Vertical Guideline #1, the Ear Anchor Point is one half step inside the Circle Guideline. When the Center Guideline sits at Vertical Guideline #2 or #3, the Ear Anchor Point sits two or three half steps, respectively, inside the Circle Guideline. The Center Guideline of a sideways head sits at Vertical Guideline #4, so the Ear Anchor Point sits four half steps inside the Circle Guideline. On a sideways head, this also happens to place the Ear

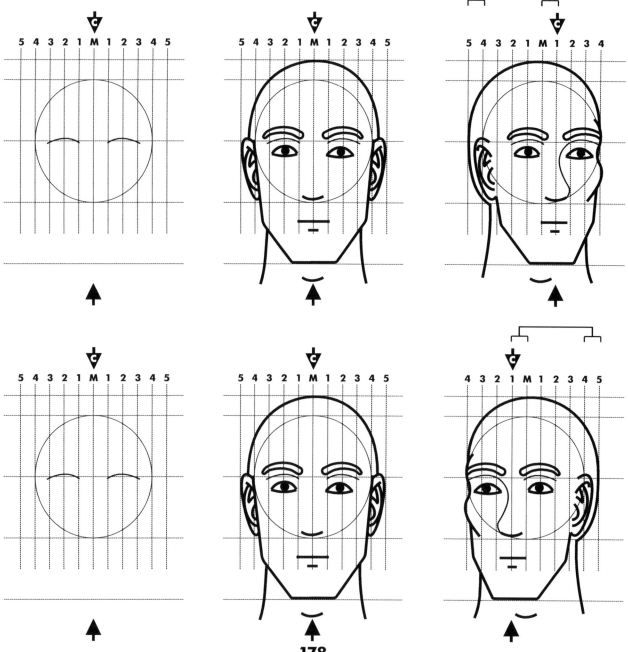

Anchor Point at the horizontal halfway spot between the front and the back of the head along the Eye Guideline.

Another way to think about positioning the Ear Anchor Point is that it sits on the Eye Guideline inside the Circle Guideline a distance equal to half the distance separating the Middle and Center Guidelines.

If you draw a line from the Ear Anchor Point down to the jaw, you will automatically get the proper angle for the ear. Turn the page back, examine the earlier illustrations of the turned head, and look for this extension of the jawline. In the illustrations below, this

helpful line in front of the ear has been removed from the turned heads, so the jaw connects to the front bottom of the ear, rather than extending up to the Ear Anchor Point at the front top of the ear.

When the head turns, the overall perimeter shape of the ear expands horizontally as we see more, until we finally view the ear at its largest on a sideways head.

VARIETY OF MOUTH TYPES

After you have created a dozen or more turned heads with a Neutral expression (as illustrated on the two pages below and the previous two pages) you are ready to start

creating other expressions on turned heads involving other mouth types.

The next several pages show the variety of mouth types you already know for forward-facing expressions and flanks them with how they appear on left and right turned heads. This is left and right from your view as the artist, not from the viewpoint of the character. Spend some time studying these turned mouths. Compare and contrast them to one another, noting their similarities and differences - especially on a sideways head. Asymmetrical mouth types have two entries - left and right - to show both possibilities.

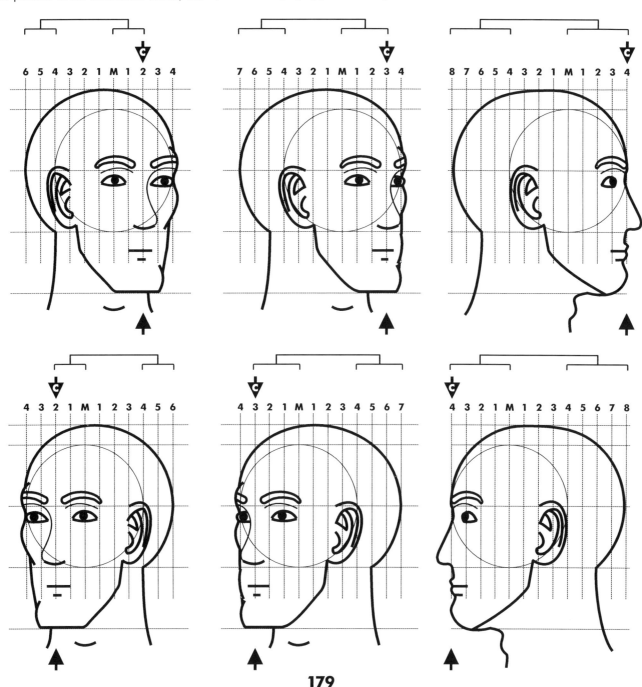

179

Mouth Types Front-Facing & Sideways

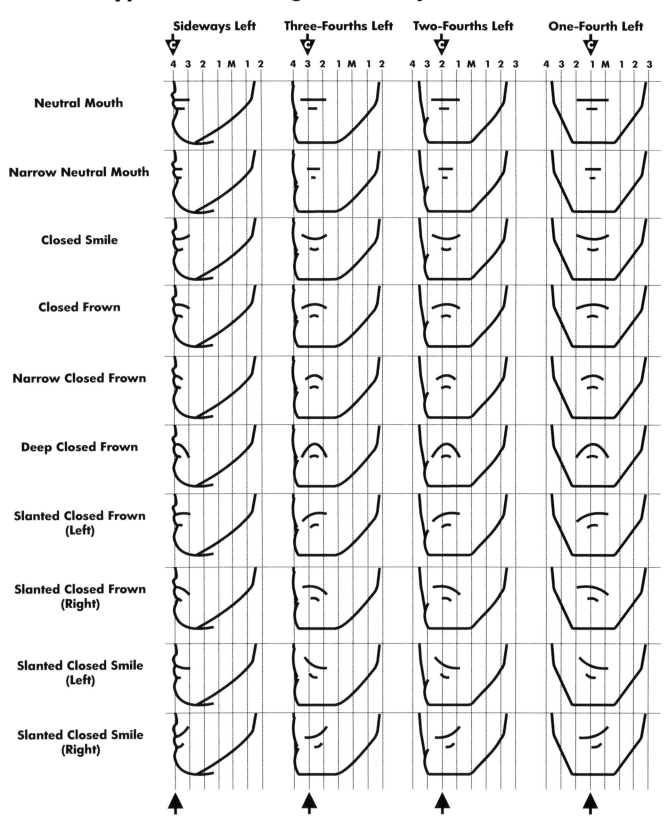

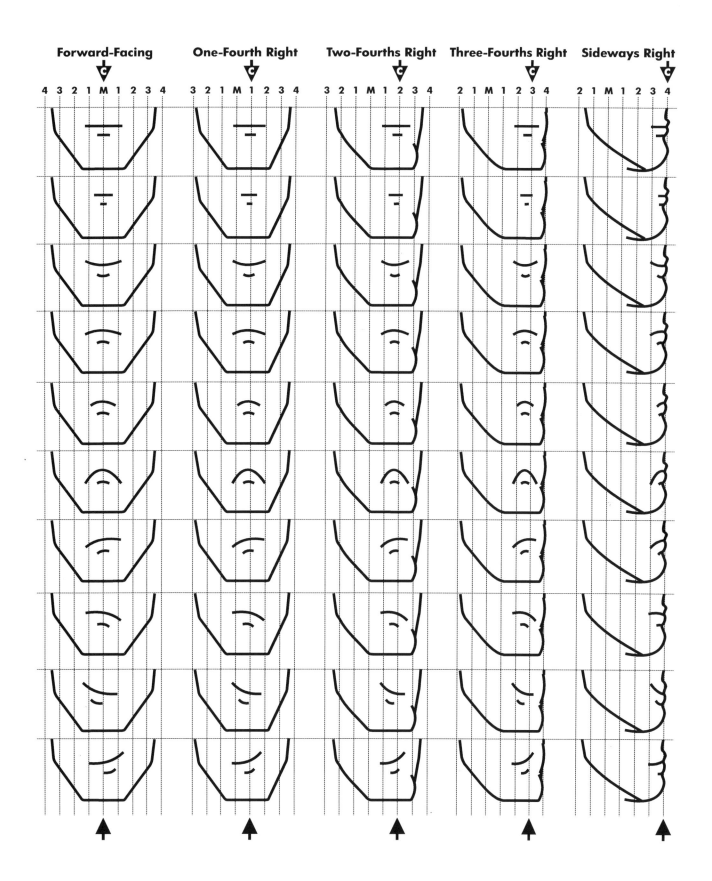

Forward-Facing	One-Fourth Right	Two-Fourths Right	Three-Fourths Right	Sideways Right

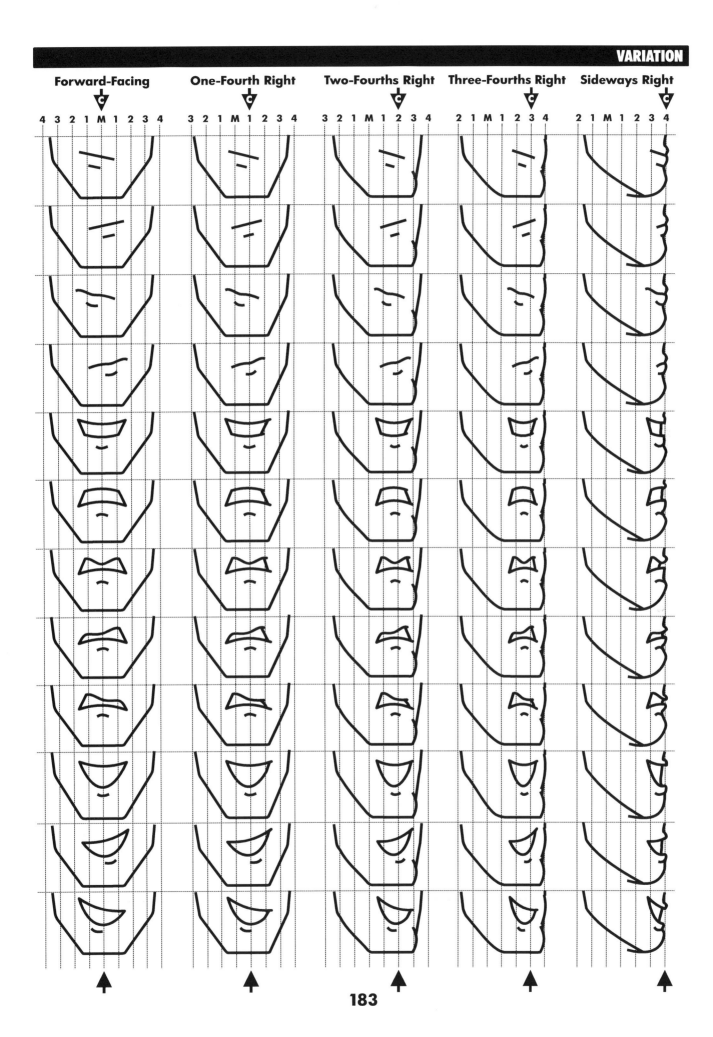

Forward-Facing **One-Fourth Right** **Two-Fourths Right** **Three-Fourths Right** **Sideways Right**

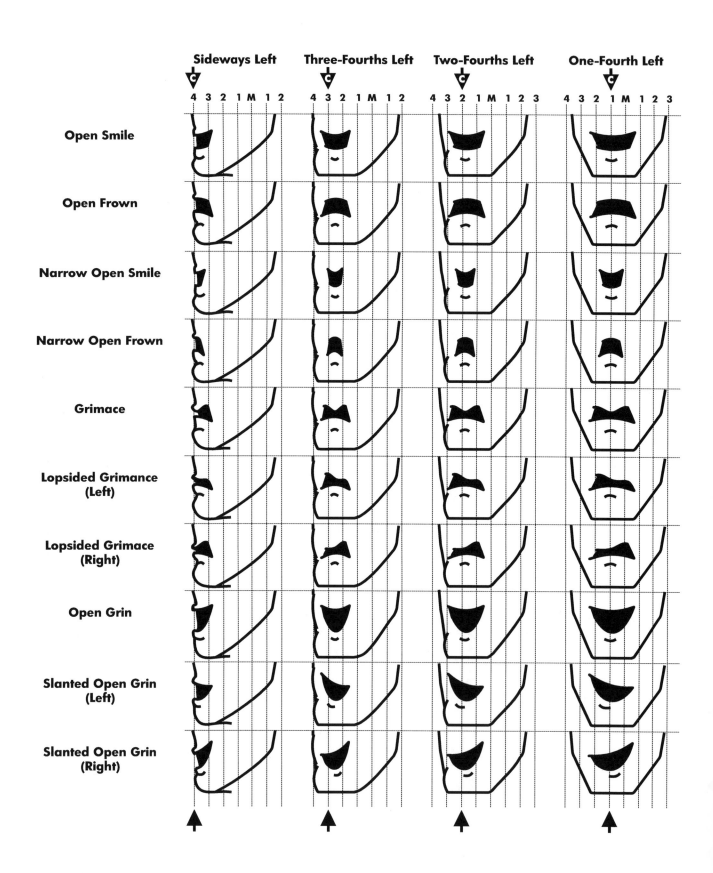

184

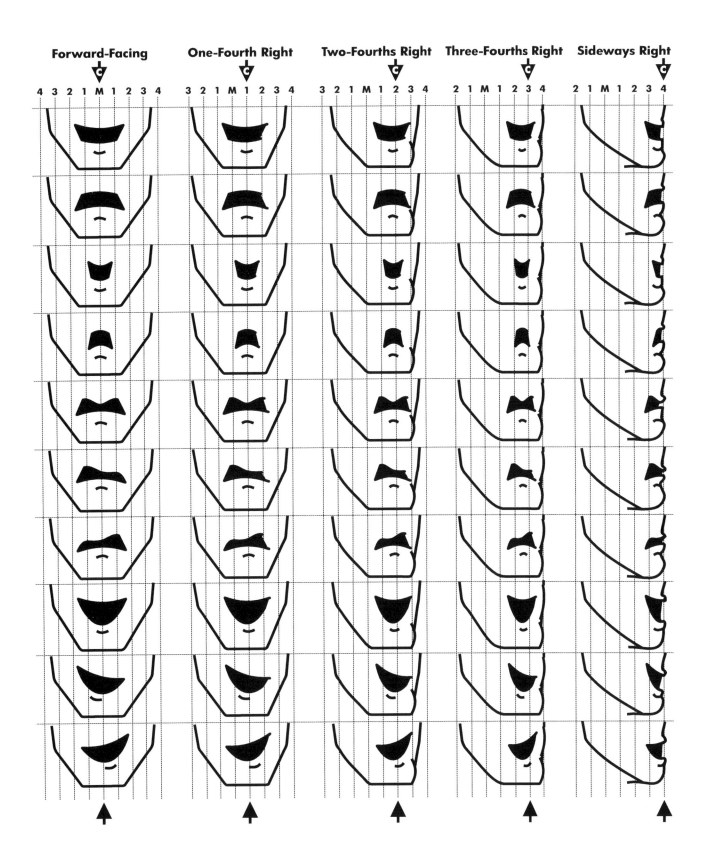

185

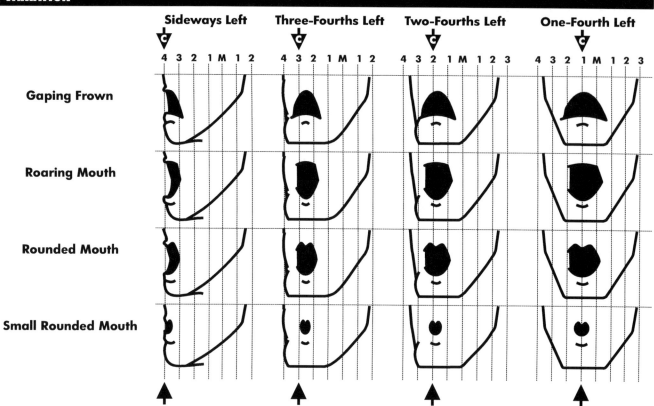

Two influences - horizontal compression and lip line extensions - are used when drawing mouths on turned heads.

HORIZONTAL COMPRESSION

As a head turns from the front to the side, the mouth becomes compressed horizontally as the viewer sees it more from the side and less from the front. This transition from front to side removes width on the far side of the mouth so more and more of the overall mouth falls on the near side of the Center Guideline until the head reaches sideways.

LIP LINE EXTENSIONS

Mouth types with parted lips result in lip line extensions to represent the impact of protruding lips.

Depending on mouth type, lip line extensions may appear on the upper line, lower line, or both. They are always drawn on the far side of the mouth and apply to any head turn between forward-facing and sideways. In other words, lip line extensions appear

on mouths with parted lips on faces where the Center Guideline is Vertical Guideline #1, #2, or #3. Forward-facing heads and sideways heads are not subject to lip line extensions.

To create lip line extensions, draw the mouth as usual, except pull any connecting lines on the far side slightly back towards the Center Guideline. For example, a Teeth Open Grin has a drooping upper line and a drooping lower line. The upper line needs a lip line extension when the head turns, so instead of drawing the lower line meeting the ends of the upper line, connect the lower line to the near end of the upper line and draw it drooping then rising back up to connect with the upper line horizontally just shy of reaching the far end of the upper line. This creates a lip line extension on the upper line of the Teeth Open Grin.

On a Teeth Open Smile, lip line extensions appear on both the upper and lower lips.

Draw the upper and lower lines as usual. Draw the near end of the mouth connecting the upper and lower lines as usual. Here is where things change. Draw the line for the far end of the mouth slightly in from the ends so it does not meet up at the corners but rather in a bit from the corners, which creates the lip line extensions on the upper and lower mouth lines.

For a Roaring Mouth and Rounded Mouth, lip line extensions are applied to the upper and lower lines by creating a straight vertical side line on the far side that sits inward into the shape towards the Center Guideline. Placement of this vertical side line is easy. Always draw it starting at its top and dropping straight down. A Roaring Mouth has an upper line and a lower line. The upper line has three segments - two segments angled in on the sides, and the third a top segment gently curving to connect the side segments. Start by drawing the near side segment followed by the top segment. Leave

Lip Line Extension on a Teeth Open Grin

Lip Line Extension by pushing in lower line **Front-Facing So No Lip Line Extension** **Lip Line Extension by pushing in lower line**

Lip Line Extensions on a Teeth Open Smile

Lip Line Extensions by pushing in side line **Front-Facing So No Lip Line Extensions** **Lip Line Extensions by pushing in side line**

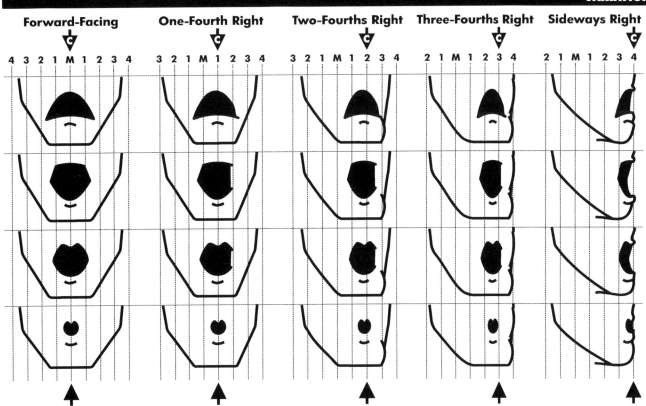

Forward-Facing	One-Fourth Right	Two-Fourths Right	Three-Fourths Right	Sideways Right

off the far side segment of the upper line. Draw the vertical side line just inside the far side of the top segment. Drop it straight down until it reaches the same level where the upper and lower lines of the mouth meet. Now draw the lower line of the mouth. Start on the near side of the mouth, connected to the upper line, and curve the lower line down from the upper line towards the far side and swoop it back up until it reaches the same far side point directly below the far side of the top segment of the upper line (this lines up the lip line extensions on the upper and lower mouth lines). Now drop the vertical side line down the rest of the way - keeping it straight -

until it reaches the lower mouth line. It winds up just inside the lip line extension.

For a Rounded Mouth, the upper mouth line has three segments - two side segments connected by a top segment that dips. The key to finding the placement of the vertical side line is to set it on the far side segment of the upper mouth line at the point which lines up vertically with the lowest point of the dip in the top segment of the upper mouth line. Starting on the near side, draw the side segment of the upper mouth line, then the top segment that dips, then the far side segment, stopping when you reach the

point just below the level of the dip. Now back up a little to the same level as the dip and drop a straight line down. Add the lower mouth line starting at the near side of upper mouth line, curve it downward and back up again until it lines up horizontally with the lip line extension of the upper mouth line. Drop the vertical side line down the rest of the way - keeping it straight - until it reaches the lower mouth line just inside the lip line extension.

A Small Rounded Mouth is the one mouth type with parted lips that does not have any lip line extensions.

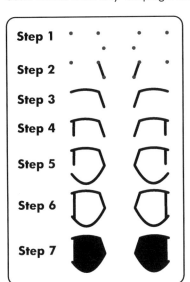

Step 1	
Step 2	
Step 3	
Step 4	
Step 5	
Step 6	
Step 7	

Lip Line Extensions on a Roaring Mouth

Lip Line Extensions by pushing in a vertical line — Front-Facing So No Lip Line Extensions — Lip Line Extensions by pushing in a vertical line

Lip Line Extensions on a Rounded Mouth

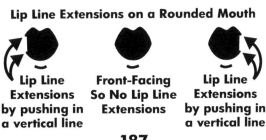

Lip Line Extensions by pushing in a vertical line — Front-Facing So No Lip Line Extensions — Lip Line Extensions by pushing in a vertical line

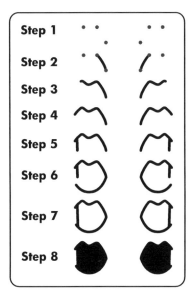

Step 1	
Step 2	
Step 3	
Step 4	
Step 5	
Step 6	
Step 7	
Step 8	

BACK-FACING HEAD TURN

Before you move on to this section, focus on creating front-facing head turns. When you have created two dozen or more and are feeling confident about your understanding of the process, then visit this section to start creating back-facing head turns.

Most rules of a front-facing head turn apply to a back-facing head turn. Any changes are noted about each feature.

The two pages below (this one and the opposite one) illustrate a head turn that ranges from a backward-facing head to a sideways head (the same sideways you learned about for a front-facing head turn). The next two pages show the same head turn illustrations with edge contours only.

Guidelines are the same as a front-facing head turn. The Center Guideline appears between the black arrows and should be imagined existing down the center of the face even when facial features are blocked from view by the angle of the head turn.

For clarity, backward-facing describes a head positioned directly facing away from the viewer, while back-facing refers to a head turned at any angle away from the viewer. It is analogous to forward-facing compared to front-facing.

BACK OF THE HEAD

The back of the head is wider than the front, so the crown on a backward-facing head is drawn out away from the sides of the Circle Guideline at the Eye Guideline, just as you draw a forward-facing crown wider.

As the head turns, the back of the head is offset from the side of the Circle Guideline at the Eye Guideline by the same distance as the offset of the Center Guideline from the Middle Guideline. The brackets above the illustrations shows this correlation.

The back of the head meets the neck at the Nose Guideline.

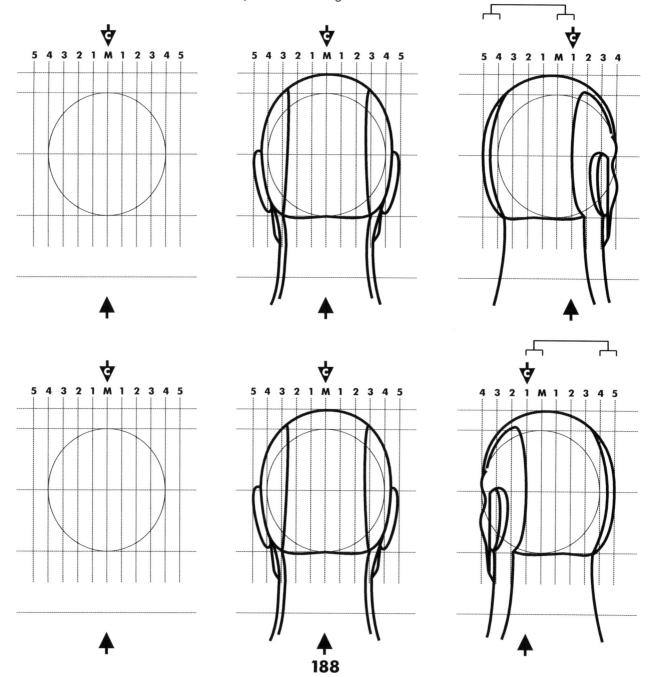

EYES
The near eye appears on the three-fourths back-facing head. The far corner of the near eye is replaced by the curve of the eyeball. The eye on the three-fourths back-facing head is half the width of the eye on a sideways head.

EYEBROWS
The near eyebrow appears on the three-fourths and two-fourths back-facing heads. Only the near end of the eyebrow appears - a part of the eyebrow that naturally wraps slightly around the side of the head and so remains visible as the head turns away from the viewer.

BROW AND CHEEK EDGE
The edge forms of the near brow and cheek are visible once the head turns between backward-facing and sideways. The curves of these edge forms (bulge of the brow, recess of the eye socket, bulge of the cheek) - even though they are viewed at a reverse angle when the head is back-facing - are the same as the curves of the edge contours of the brow and cheek when the head is front-facing, because these particular features happen to wrap around the curvature of the head. Flip back and forth to the front-facing illustrations and compare these edges to the back-facing ones below.

NOSE
As a head turns from sideways to back-ward-facing, the nasal bridge, nasal ridge, and finally the nose tip vanish behind the edge of the near cheek. Conversely, as a head turns from backward-facing to side-ways, the tip, ridge, and bridge of the nose (in that order) emerge from behind the edge of the near cheek.

JAW
Since a jaw (where it meets the bottom of the ears) is slightly wider than the adjacent neck, the underside of the jaw is visible to varying degrees on all back-facing heads.

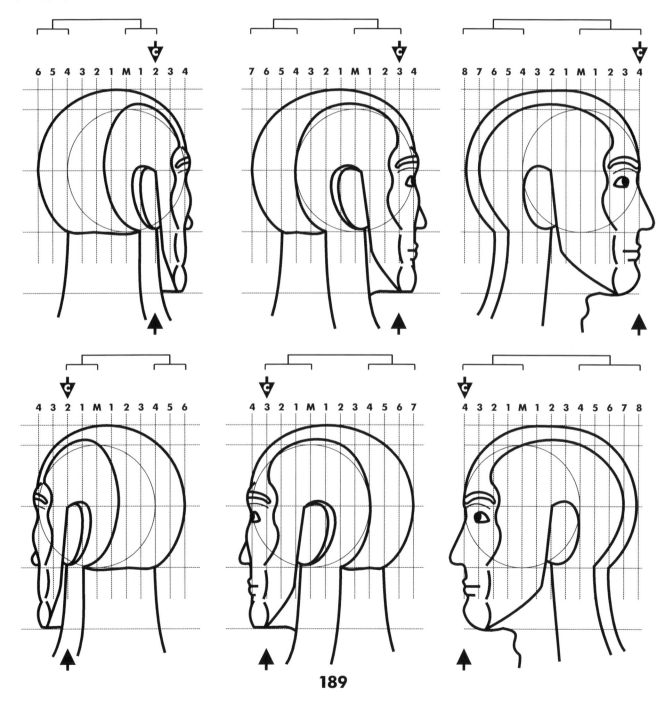

NECK AND CHIN

The neck on a sideways head merges with the underside of the chin beneath the jawline. This connection between neck and chin remains visible as the head turns away until the angle causes the chin to be blocked from view behind the neck of the one-fourth back-facing head and the backward-facing head.

While the laryngeal prominence on male necks is visible on front-facing as well as sideways heads, the bump is not visible on back-facing heads since the prominence is blocked at these angles by other parts of the neck. On female necks, the prominence always remains hidden beneath the surface of the skin, so no bump appears. Instead, the neck smoothly curves back and downward from the underside of the chin.

EARS

A head grows wider from front to back. On a backward-facing head, the backs of the ears are obscured by the expanded width of the back of the head. Therefore, you do not see as much ear on a backward-facing head as you do on a forward-facing head, even though the ears extend out to the side the same amount on both heads.

On a head in-between backward-facing and sideways, the near ear is visible. The ear also follows the same rules as a front-facing ear about using the imaginary line created by extending the jawline up to the Eye Guideline to determine the positioning of the Ear Anchor Point and the angle of the front of the ear. However, since the viewing angle of the jaw changes considerably on back-facing heads, the tilt angle of the ear does too. Turn back a page to see the extended jawlines as guides in front of the ears. On a one-fourth back-facing head, the angle of the jawline is almost vertical as it approaches the Nose Guideline. Extending this jawline upward to create a guide for the ear ends up placing the Ear Anchor Point almost directly above the bottom front

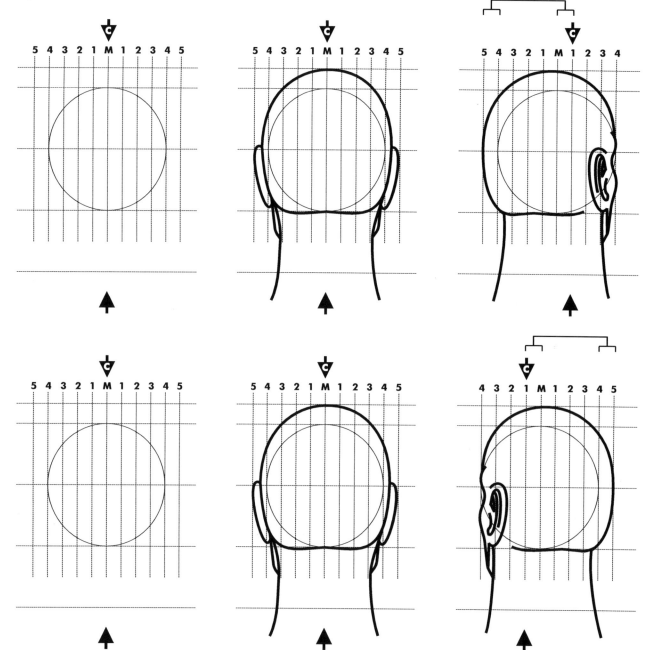

190

point of the ear, meaning the ear has next to no tilt when viewed at this angle. The familiar tilt angle of the ear (the top front of the ear set further back than the bottom front of the ear) returns as the head turns more towards sideways.

A unit equals the distance between adjacent Vertical Guidelines. The Ear Anchor Point for a back-facing head, including a sideways head, follows a simple rule: *half unit or two units*. The Ear Anchor Point falls on the Eye Guideline either a half unit or two units from the Circle Guideline or center of the Circle Guideline (i.e. from the Middle Guideline).

MOUTH
Though the three back-facing angles without mouths have restricted ability to convey expressions, it nonetheless remains important to learn about them to round out your understanding of drawing head turns. These angles are helpful when conveying things such as crowds. Everyone at a party might be drawn randomly turned as they mix and mingle, requiring a range of head turns including facing away from the viewer. People might be drawn front-facing as they confront an encircling mob. A person might be drawn forward-facing at a podium addressing a back-facing audience, or drawn backward-

facing in the foreground talking to a front-facing group in the background.

The mouth is visible on the sideways head (which you previously learned to create) and on the three-fourths back-facing head. The next pages illustrate all mouth types for both head turns so you can study, contrast, and compare their similarities and differences. For instance, in general, mouths of three-fourths back-facing heads are half the width of their counterpart sideways heads. This width difference impacts the angle of some diagonal lines, but the height of the mouth counterparts remains equal.

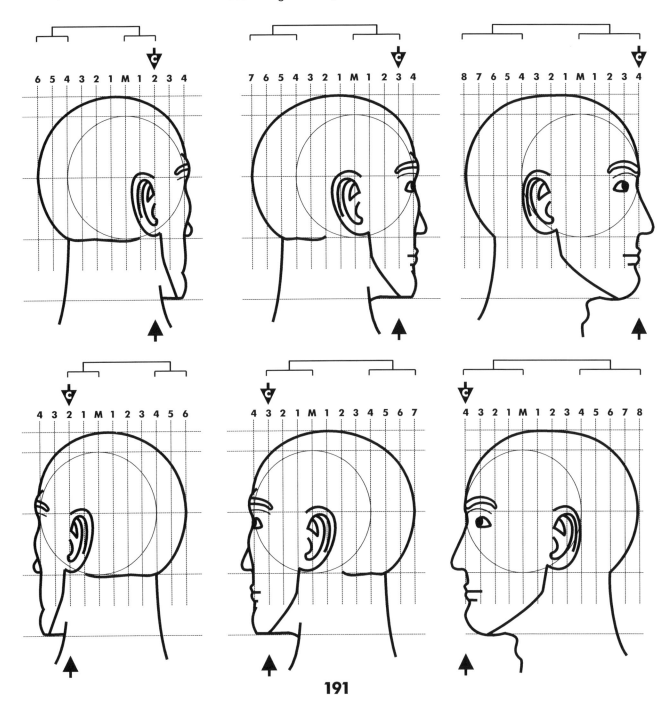

191

Mouth Types Back-Facing & Sideways

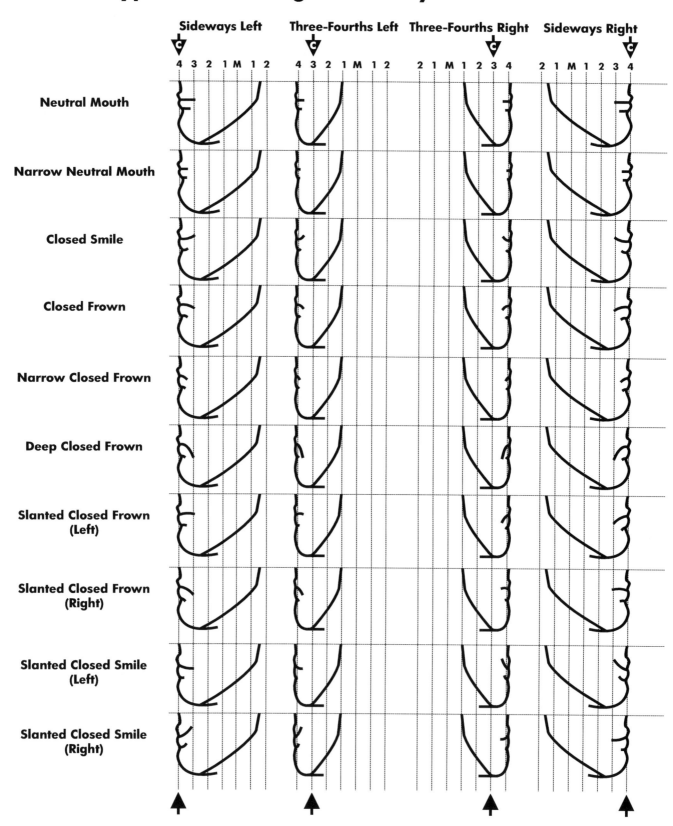

	Sideways Left	Three-Fourths Left	Three-Fourths Right	Sideways Right
	4 3 2 1 M 1 2	4 3 2 1 M 1 2	2 1 M 1 2 3 4	2 1 M 1 2 3 4
Slanted Neutral Mouth (Left)				
Slanted Neutral Mouth (Right)				
Slanted Contradictory Mouth (Left)				
Slanted Contradictory Mouth (Right)				
Teeth Open Smile				
Teeth Open Frown				
Teeth Grimace				
Lopsided Teeth Grimace (Right)				
Lopsided Teeth Grimace (Left)				
Teeth Open Grin				
Slanted Teeth Open Grin (Right)				
Slanted Teeth Open Grin (Left)				

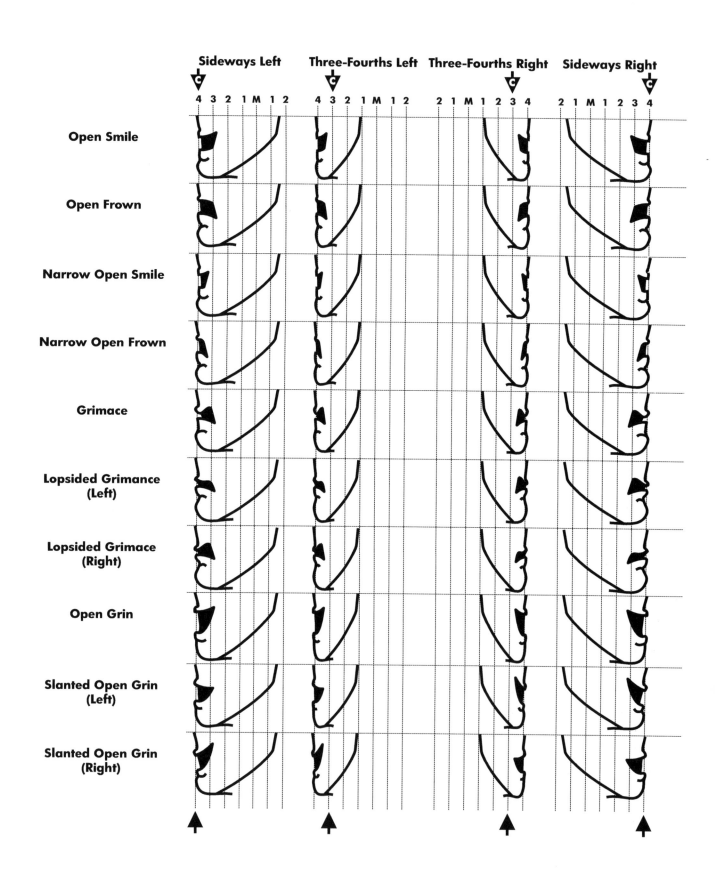

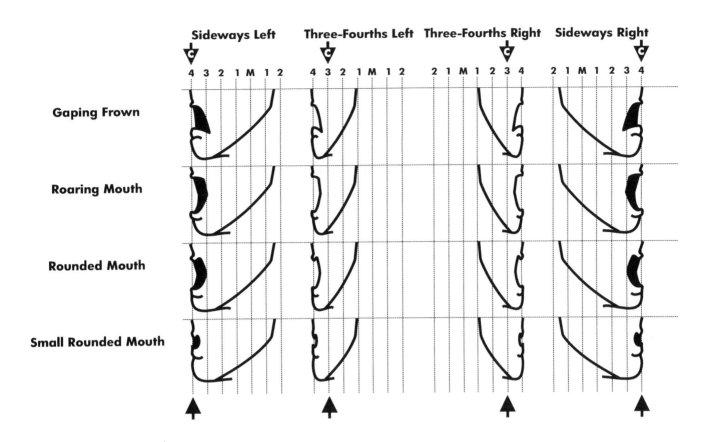

SET OF REUSABLE GUIDELINES

A set of reusable guidelines saves you time and effort as you practice drawing head turns. To build this set, you will need paper, pencil, and a black marker.

Use pencil to draw a 1-inch diameter Circle Guideline on a sheet of paper. Now add a Middle Guideline, Eye Guideline, Nose Guideline, Chin Guideline, Top of Circle Guideline, Crown Guideline, and then add Vertical Guidelines that go 8 lines out from both sides of the Middle Guideline, as illustrated to the right. Once satisfied with your guidelines, go over the pencil in black marker to darken all the guidelines.

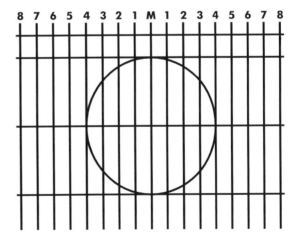

Grab another piece of paper. Repeat the steps above, except start with a 2-inch circle. Then grab another sheet and create one more Reusable Guidelines Sheet with a 3-inch circle. Create other sizes as desired.

To use these helpful tools, place paper over one of the Reusable Guidelines Sheets so you see the darkened lines underneath.

Lightly draw a temporary small plus sign(+) on the blank sheet at the spot where the underlying Middle Guideline meets the Eye Guideline (i.e. where they cross each other at the center of the Circle Guideline). This allows you to realign the sheet if it moves from atop the Reusable Guidelines before you finish drawing your face. Next select which underlying guideline will be your

Center Guideline for the face and mark a lightly-drawn arrow pointing at it so you remember the vertical center of your face. Then draw your face on the blank sheet using the guidelines that show through from the underlying Reusable Guidelines Sheet. You can repeat this process as many times as you want to produce additional faces on the same or a different sheet of paper.

HAIR ON HEAD TURNS

Hair on head turns makes use of contours, including some additional kinds.

HAIR CONTOUR
Earlier illustrations of the front-facing and back-facing head turns in previous sections contained a new kind of contour, a Hair Contour, above each brow contour. Each of these two Hair Contours reveals the transition between the top and the side of the head, extending all the way to the back of the head. Hair Contours help in drawing hairstyles because they fall where a person typically parts their hair on the side.

CENTRAL FOREHEAD CONTOUR
The Center Guideline is a straight line that shows the center of the facial features. The forehead, however, curves back as it approaches the top of the head. To locate the center of the forehead, draw a line from the point where the crown meets the Middle Guideline down to the nasal bridge at the spot where the Center Guideline intersects the midpoint between the Ridge Guidelines.

On a forward-facing head turn, the Central Forehead Contour is a straight vertical line, while on other front-facing head turns, it is a gentle curve. On a sideways head this contour already exists because it matches and duplicates the existing crown edge line as it curves down to the brow edge line, just above the Ridge Guideline.

CENTRAL SIDE CONTOUR
The Central Side Contour travels along the curving dome-shaped crown and divides the front and back sections of the head. It falls from the top of the head down the center of both sides. On front-facing heads, draw the Central Side Contour from the Ear Anchor Point on the Eye Guideline to where the crown crosses Vertical Guideline #2.

Because the front of a head is narrower than the back of a head, the left and right Central Side Contours can both be seen on a forward-facing head, where they appear just inside the crown line. Otherwise on front-facing heads only the near Central Side Contour can be viewed. This contour gently curves except on sideways heads, where it is seen as a straight vertical line because of the viewing angle.

On back-facing heads, the rules for drawing Central Side Contours are different. One

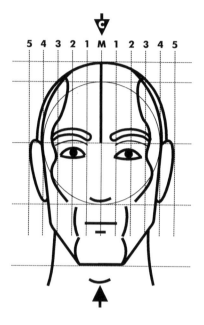
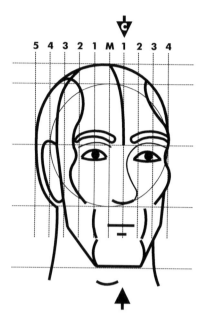
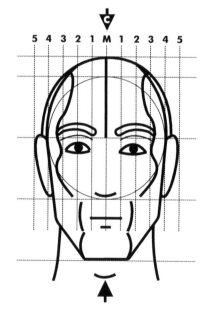
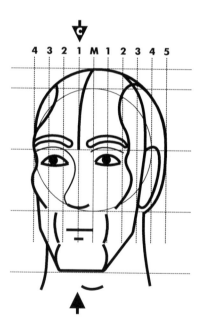

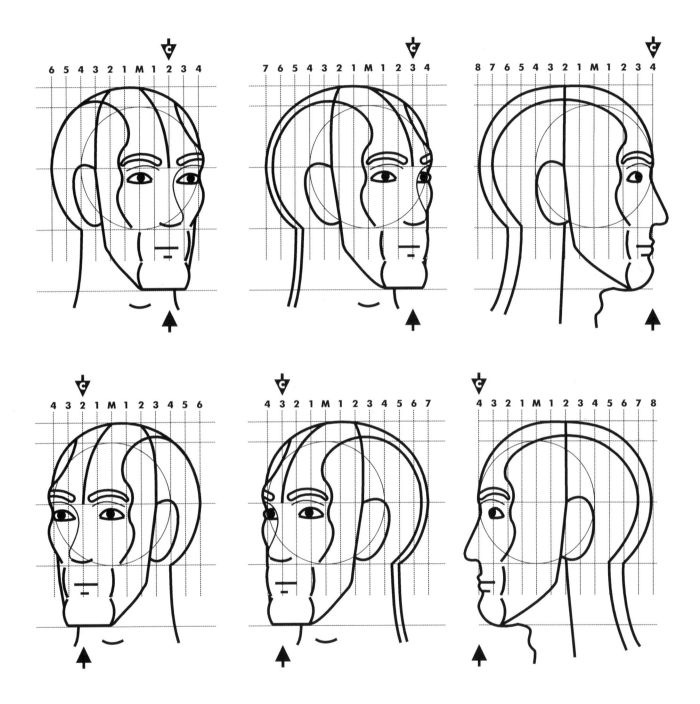

end of the contour line is still the Ear Anchor Point on the Eye Guideline. The other end depends on the head turn. On a one-fourth head turn, the contour ends at the point where the crown intersects the nearest Vertical Guideline #1. On a two-fourths head turn, the contour ends at the spot where the crown meets the Middle Guideline. On a three-fourths head turn, the contour ends at the point where the crown crosses the other Vertical Guideline #1 (the one that runs through the back of the ear).

Placement on the sideways head remains unchanged. The Central Side Contour runs from the intersecting point of the crown and Vertical Guideline #2 straight down to the Ear Anchor Point on the Eye Guideline.

The back of a head is wider than the front, so the Central Side Contours are not visible on a backward-facing head. Turn back a page and look at the forward-facing head to see why their location sets these contours out of sight when you reverse the viewing angle to create a backward-facing head.

HAIR PARTS (FROM THE BACK)
The Hair Contours are illustrated on the back-facing head turns. When parting hair on the sides along one of these contours, the part does not go all the way to the neck. It typically ends in the back where the Hair Contour crosses the horizontal guideline at the top of the Circle Guideline. For hair parted in the middle, the part ends where the Central Back Head Contour (described next) meets that same horizontal guideline.

CENTRAL BACK HEAD CONTOUR
This contour is the back-facing counterpart to the front-facing Central Forehead Contour, picking up where the other leaves off. It extends from the top of the head along the center of the back of the dome-shaped crown to the point where the head meets the neck at the Nose Guideline.

The key to placing the Central Back Head Contour is knowing three points: where it starts on the crown, where it ends at the neck, and the point where it passes through the Eye Guideline. Beginning with the backward-facing head and finishing with the sideways head, a simplified code for remembering which guidelines to use for starting, ending, and pass-through points is: M-M-M, M-1-2, 1-2-3, 2-4-6, 2-6-8.

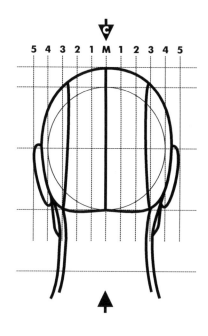

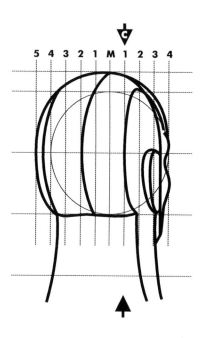

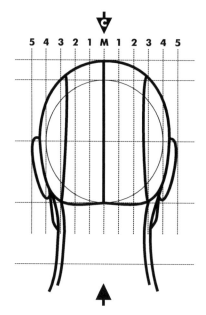

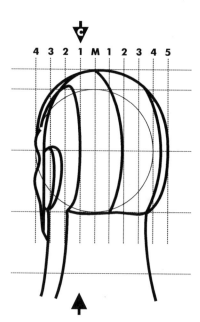

On a backward-facing head, the Central Back Head Contour starts where the crown meets the Middle Guideline and drops down as a straight vertical line to the Nose Guideline, where the neck meets the back of the head.

On a one-fourth head turn, the Central Back Head Contour starts where the top of the crown meets the Middle Guideline and ends at Vertical Guideline #1 on the Nose Guideline, curving through Vertical Guideline #2 at the Eye Guideline.

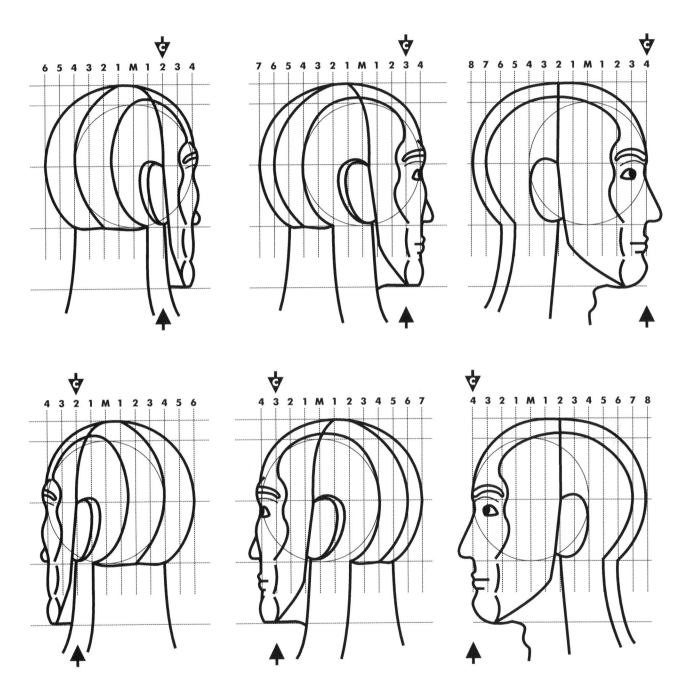

On a two-fourths head turn, the Central Back Head Contour starts where the top of the crown meets the Vertical Guideline #1 and ends at Vertical Guideline #2 on the Nose Guideline, curving through Vertical Guideline #3 at the Eye Guideline.

On a three-fourths head turn, the Central Back Head Contour starts where the top of the crown meets the Vertical Guideline #2 and ends at Vertical Guideline #4 on the Nose Guideline, curving through Vertical Guideline #6 at the Eye Guideline.

The Central Back Head Contour on a sideways head turn matches the existing crown edge line, which starts where the top of the crown meets Vertical Guideline #2, and ends at Vertical Guideline #6 on the Nose Guideline, curving through Vertical Guideline #8 at the Eye Guideline.

199

ANCHORING HAIR

Hair is organic and free-flowing. It reacts to its environment - wet, windy, etc. One thing remains constant - where it attaches to the head.

Imagine the hair shaved close to the skin to see what pattern it forms on the head. This reveals the hairline of your character. Is it high on the forehead, medium, or low? Most hairlines on the front of the forehead are close to the horizontal guideline at the top of the Circle Guideline. Otherwise they sit no farther down from the top of the Circle Guideline than a third of the way to the Eye Guideline - which, for easy measure, is the same distance that the top of the crown sits above the top of the Circle Guideline.

Now that you selected the shaved hairline, imagine hair growing out into its particular style.

Always return to the shaved hairline as your starting point when environmental factors influence the appearance of hair. Wind and water readily come to mind but also the movement, position, and actions of the character. Individuals with longer hair, who engage in combat, have hair trail behind their maneuvers as they dodge and attack. Characters hanging upside-down see their hair dangle, while the hair of subaquatic or zero-gravity characters floats freely. People moving to music see long hair sway. Folks donning a hat, cowl, or hood have scrunched hair, and so forth. Take time to think

about the circumstances enveloping your character to ensure hair stays consistent with the setting and events.

A hairstyle may hide features, so determine the style first to save yourself time by not having to draw unnecessary features.

To create a hairstyle that can be applied to any head turn, anchor the hair to existing set landmarks such as contours, edges, or guidelines. Think of its placement in terms of relative positioning so that with any turn you pick you know where the hair goes based on the new configuration of the set landmarks.

Hairstyle adds to expression by helping to define the overall personality of a subject. Likewise, a sudden change in hairstyle can

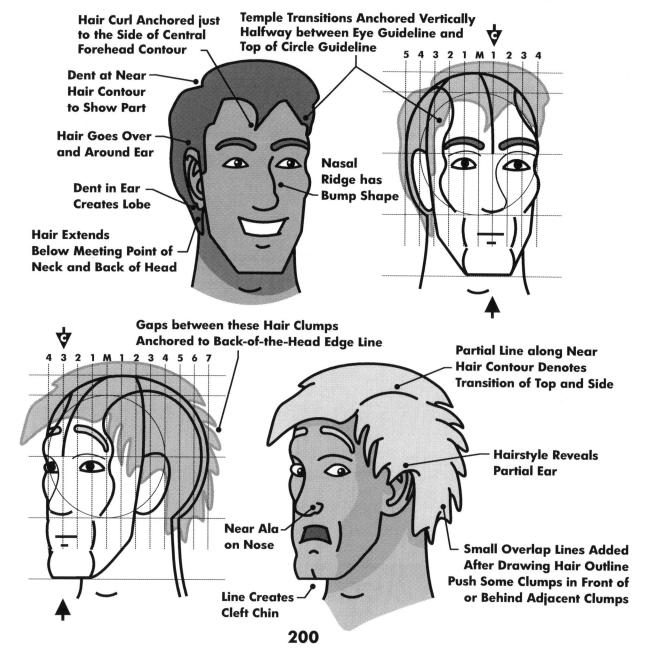

Hair Curl Anchored just to the Side of Central Forehead Contour

Temple Transitions Anchored Vertically Halfway between Eye Guideline and Top of Circle Guideline

Dent at Near Hair Contour to Show Part

Hair Goes Over and Around Ear

Dent in Ear Creates Lobe

Hair Extends Below Meeting Point of Neck and Back of Head

Nasal Ridge has Bump Shape

5 4 3 2 1 M 1 2 3 4

Gaps between these Hair Clumps Anchored to Back-of-the-Head Edge Line

4 3 2 1 M 1 2 3 4 5 6 7

Partial Line along Near Hair Contour Denotes Transition of Top and Side

Hairstyle Reveals Partial Ear

Near Ala on Nose

Line Creates Cleft Chin

Small Overlap Lines Added After Drawing Hair Outline Push Some Clumps in Front of or Behind Adjacent Clumps

indicate personal growth or a significant event in the development of a character. Examples include coming of age, shifting pace, exploring a different path, beginning a fresh career, initiating a courtship, attaining a higher station, trying to make an impression, letting go, falling into utter chaos, no longer keeping up appearances, and so forth. It can also be an undertaking such as going undercover, preparing for a sporting competition, enjoying a night out on the town, seeing how the other half lives, attending a costume party, or simply trying out something novel.

Facial hair is bound by the same rules. It grows out from the skin. Anchor it relative to landmarks on the face such as contours,

jawline, and guidelines (e.g. you might decide for a particular character to anchor their trimmed moustache just under the Nose Guideline and just above half way down to the Chin Guideline). Imagine your character growing out their facial hair, which starts as stubble and blossoms into strands. Left to its own nature, it keeps growing and droops with gravity, eventually creating long sideburns, moustache, and beard.

Does the character keep all or part of it? It can result in any combination or variation: sideburns with moustache, connected or disconnected moustache and beard without sideburns (i.e. a goatee), connected or disconnected beard and sideburns without moustache, sideburns only (short, medium,

or long), trimmed moustache only, long moustache only that hides lips, moustache and tiny bit of beard (i.e. soul patch) under the lower lip, moustache with wispy bit of beard on the chin, long moustache with trimmed beard, trimmed moustache with long beard, stubble only (minor, medium, or major five o'clock shadow), stubble beard with moustache, braided pieces of beard within full beard, bushy beard, scraggly beard, long beard that narrows to a point at the tip, moustache with waxed tips twisted or upturned, moustache tips with bare upper lip, etc. Facial hair is typically symmetrical, but can be asymmetrical - either on purpose or as a result of wounds such as gashes, scars, or burns.

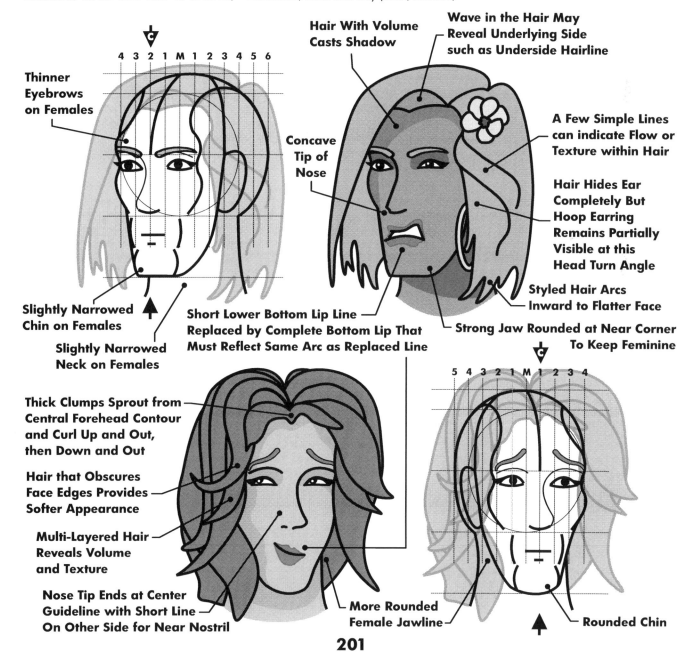

Thinner Eyebrows on Females

Hair With Volume Casts Shadow

Wave in the Hair May Reveal Underlying Side such as Underside Hairline

Concave Tip of Nose

A Few Simple Lines can indicate Flow or Texture within Hair

Hair Hides Ear Completely But Hoop Earring Remains Partially Visible at this Head Turn Angle

Slightly Narrowed Chin on Females

Slightly Narrowed Neck on Females

Short Lower Bottom Lip Line Replaced by Complete Bottom Lip That Must Reflect Same Arc as Replaced Line

Styled Hair Arcs Inward to Flatter Face

Strong Jaw Rounded at Near Corner To Keep Feminine

Thick Clumps Sprout from Central Forehead Contour and Curl Up and Out, then Down and Out

Hair that Obscures Face Edges Provides Softer Appearance

Multi-Layered Hair Reveals Volume and Texture

Nose Tip Ends at Center Guideline with Short Line On Other Side for Near Nostril

More Rounded Female Jawline

Rounded Chin

201

HEAD TWIST

Three lines - Neck Contours - are being introduced. They represent the front of the neck. There are two for the sides and one for the center of the front of the neck. Place your finger on your chin and slowly trace down the center to the underside and continue straight down until you reach the spot where your neck meets the top of your chest between your collar bones on either side. You have just traced the Central Neck Contour, which travels from the bottom of the chin back and down the center to where the neck hits the chest.

Now put your finger on your chin at the center. This time, instead of tracing straight down to your chest, trace along the bottom edge of your jawline. When you reach the spot where your jawline starts to curve upward towards your ear, drop your finger slowly down along your neck until you wind up at the same stopping point as the Central Neck Contour at the spot where the neck meets the chest flanked by collar bones. Now repeat what you just did starting at your chin but use your finger to follow under the other side of your jawline before slowly tracing down to the same finishing point. You have just traced the Front Side Neck Contours.

All three contour lines begin at the same starting anchor point just under the center of the chin, follow their own path, and then all conclude at the same ending anchor point where the neck merges into the top of the chest directly between the two collar bones. Together the Central Neck Contour and the Front Side Neck Contours reflect how the underside of the chin and jaw meld into the tree-stump-like remainder of the neck. These contours are crucial since they come into play when you want to depict a twist of the head.

Until now, you have learned about head turns with the body turned in the identical direction. You already encountered the Central Neck Contour in profile when you examined the neck line under the chin of a sideways head turn. To the right, the front-facing head turns show the Central Neck Contour - under the chin at the Center Guideline and ending on the Middle Guideline (passing through the center of the laryngeal prominence at the Middle Guideline).

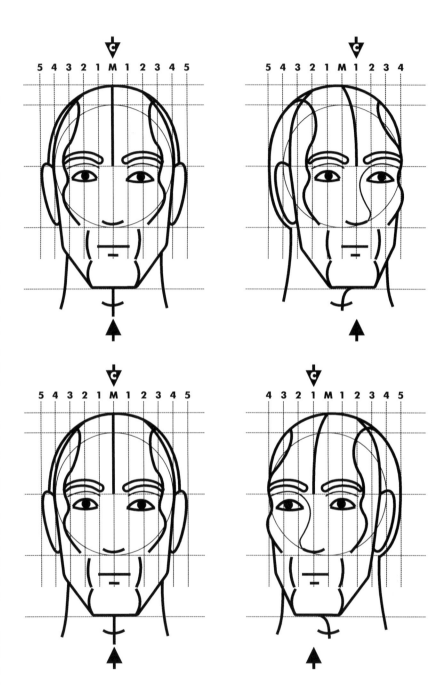

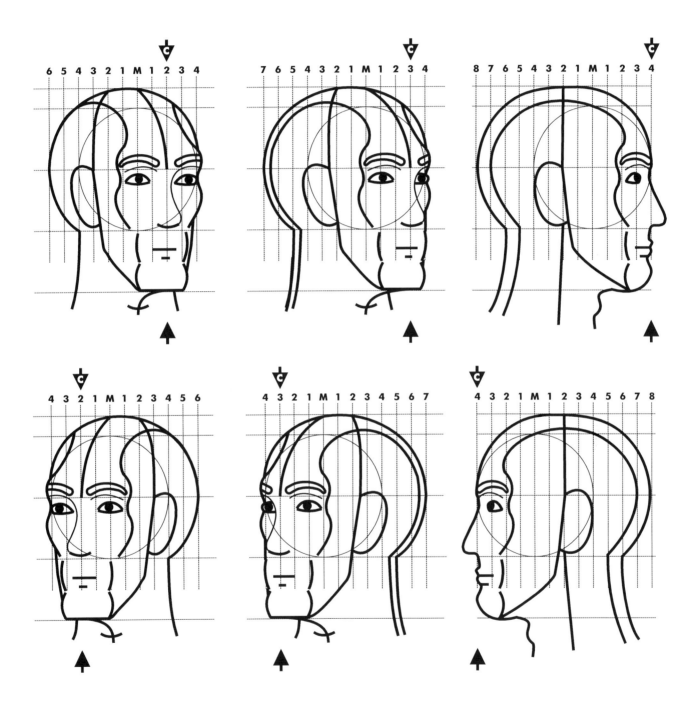

A *head twist* expands on a head turn and is based on the body turned in one direction with its head turned another, expanding the possibilities for expressions. For example, a person twists their head to further avert their eyes in horror, disgust, shame, or disapproval. A startled person twists to see the source of a loud noise.

The illustrations to the right show a forward-facing body and head twists at different angles. The Front Side Neck Contours end on the Middle Guideline at the same spot as the Central Neck Contour (where the neck meets the chest between the collar bones). This point remains stationary as the head twists (unlike a head turn, where this ending point moves because the body is also turning with the head). The resulting stretching of the Central Neck Contour and Front Side Neck Contours is visible from their ending anchor point to where they respectively connect beneath the jawline.

The laryngeal prominence is a flexible part of the neck so small curve stays centered on the Central Neck Contour. The prominence is anchored and centered on the Middle Guideline for front-facing *head turns,* but for front-facing and sideways *head twists* it is anchored and centered on the Central Neck Contour at the same vertical level as it would on a turn.

Flip back and forth to the previous two pages to compare and contrast the head turns with these head twists. You only have to focus on the necks and study their differences, since the other features remain the same for turns and twists.

If you position the common ending anchor point of the Central Neck Contour and Front Side Neck Contours elsewhere to indicate the body turned a direction other than forward-facing, you must follow one rule - the maximum amount of twist. A human being can only twist their head so far before they must turn their body to keep going. Ninety-degrees of twist is the typical limit. When you change the ending anchor point, make certain you aren't inadvertently creating an impossible pose for your character. Draw the head first, then the neck. Begin at your chosen ending anchor point and draw the contours upward to connect them to their appropriate points along the jawline.

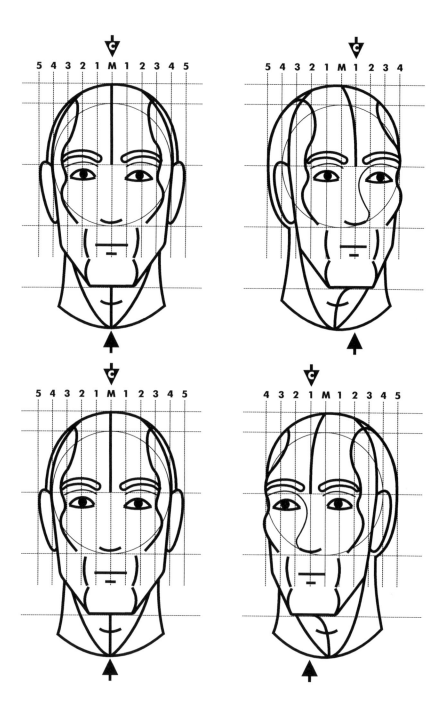

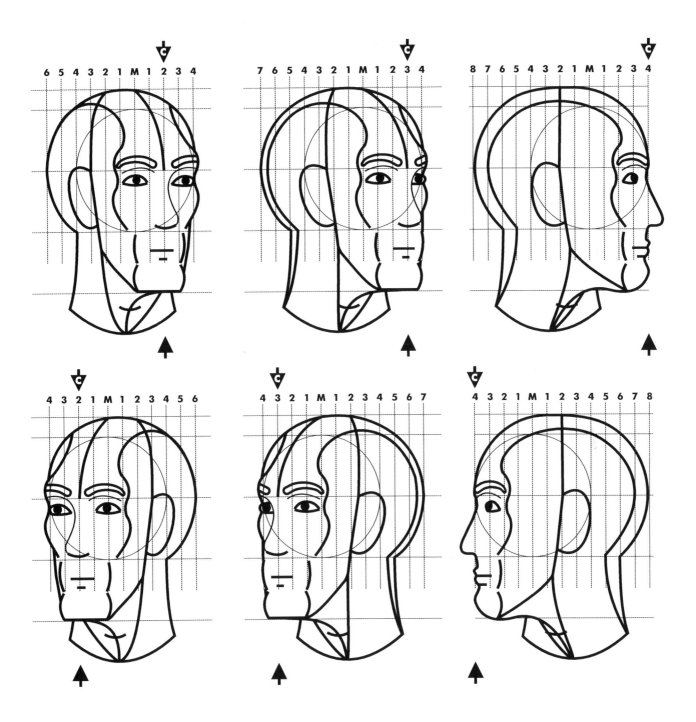

HEAD TILT

A head tilt uses the basic head guidelines and introduces arcs bending from one side of the Circle Guideline to the other. These curves start and end at Vertical Guideline #4 on both sides of the Center Guideline.

These arcs bend the same amount. Simply duplicate each curve when you draw them where the Eye, Nose, and Chin Guidelines meet the #4 Vertical Guidelines. The more the head tilts backward, the more the three arcs bend. The degree of curve change from one illustration to the next illustration, *right,* is equal to one-third of the distance between the Eye and Nose Guidelines.

The only adjustment to other guidelines is the location of the Ridge Guidelines, which are centered upon (and cross through) the spots where the arc on the Eye Guideline crosses both #2 Vertical Guidelines.

The three arcs replace the Eye, Nose, and Chin Guidelines, respectively. Draw eyes and eyebrows based on the new location of the Ridge Guidelines. Draw the base of the Nose just above the new curved Nose Guideline. Place the ears based on the new Eye and Nose Guidelines. Notice how the ears of a tilted head appear lower relative to the eyes than they would otherwise on a forward-facing, non-tilted head.

All the illustrations, *right,* show a Neutral expression. Look at the mouth. Recall that the center of a mouth sticks out farther than the corners of a mouth. This reflects that a mouth wraps around the curvature of a head. Viewed straight-on, a Neutral Mouth appears as a straight line, but once a head starts to tilt, the difference becomes visible between the jutting center and receding corners of the mouth. The "straight line" of the mouth becomes a curved line, bending the same degree as the three new arcs you added as guidelines to reflect the curve of the overall head. Any change in the mouth expression means you have to account for this change of perspective. A Closed Frown, for example, has to curve downward even more than the curve of the Neutral Mouth. Place your starting dots accordingly before drafting any mouth.

The chin follows the curve of the New Chin Guideline. With enough head tilt, the neck underneath the chin comes into view.

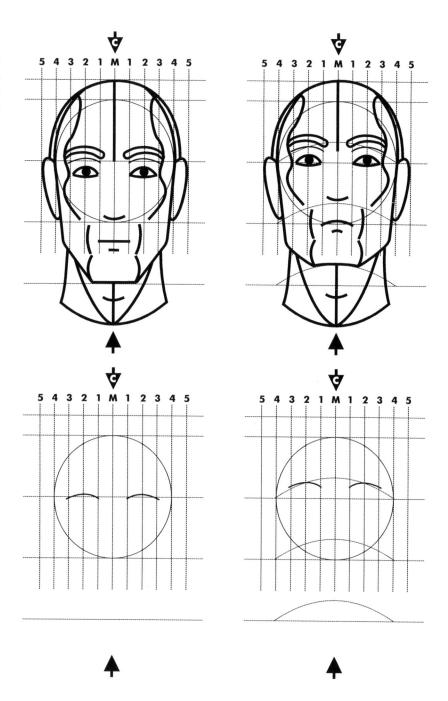

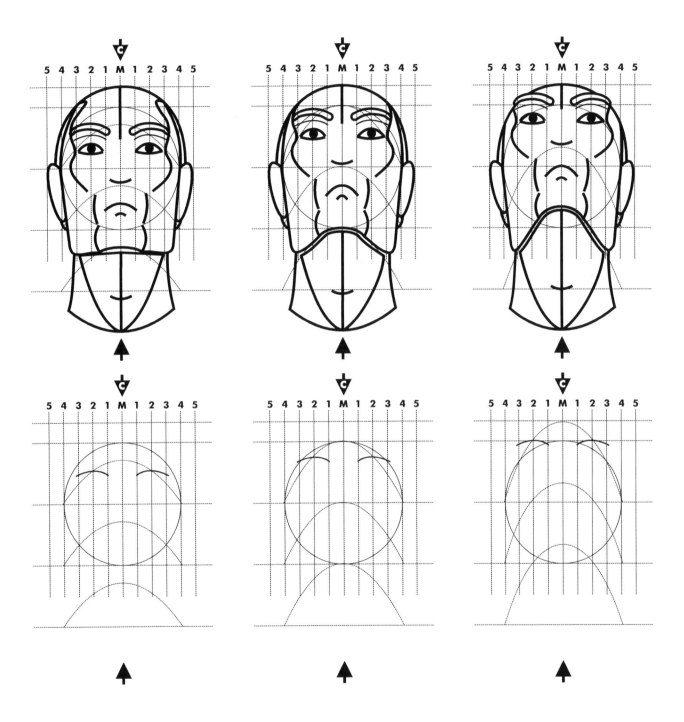

On forward-tilting heads, the three equal arc guidelines curve downward from the Nose Guideline and Eye Guideline as well as the guideline at the top of the crown. Arcs from the Eye and Nose Guidelines act just as they do for a back-titling head. For instance, the Ridge Guidelines are centered upon (and cross through) the two points where the Eye Guideline arc meets the #2 Vertical Guidelines. Notice the location of the ears gradually rises above the relative location of the eyes, eyebrows, and nose as the head tilts further forward.

More of the top of the head appears as the head tilts forward. The arc from the crown guideline intersects the Middle Guideline, revealing the point where the Central Side Contour runs over the top of the head.

All of the illustrations, *right,* show a Neutral expression. Tilting forward causes the line of the Neutral Mouth to become a curve for the same reasons explained for a back-tilting head - to reflect the curvature of the mouth across the curvature of the head. The direction of the bend this time is downward instead of upward because it is being viewed from above rather than from below. The degree of curve matches the bend of the arc from the Nose Guideline above the mouth. At each angle, the tips of the upper line of the Neutral Mouth point to the bend where the jawline changes direction below the ear to head out to the chin.

The chin does not drop straight down when the head tilts forward. It lowers and recedes from the viewer during the move. Ultimately the chin hits the base of the neck and can tilt no further without involving the upper torso.

The arcs in the illustrations are increments of one-third of the distance between the Eye and Nose Guidelines. For each one-third increment of the arc guidelines, the chin drops just one-fourth of the distance separating the Eye and Nose Guidelines, so the chin lowers more slowly than the arcs and stops when it reaches three-fourths.

The tilted chin shares the same curve as the arc guidelines since the line now represents the chin more and more as seen looking down at it from above as the head tilts downward instead of viewing the chin from the front (as seen in the non-titled head).

The same kind of change applies to the nose line as well. It goes from representing

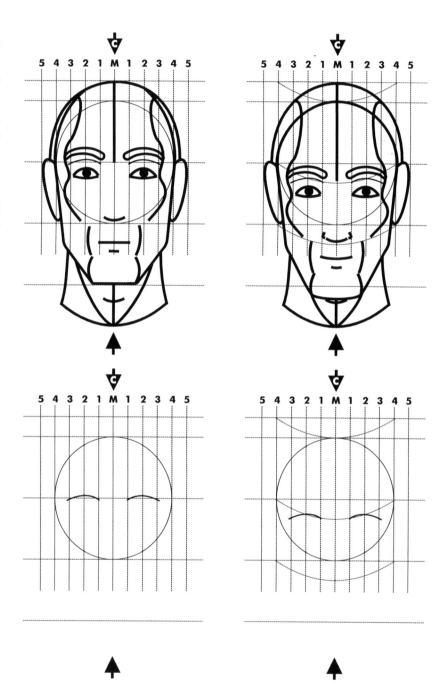

the bottom curve of the nose in the non-titled head to representing the front of the tip of the nose as the head tilts downward. In the end, it completely represents the tip of the nose as seen looking down at it from above. The alae are drawn flowing more and more up from either side of the nose line to match the greater angle of the tilted head as these nostril coverings are seen less from the front and more from overhead as the face bows towards the viewer.

The small line of the bottom lip likewise changes from representing the underside of the lip to representing its thickness from front to back. In other words, the line now shows how far the lower lip juts out from the face because with the chin dropping down and away at the tilted angle, viewers are looking "down" at the lip from an "above" point of view - just the same as if the viewer were standing up on a ladder peering down at a non-tilted face.

Since the nose curve and chin line go from representing the underside to being the front edge of these two features as the head tilts forward, the bottom of the nose and bottom of the chin disappear from view behind these front edges (i.e. behind the tip of the nose and the front of the chin). As a result, the method changes for determining the location of the Mouth Anchor Point. For drawing mouths on forward-tilted heads, the Mouth Anchor Point sits on the Center Guideline beneath the arc from the Nose Guideline at a spot one-fourth the distance between the Nose Guideline arc and the edge of the chin.

The Mouth Contours sit just below the level of the bottom of the nose on a forward-facing, non-tilted head. The bottom of the nose disappears, hidden by the nose tip, on forward-tilted heads. If the position of where the nose bottom merges with the rest of the face beneath it could also be seen on a forward-tilted head, it would be located above the nose tip curve, and the greater the angle of forward tilt, the higher the bottom of the nose would appear on the face compared to the nose tip curve. The tops of the Mouth Contours keep their position relative to the unseen bottom of the nose - not the tip - so they gradually rise above the arc guideline as the head tilts forward and thus eventually end up higher than the nose tip curve.

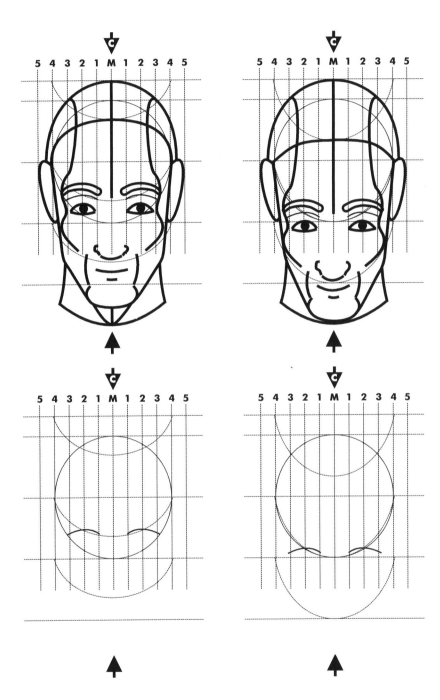

Neutral Mouth

Teeth Open Smile

Teeth Open Frown

Study the left column on the opposite page and examine the amount of change that impacts a Neutral Mouth when a head tilts backward and forward. This degree of upward or downward change to any lines crossing the curvature of the head side-to-side applies to other mouth types.

Examine the center column on the opposite page. It shows a Teeth Open Smile. When the head tilts forward, the side-to-side curvature of a face makes the already-dipping top and bottom lines of the mouth opening of the Teeth Open Smile dip even further downward. When the head tilts backward, the side-to-side curvature of the front of a head causes the already-dipping top and bottom lines to straighten out until eventually, at the furthest backward tilt, the top and bottom lines actually arc slightly upward.

In the right column on the opposite page, the Teeth Open Frown is impacted in the same way. When the head tilts backward, the slightly-upward-curving top and bottom lines of the mouth opening of the Teeth Open Frown arc upward to an even greater degree. During a forward head tilt, the upward-curving top and bottom lines straighten out and eventually arc slightly downward.

Think of the lines crossing side-to-side as flexible and imagine them being slowly pulled up in the middle during a backward head tilt and slowly pulled down in the middle during a forward head tilt.

Vertical and mostly-vertical mouth lines are not impacted by the curvature. The impact applies just to mouth lines that are horizontal and mostly-horizontal.

Regardless of the head tilt, the open smile and open frown still read as a smile and a frown because the upper and lower corners of these mouth types remain unchanged. The upper corners of an open smile are farther from the Center Guideline than its lower corners, while the lower corners of an open frown are farther from the Center Guideline than its upper corners.

Run your tongue over your upper and lower teeth. Notice your center teeth stick out the farthest while your side teeth recede into the back of your mouth. The center sections of your upper and lower lips pass over the

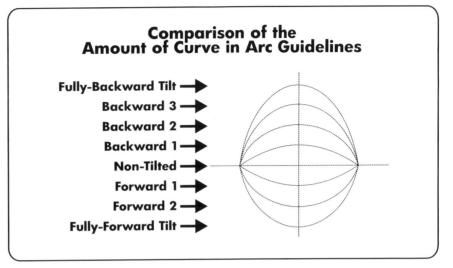

Comparison of the Amount of Curve in Arc Guidelines

Fully-Backward Tilt →
Backward 3 →
Backward 2 →
Backward 1 →
Non-Tilted →
Forward 1 →
Forward 2 →
Fully-Forward Tilt →

curvature of your teeth - a reason the center of your lips jut out farther than the corners of your lips. The corners are more immune to the effects of the shape of the teeth behind your lips.

This fact plays a role in how you depict various mouth types when a head tilts backward or forward. During a tilt, the center section of the mouth is typically impacted by the curvature of the head, especially when the lips are spread across the teeth, while the corners of the mouth move relatively freely and independently of the effects of the curvature. So, for instance, a Closed Smile on a non-tilted head has both corners of the mouth raised while the center section of the mouth forms a smooth dip between them. During a backward head tilt, the center section of the mouth spanning the teeth and the curvature of the head turns into an upward curve rather than continuing to be a downward one, but

this upward curve is sandwiched between the two corners of the mouth, which still point in the same direction as they did during the non-tilt. Examine the illustration on this page of closed mouth types to compare the fully-backward, non-tilted, and fully-forward angles. The third column from the left on the illustration shows the Closed Smile. Study the way the corners of each mouth type change based on the tilt angle and contrast that with how the center sections of each type change.

Recall how you learned early in this book to place dots at the corners of the mouth and then draw the connecting lines. The corner dots remain the same regardless of the tilt. Study the illustration of closed mouth types to confirm this helpful relationship. The lines drawn between the dots are what change based on the tilt, but the corner dots are placed in the same position to each other regardless of any tilt.

Closed Mouth Types with Lips Together

Fully-Backward Head Tilt

Non-Tilted Head

Fully-Forward Head Tilt

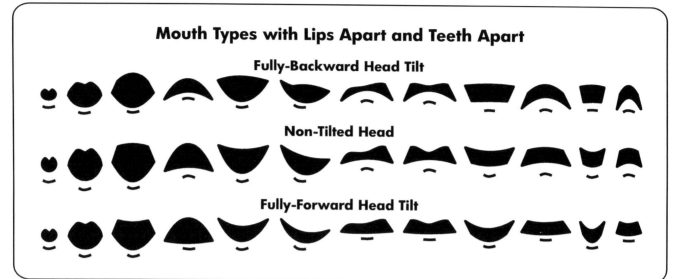

Mouth Types with Lips Apart and Teeth Apart

Fully-Backward Head Tilt

Non-Tilted Head

Fully-Forward Head Tilt

On mouth types with parted lips, the dots are positioned in the same location relative to each other, but they compress slightly vertically during any tilt, which compresses their openings. Rounded Mouth and Small Rounded Mouth are not impacted by the curvature of the head. Arches like the top of Gaping Frown and the bottom of Roaring Mouth, Teeth Open Grin, and Slanted Teeth Open Grin are also not impacted.

When you have any doubts about placing a certain mouth type, always go back to the Neutral version. Lightly draw a properly-placed Neutral Mouth onto the head. This reveals where the Mouth Anchor Point crosses the Center Guideline. Next, draw the desired mouth type on top of the lightly-drawn Neutral Mouth. Erase the Neutral Mouth lines afterward. This process of first drawing the Neutral version lightly as a guide can be applied as needed to other facial features.

On tilted heads, place eyes and eyebrows onto the face according to their positioning based on the Ridge Guidelines rather than the arc guidelines.

On tilted heads, ears are positioned based on the space between the Eye and Nose arc guidelines. On forward-tilting heads, ears steadily grow higher compared to the sinking Ridge Guidelines. Conversely, on backward-tilting heads, ears steadily sink compared to the rising Ridge Guidelines.

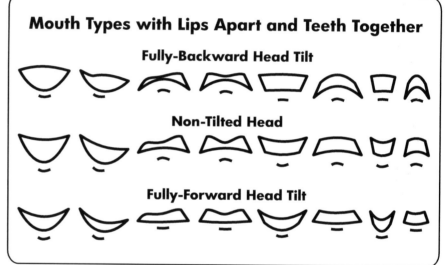

Mouth Types with Lips Apart and Teeth Together

Fully-Backward Head Tilt

Non-Tilted Head

Fully-Forward Head Tilt

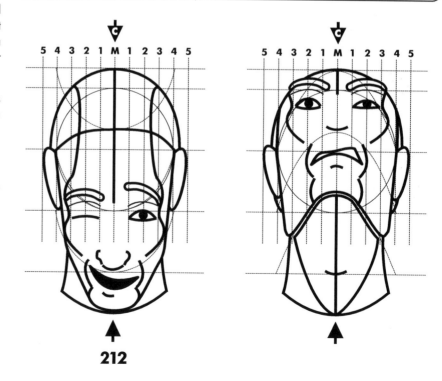

212

BETWEENS

Betweens are transitional and take a face from one expression to the next. They can be helpful in sequential art. There are two methods to create them. The first way is to select the two expressions - the current one on the face and the next one to appear on the face. Then create the between by taking a single feature from the next expression and introduce it into the current one. Use the eyes, eyebrows, nose, mouth, or any two or three of these features. The top row of faces below illustrates this method. The Lower-Wide Eyes of the Shocked next expression are added to the Neutral current expression to create the between.

The second way is to select the current and next expressions. Then determine if there is a feature that fits the mid-stage and use it to modify the current expression to create the between. The lower row of faces below is an example of this approach. The next expression Regret has a Narrow Closed Frown, while the current expression has a Neutral Mouth, so a Closed Frown is used along with the remainder of the features from the current expression to construct the between. The Closed Frown does not come from either the current or next expression but it is selected to provide a middle ground that is perfect for creating the between. More examples of "current, between, next" sequences include: 1) Closed Eye, 2) Half-Open Eye, 3) Neutral Eye; 1) Neutral Eyebrow, 2) Dipping Eyebrow, 3) Inward Slope Eyebrow; 1) Open Smile, 2) Closed Smile, 3) Neutral Mouth.

You can include more than one between. You might take a single feature from the next expression to create one between. Then create the next between by adding another feature from the next expression to the first between. You might employ several types of one or more features to create more than one between. A long sequence of mouth types resulting in five betweens could be: 1) Teeth Open Grin, 2) Teeth Open Smile, 3) Closed Smile, 4) Neutral Mouth, 5) Closed Frown, 6) Open Frown, 7) Gaping Frown.

Current Expression	Between	Next Expression

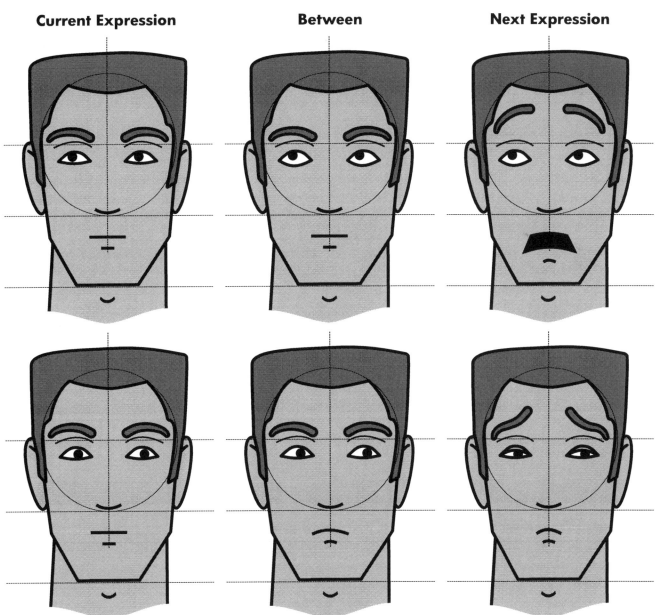

PARTIALS

Partials share the same basic shape but with different triangular tips. Study the illustration to the right which shows the pieces of a Partial broken apart to reveal their basic parts. Each Partial has a straight-edged rectangular body the same width as a Neutral Mouth. Each center rectangle is capped by triangles with their outermost tip positioned at a point along the top, bottom, or midway edge of the rectangle. Merged together, the rectangle and its triangular end-caps form the full shape of the Partial.

You have some latitude in how "open" you draw a Partial, which can be slightly thicker than a Neutral Mouth or can be open even more. Keep in mind that being too open may cause the Partial to be misread as another specific mouth type such as a Teeth Open Smile or an Open Frown, so aim to keep Partials no more than half as open as you depict standard mouth types that have parted lips. By their nature, partials can suggest other mouth types based on which shape you select for them. You can include them when creating Between expressions (see opposite page) to indicate a transition to another mouth type, but the core purpose of Partials is providing options when you want to draw a Neutral expression.

Partials can show teeth. Those without teeth are filled in black while those with teeth are drawn as an outline shape.

Partials on a front-facing head are centered horizontally on the Center Guideline. The

Basic Pieces of Partials

Mouth Anchor Point is located at the top of Partials not showing teeth. It is found at the vertical center of Partials showing teeth.

Treat the upper shape of all Partials as you would a Neutral Mouth when you tilt a head. The overall rectangle-with triangular-caps-shape bends to the same degree as the upper line of a Neutral Mouth on a tilted head, while the small lower line of a Partial mimics the lower lip line of a Neutral Mouth on a tilted head.

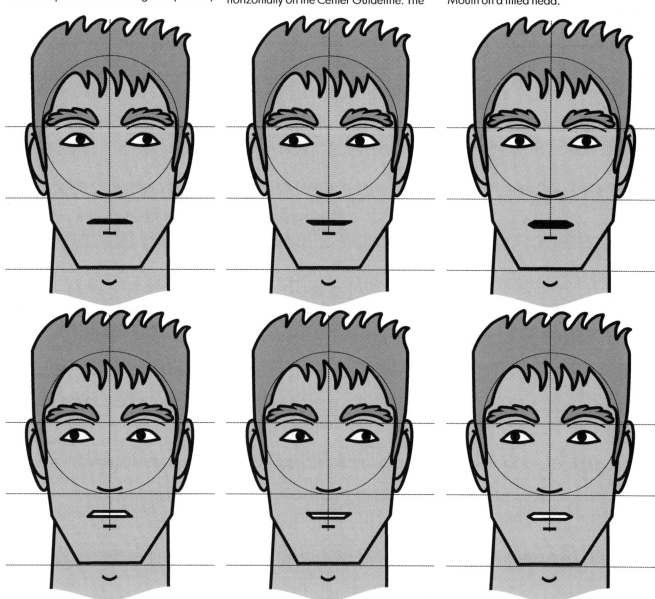

FRACTIONS

Fractions are when you decide to intentionally include less than the whole of a feature on a face. You and viewers instinctively know that certain lines of the feature must exist - indeed your minds will subconsciously fill in the missing segments - so as the illustrator, you are willfully excluding a tiny bit or even most of the lines to add to the variation in your artwork.

In sequential art, the amount of fractions can change from image to image and even from face to face. Just because you exclude a particular line or piece of line on one character does not mean it has to be the same for other characters in the same image or subsequent images. At any point, you can restore any or all of the missing pieces as well as shrink the size of fractions or use more of them on any given face. Use of and changes to fractions are independent of any use of or change in expression or any head turn, twist, or tilt.

When you initially learned the first steps to creating a face, you also learned to use a common fraction - the simple curve that represents the bottom of the nose tip. This single line invokes the remainder of the nose feature in the mind of a viewer without needing any more clues to know what it is. Similarly you could show just the nostrils (without the curve for the bottom of the nose tip) and the openings would invoke the rest of the nose. These are two examples of a bare minimum threshold needed to convey

a feature. You want to be careful not to create a fraction so small or one so hard to identify that viewers no longer comprehend it as a viable piece of the facial feature.

The two approaches to fractions are: draw part of the facial feature and gradually add to it, or draw the entire facial feature - every line - then gradually subtract from the whole by erasing bit by bit. Either approach works to get to the fraction you believe best for your drawing. The subtraction method is often easier for creating fractions on head turns, twists, and tilts. Remember to draw lightly when creating fractions until you find the one that pleases you. Then darken the lines of the fraction you decide to use.

Fractions can also be created using shading in conjunction with lines from a facial feature - as long as you still meet the bare minimum threshold for the fraction to be easily understood. The keyword is easily. You don't want viewers to have to stop and ponder what they are seeing. If you have any doubt, add a bit more to the fraction.

Common fractions also include eye creases, contours (Brow, Cheek, Mouth, Chin, Front Side Neck), and the outer outline of the upper and lower lips. Fractions can be symmetrical or asymmetrical. They can appear by themselves or in concert with others on one or both sides of a face.

The same character is illustrated in each of the five examples on this page. All show a Neutral expression, but each one contains different fractions to add variation.

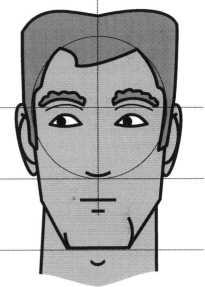

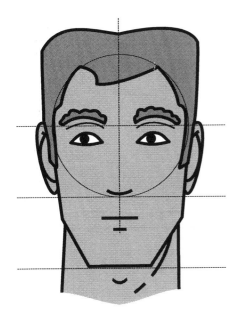

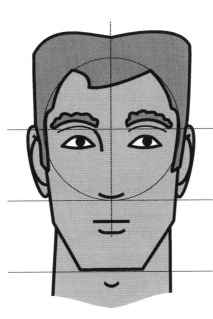

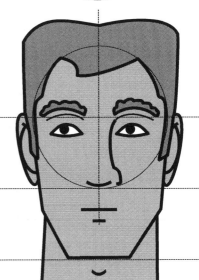

MIXTURES

The specific combination of features on a particular character is its mixture. Does the face routinely show select contours such as Cheek Contours? If so, are they high, middle, or low - short, medium, or long - wide, moderate, or narrow? Does the face include the outer outline of the lips? What type of nose does the face have? Is the nose wide, slim, pointed, rounded, or squared? Is the nose drawn with or without the alae showing, and with or without tilted or visible nostrils? Is the face drawn with eye creases and which type of crease? What is the hairstyle? Will close-up details come into play? If this character is part of a larger project with other characters, how will this face integrate or contrast with other faces?

ELEMENTS
Mixtures can incorporate some, most, or all potential elements of the face. These include inner and outer facial features, contours, fractions (these would permanently be part of the face design, rather than their normal temporary, fluctuating manifestations), and Extras (discussed in the next chapter) as well as any other component such as pieces of an outfit, uniform, or costume.

DESIGN SKETCHES
Sketch a number of possibilities to try out mixtures to find the one that most fulfills the vision of the character you wish to create.

You will create lots of drawings when you are sketching. Not all will work out. It is perfectly okay and to be expected. Some will be strange, while others will be close but not quite what you want, so you keep making changes and adjustments until you are satisfied. Save any rejected designs you think might work for other characters.

Grant yourself permission to be creative when sketching, which is the time during character design to have fun and exercise your imagination. Go out on a limb as you explore your whims, follow your gut feelings, and pursue the options to see where they lead your designs.

Sketches get messy - filled with erase marks, stray lines, a little bit of this and that. To clean them up at any time and tighten your work, cover the design with another sheet of paper and trace the best lines you pluck from the underlying "messy" sketch.

Keep drawing and exploring options. Adjust the evolving results revision-by-revision until you reach your final character design.

ASSIGNING MIXTURES
Mixture elements can be consistent across all faces within a single picture or across the entire project. For instance, all noses on all faces regardless of character may have squared alae and high Cheek Contours.

Mixture elements can be assigned to types of faces to cluster characters together. For example, good folks could have rounded noses with alae, bystanders could possess single-curve noses without alae, and bad folks could have pointed noses with alae.

Mixture elements can be individualized for each character in an image or project.

DEFAULT EXPRESSION
The default expression for a character is also part of its mixture. While a Neutral expression is the most common one given to faces, any expression can be assigned as the default for the character. It is the automatic expression a face assumes when the person's mind is not focused on anything that would distract it from expressing its default.

Give careful consideration to the default expression for characters since it provides visual insight into and reflects their overall personality and outlook on life, the world in general, their circumstances or upbringing, or their reaction to the immediate events unfolding about them. A sour curmudgeon might possess a Displeased, Appalled, or Miffed default expression, while a brave do-gooder might have a Focused, Proud, or Confident default expression.

MODEL SHEET
If you are designing a recurring character for sequential art, create a model sheet for the face. A model sheet consists of several drawings of the character (with guidelines) on a piece of paper. The six drawings are: forward-facing head, left and right two-fourths head turn, left and right sideways head, and backward-facing head. Include additional turns, twists, and tilts as needed to convey any particularly complex design.

During your project, the model sheet of the character provides an easy reference so you don't have to commit all the details of the face or its mixture to memory. Write any helpful notes about the face, mixture, and character on the model sheet. In the upper right corner, label the model sheet with the name of the project and the name of the character. Keep model sheets for a project filed together for quick access and easy storage during work on the sequential art.

Model sheets exist so that you or any other artist working on the project can study and apply it to reproduce the character.

EXAMPLE OF NOTES ON A MODEL SHEET

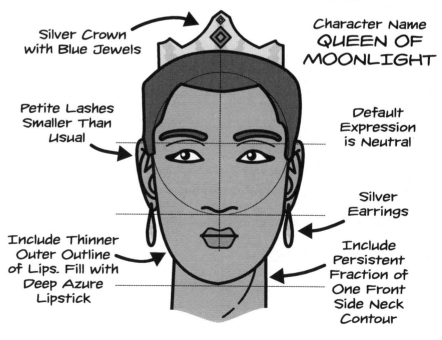

Silver Crown with Blue Jewels

Character Name
QUEEN OF MOONLIGHT

Petite Lashes Smaller Than Usual

Default Expression is Neutral

Silver Earrings

Include Thinner Outer Outline of Lips. Fill with Deep Azure Lipstick

Include Persistent Fraction of One Front Side Neck Contour

EXTRAS

Extras are optional additions or enhancements to your drawings. These were saved for last so that you'd have solidly practiced the core construction skills leading up to this point before considering their application to your images.

Incorporate some or all of them. Study each one. Try it out. You can add these extras to your earlier faces (the ones you drew in this book, for example) to see how they impact your creations before deciding which ones, if any, you want to apply to future faces.

The familiar faces illustrated in this section are the same ones created in the hairstyles section - rather than introducing new ones - so you can focus on the particular extra that has been applied to them.

Mouth Corner Marks

Lips merge together at the corners and tuck into the flesh of the cheek, forming Mouth Corner Marks. They are prominent on some folks (as illustrated on this page) and nearly invisible on others (smaller than illustrated or not included at all). Draw these marks as little arcs at the corners of the mouth. One arc appears on each side of the mouth and curves out away from the Center Guideline. They appear at the top for open smiles and at the bottom for open frowns or grimaces. On some people just the lower half of the marks appear at the corners - in which case draw only the lower half of each arc (or draw the full arc and erase the top half). To "aim" the curves of the marks - regardless of mouth type - imagine the arcs like "satellite dishes" beaming a signal towards the spot where a Neutral Mouth crosses the Center Guideline - a third of the way between the Nose and Chin Guidelines (i.e. the Anchor Point you already learned in Mouth Close-Up Details).

Lower Line of Lower Lip

If you show the full lower lip filled, you can either still keep the smaller lower mouth line as usual (*illustrated, near right*) or you can show the entire outer perimeter line of the lower lip (*illustrated, far right*). If you show the perimeter, make certain it reflects the upward or downward curve, or straight line as the case may be, of the smaller lower mouth line (which is part of the perimeter).

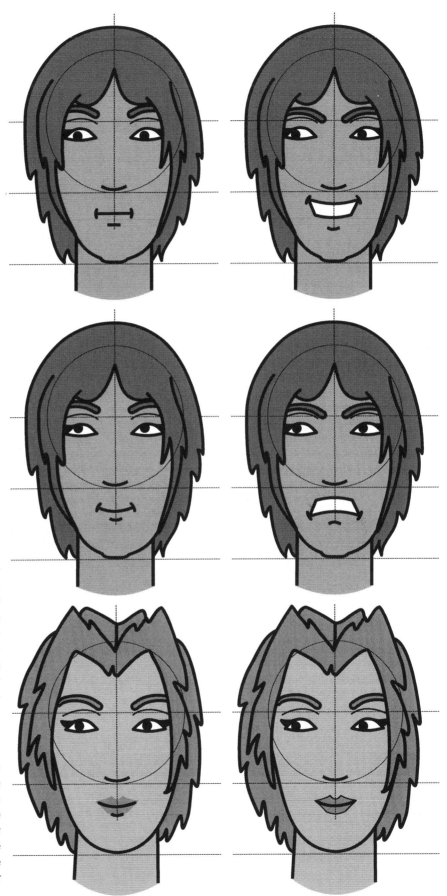

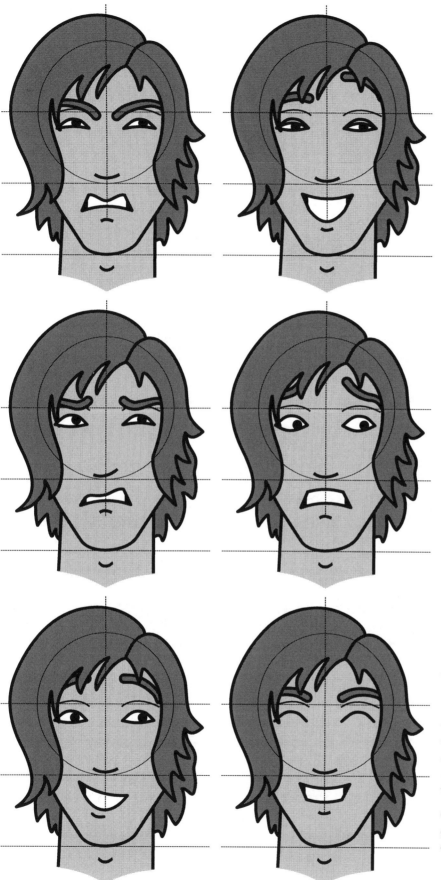

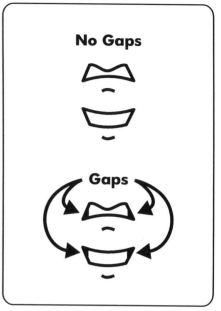

Mouth Gaps

For simplicity, mouths containing teeth are drawn showing all white from one side to other with no gaps. However, the lips of many people stretch wider than their front teeth, so mouth gaps on either side of the teeth can be used to reflect this reality while simultaneously conveying the hollowness of the mouth cavity that contains the teeth.

Select the width of the teeth on your face. A good general rule is slightly wide than the space between the inner corners of the eyes. They draw a vertical line inside the upper and lower lip lines on either side of the teeth. Then fill in any leftover space flanking the teeth. Regardless of the mouth type, the width of the teeth should remain constant. On a Slanted Teeth Open Grin, only one gap is visible and appears on the raised side of the mouth.

The gap rules described so far apply to mouths showing teeth on forward-facing heads. For front-facing heads that are not forward-facing, only the gap (if any) on the far side of the mouth is drawn. The gap (if any) on the near side of the mouth is no longer visible once the front-facing head turns from being forward-facing.

On sideways and back-facing heads, no gaps are visible from these angles so you don't include them.

218

No Teeth Wedges

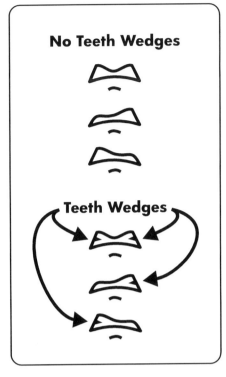

Teeth Breaks

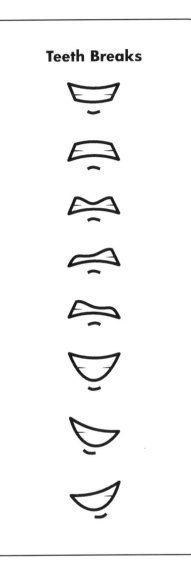

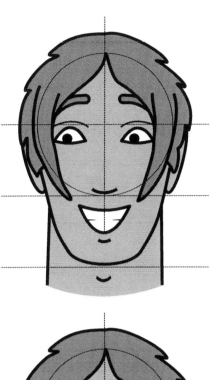

Teeth Marks

Two varieties of teeth marks apply to certain mouth types. These are teeth wedges and teeth breaks.

Teeth Wedges apply to Teeth Grimace and Teeth Lopsided Grimace. They are small, solid triangles placed midway down the side of the grimace. They have a tip aimed inward at the Mouth Anchor Point (i.e. the spot where a Neutral Mouth would cross the Center Guideline). The triangle outer edge occupies a third of the edge of the mouth and sits slightly below the halfway point of the edge so the upper teeth appear slightly taller than the lower teeth above and below the triangle. Wedges extend inward a third of the distance from the edge of the mouth to the Center Guideline.

Teeth Breaks appear at the separation of the upper and lower teeth in mouth types where the teeth are visibly touching. The Mouth Anchor Point determines the vertical placement of where to draw teeth breaks since the anchor point indicates the bottom of the upper teeth. Draw them parallel to the Nose Guideline coming from the sides of the mouth. Each generally has a length equal to half the distance from the edge of the mouth to the Center Guideline, but their

length is not set in stone since they are simply hinting at the horizontal division between the teeth and need not be equal to one another. They can change length from expression to expression and can even be drawn a new length if you show the same expression or mouth type more than once (such as drawing a character repeatedly in sequential art). Try out different lengths to see the effects on your particular character. These marks are helpful since it is impractical to draw individual teeth on faces that are a mid-range-and-beyond distance from the viewer. Teeth breaks can also be used in close-up in lieu of drawing individual teeth.

Upper Lip Dip

Some individuals have a more noticeable contour on their upper lip when the flesh is not stretched out. To add this detail, place a small V-shaped dip into the center of the upper lip line when you draw any closed mouth configuration for the character.

Indentation Above Lips

An indentation above the lips is called the philtrum. Its edges extend from the inside corners of the nostrils down to the "peaks" found near the center of the top line of the upper lip. This gently-recessed feature is elastic so its appearance changes slightly whenever the attached upper lip stretches or contracts. Its shape closely resembles a downward-facing teardrop with its top cut off.

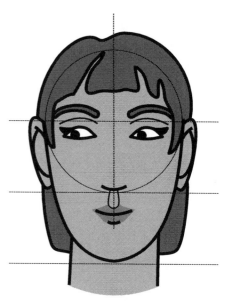

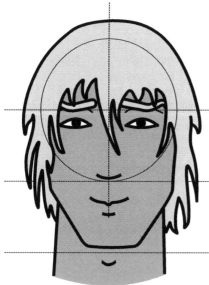

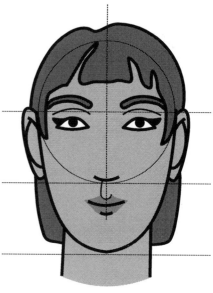

Another way to describe its shape is the letter U with its tips pinched inward a bit. The bottom ranges from smoothly curved like a semi-circle to more squared-off with rounded corners. The tips of the U-shape begin just on either side of the flap of skin that separates the nostrils on the underside of the nose. The arc at the bottom of the indentation shares the same space as the center dip in the top line (i.e. the center curve connecting the two "peaks" of the top line) of the upper lip. If you include only the bottom line of the upper lip without also drawing the top line of the upper lip, you still can draw the bottom of the indentation if you want to include this entire feature on the face. You can also partially draw this feature - just one side edge, or a side and the bottom edge, or the bottom edge and just a bit of the side edges - if you like that particular look better for your character design.

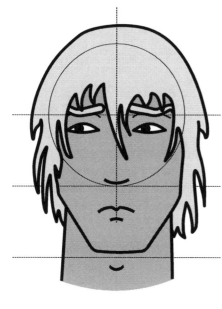

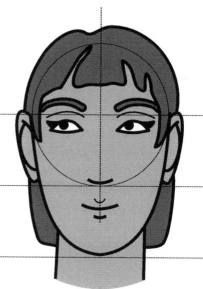

Teeth Option in Roaring Mouth & Gaping Frown

The Close-Up Details of Roaring Mouth and Gaping Frown include the teeth. The basic versions of Roaring Mouth and Gaping Frown omit the teeth. If you wish, you can include them in the basic versions of these mouth types. The Roaring Mouth would show upper and lower teeth, while the Gaping Frown only reveals lower teeth. The lower line of upper teeth should pass through the Mouth Anchor Point (i.e. where a Neutral Mouth cross the Center Guideline). Lower teeth should not be taller than upper teeth. In a Roaring Mouth, the upper line of the lower teeth should gently curve downward

in the middle from the edges to indicate the jaw has dropped and swung backward a bit. In a Gaping Frown the upper line of the lower teeth is straight horizontally since the dropped jaw of this mouth type is pushing upward against the force of its own muscles that are pulling the lips downward. These opposing forces result in the lower teeth being kept more level. If you decide to use them, teeth should be included when the face draws nearer. They should be excluded once the face gets farther away to make reading the mouth expression easier.

Eyeglasses

Think of eyeglasses as three main parts - temples that rest on the ears, lenses that rest in front of the eyes, and a bridge piece that rests on the bridge of the nose. You have already been drawing lots of eyes so start with the lenses. Select a shape for them. It can be identical for both lenses or their shape can mirror each other on either side of the Center Guideline. Base the positioning of lenses relative to the eyes so when eye placement changes you can adjust the location of the lenses accordingly.

Next draw the bridge of the glasses. It connects the inner edge of both lenses. In its simplest form, the bridge of eyeglasses is a single line that arcs over the bridge of the nose from one lens to the other. An easy way to place the single line is to imagine it would reach the inner corners of the eyes if you were to continue its arc. The bridge piece also can be thick but its bottom edge will typically be curved to fit comfortably across the nose of the wearer.

Lastly draw the temples, the namesake bars which cross the temples of the wearer on either side of their head. These sidebars run from the outer edge of a lens to the Ear Anchor Point at the top front of the ear. Base where each temple connects vertically to a lens on where the bridge piece vertically meets the lens. They generally attach to a lens at a similar, if not equal, level.

Lenses can be left without shading, shaded lighter than surrounding flesh tones to indicate regular glass, or shaded darker for sunglasses. Make sunglasses very dark instead of pure black if you want the eyes still visible and able to be read for expression.

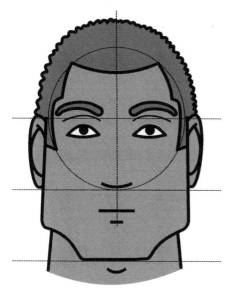
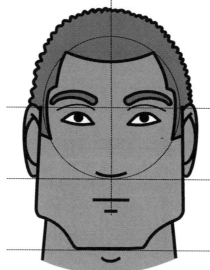
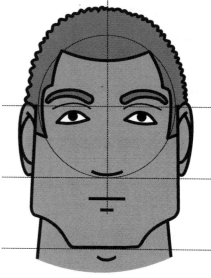

Eye Tilt

Eyes have a natural variation in their tilt. Some pairs are level, which is how you have drawn them so far. Other pairs tilt inward towards the Center Guideline or outward away from it.

To draw level pairs, you have placed four starting dots (representing the corners of the eyes) the same distance below the Eye Guideline. To draw inward-tilting eyes, put the dots for the inner corners of the eyes at the same spot as you do for level eyes and place the dots for the outer corners slightly higher than you do for level eyes. To create outward-tilting eyes, draw the dots for the outer corners of the eyes at the same location you do for level eyes and draw the dots for the inner corners of the eyes slightly higher than you do for level eyes.

The reason you raise either the outer or inner dots but keep the other dots in the same spot as level eyes is to ensure the overall eye does not sink farther down the face. Regardless of the Eye Tilt, the lowest part of any eye will still rest a quarter of the way between the Eye and Chin Guidelines. Other than this new placement of corner dots for eyes with an inward or outward tilt, you create eyes using the same remaining steps you have been using to create level pairs.

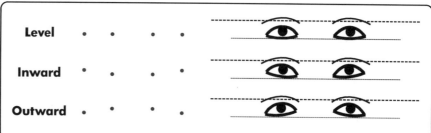

Eye Impairment

To indicate a temporarily or permanently damaged, impaired, or blind eye, change the black circle to a light tint. On a detailed eye, draw the pupil outline and fill it with a light tint instead of black.

Power Eyes

Some characters might be super-powered, supernatural, magical, cybernetic, and so forth where you want to showcase their special nature using one or both eyes. To create Power Eyes, remove the black circles from the eyes. Fill the eyes with a color other than white, steering clear of hues that could be mistaken for closed eyes.

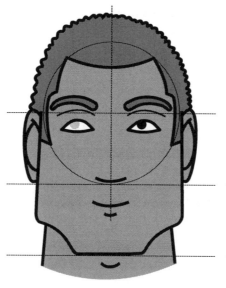
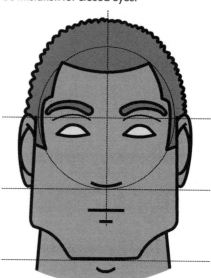

Split Eyelashes

Eyelashes are drawn as a single unit to maximize their ability to be "read" when faces are drawn in the distance. As a face gets closer, you can keep them together or split the unit apart into two or more forms. Draw these divisions in the same location and with the same curved shape as the original single unit. Make them more narrow (and inner ones a bit shorter) the more forms you cluster together. Regardless of the num-ber, only place them on the outer half of the lower line of the upper lid.

Varied Eyelights

If you decide to include eyelights, you can draw more than one in each eye. Both eyes should have the same number in the same location (i.e. not mirrored). The shape of eyelights can also be changed to a square or triangle shape, but bend all sides slightly so the lines become gentle arcs, reflecting the curvature caused to straight lines that travel over the surface of spheres or domes.

Pinpoint Pupils

Halve the diameter of the circles in the eyes from one-third down to one-sixth the width of the eye. The remainder of the eye stays the same. Pinpoint Pupils are often applied to fearful and insanity-based expressions to take them to a more extreme level, but they can be applied to any expression to add hysteria, craziness, or mindlessness. Use them sparingly to maximize their impact.

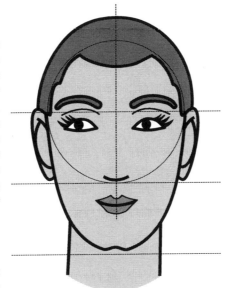

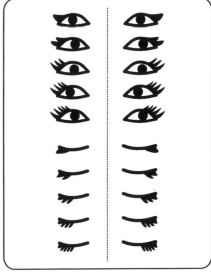

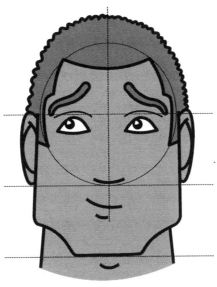

Single Eyelight

Double Eyelights

Triangular Eyelight

Square Eyelights

Bags under Eyes

Draw a curved line under each eye. The curve should be slightly less wide than the eye itself, should mirror the arc of the Ridge Guideline above it, and should sit at a spot that would be the same distance below the lower lid line of a Neutral Eye as the Ridge Guideline sits above the upper lid line of a Neutral Eye. This location sets each curve where the bottom of each eye socket would be if you could see the sockets under the skin. Sockets are also known as orbits of the eye. The bags are a result of puffiness in the soft tissue found below the eyes. Causes of bags under eyes include sleep deprivation, illness, exhaustion, fatigue, worry, and eye strain.

BODILY FLUIDS

Since faces are a part of living organisms, they are subject to the everyday mechanisms of being human, including bodily fluids. These are tears, snot, sweat, drool, and blood.

Bodily fluids do not spontaneously appear for no reason. They occur in reaction to an event or exposure such as physical activity, emotion, hunger, illness, allergies, dust, heat, cold, and damage. Some factors impact their depiction:

1) Bodily fluids flow at different rates. Blood is thicker than water, which means it does not flow as fast. Drool is watery but it can also be frothy, which slows flow.

2) Bodily fluids are active elements. If you are drawing sequential art, you must change the appearance (amount, location) of bodily fluids as time progresses in the series of images.

3) Bodily fluids can change consistency and color. Over time, snot and blood dry, crust, and flake away. Both grow darker in color during the drying-out process. Blood starts vibrantly red and shiny but dries to deep reddish-brown and dull. Snot starts amber and glistening. It dries to yellowish-gray and matte. Some color will remain as stains on any absorbent material like most fabrics. Plastics and metals are generally immune to permanent staining. Tears leave temporary stains on absorbent materials but they vanish when the liquid evaporates in average or above temperatures. In cold temperatures, bodily fluids will freeze to the face, at which point any facial movement may cause them to crack and fall away.

4) Bodily fluids are bound by the effects of environment. Under normal circumstances, they are pulled downward along the contours of the face. In zero-gravity settings such as space, they will flow outward away from the face. Strong air currents can defy gravity's pull on the liquid. The tears of a person with watering eyes in a windstorm or in an open-top racecar will flow in the direction of the powerful gusts. Likewise, the blood from a head wound on a skydiver will flow upward as the injured daredevil plummets through the atmosphere. A quick snap of the head can send drool flying.

Tears

Tears can emerge from the inner and outer corners of eyes. Sometimes just one corner of one eye produces a tear, while at other times tears are shed by the inner and outer corners of both eyes. Tears can also well up along the lower lid of the eye and cascade together, streaming freely as they fall. Tears happen in response to emotions (like pain, sadness, pain, fear, empathy, grief, joy), to irritants (like smoke, smog, sandstorms), and to physiological changes (like eating spicy food or chopping onions).

Snot

Mucus drips from one nostril or both. It can appear as a thick, slow flow or a thin, swift faucet of snot. Mucus can flow on its own as a result of an illness or allergy. It can also be triggered when tears flow from sadness.

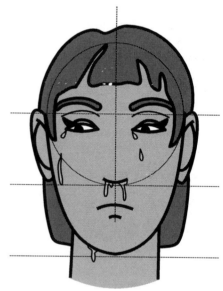

Viewed from the front, a drop is symmetrical. From the side, a drop has the shape of the surface under it on one side and the bulge of the liquid on the other.

Liquid pools along the underside of surfaces so its upper edge matches the shape of that surface. Its lower edge wavers and begins to form drops, which elongate and eventually pinch off from the main mass as independent pieces.

An elongated drop has a bulbous tip and an extended tail. The liquid tends to cling and spread out a bit along its path as it travels.

Drool

Drool appears at the corners of the mouth and will cascade over the entire lower lip if the person starts to salivate uncontrollably. Drool can be triggered by hunger, desire, even loss of mental faculties. A slobbering kiss can result in drool as can taking a punch to the jaw. Chugging a drink can leave drool dangling from the corners of the mouth, while spitting liquid can also leave drool - typically near the center of the bottom lip. Coughing up water can result in drool at both corners of the mouth or across the entire lower lip. Some people drool out one corner of their mouth when they doze off.

Sweat

Sweat forms as beads on the skin and drips downward when enough surfaces. The forehead, the temples, and the neck are common places for the formation of sweat. It also forms on top of the head and drips down from along the hairline. Depending on its style, sweat-soaked hair may take on a different appearance. Common causes of sweat are external heat (e.g. weather, spotlights, fire), exertion (exercise, combat, lifting), illness (fever, chills), and emotional state (anxiety, fear, anger, anticipation).

Blood

Unlike other bodily fluids which routinely occur without a second thought, blood is triggered by trauma such as an impact, an illness, a fall, or a fight. Blood can come from the mouth, nose, ears, or wounds to the face or neck.

For the mouth and nose, treat blood like you were drawing the outline for drool and snot respectively. Blood from the mouth can originate from a split lip or from inside the mouth - for example, a bitten tongue, dental damage, or internal bleeding. Common causes of nosebleeds are sudden pressure changes, brain injury, and impact to the nose from a punch or kick.

For ears, treat drawing blood like drawing tears, except the blood comes out of the ear canal, pools on the underside of the ear, and drips down from there. Blunt-force hits to the skull and proximity to an explosion are causes of bleeding from the ears.

For wounds, first determine their cause to find the type of edge to draw. Slashes, stabs, and life-draining vampire bites have smooth edges, while chainsaws, barbed whips, and savage werewolf bites inflict wounds with jagged edges. Your character's background or profession (e.g. ninja, soldier, superhero, crimefighter) will often dictate the types of injuries the person may experience. First draw the wound - the slice or tear. Then draw blood flowing from it.

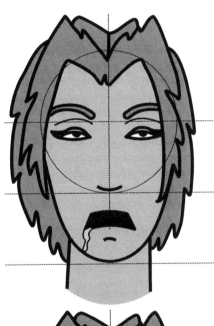

Wrinkles and Crinkles

Think of wrinkles as permanently-etched skin lines on the face as a result of time and repetitious stretching and contraction of the tissue. In contrast, consider crinkles as a way to describe temporary wrinkles - ones that appear as a result of specific facial muscle movements and vanish from view otherwise. The three main wrinkles that can also be crinkles are the brow wrinkles, nose wrinkles, and eye wrinkles.

Draw brow wrinkles by extending the inner ends of the Ridge Guidelines to continue their curve down and inward towards the Center Guideline, arcing upward before they reach it and curving slightly away from the Center Guideline. If there are eyebrows in the way, the brow wrinkles will curve beneath them - hugging their underside - before heading upward. Brow wrinkles are symmetrical on some faces and lopsided on others (both in length and in distance from the Center Guideline).

Draw nose wrinkles by placing one-to-four upward curves that travel across the region where the lower part of nasal bridge meets the upper part of the nasal ridge between the eyes. These curves share the same arc as they cross the Center Guideline, but draw them asymmetrical by chopping off a bit of one tip or the other to keep them organic.

Eye wrinkles appear at the outer corners of the eyes. They match the curvature of the underlying bone structure of the eye socket in the skull. Draw two-to-five arcs. Lower ones gently curve downward and higher ones gently curve upward. Vary the length if you wish - some longer, some shorter - or make them roughly the same length. In any event, they should not be much longer than the diameter of the black circle of the eye (i.e. one-third of the width of the eye). Place them near but not touching the eyes or one another to avoid being mistaken for lashes.

Crinkles only appear when certain facial features are present in expressions. Brow crinkles appear for Inward Slope Eyebrow and Dipping Eyebrow, while nose crinkles appear for Lifted Nose and Slanted Nose. Eye crinkles appear for Narrow Eye and Upturned Eye.

Scars, Tattoos, Birthmarks

Scars, tattoos, and birthmarks must follow the contours of the face.

Scars develop during the healing process of scrapes and wounds. Draw scars with a thinner line than other features. Decide the cause of the scars and try to imagine what pattern they would take on the skin. For example, a claw attack or an animal bite would tear flesh differently than the slice of a sword. Regardless of the cause, the thin outlines of scars should be asymmetrical, generally jagged, and filled with a lighter tint of flesh tone than the surrounding tissue.

Tattoos are composed of text, pictures, or both. Draw them entirely black or draw just their outlines, which can optionally be filled with colors or shades of gray. Unlike scars, draw the outlines of tattoos smooth-edged and artistically purposeful since tattoos are mini works of art on the skin.

Birthmarks range from a tiny region of flesh all the way up to a large piece. Most have an asymmetrical, irregular shape. To create a birthmark, shade a skin patch distinctly different than the adjacent tissue. The color difference may be abrupt and sharp. Since the texture remains unaltered in the skin of a birthmark, an outline is not drawn around the affected skin (unlike scars).

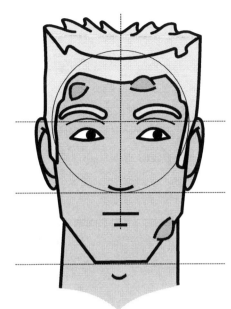
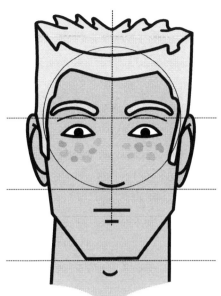
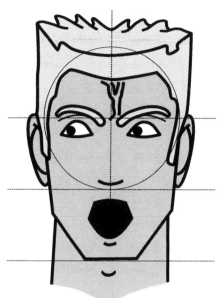

Lumps and Bumps

Lumps and bumps on skin can be temporary or permanent. Some happen suddenly from swelling such as being hit with a blunt instrument, being stung or bitten by an insect, or being exposed to a disease, heat, or to an irritant that triggers a skin reaction.

Lumps and bumps can be quite large or small and can appear solo or in multiples. Common ones are blisters, welts, pimples, boils, moles, warts, and natural variations in skin.

Draw lumps and bumps using two curves. One line arcs gently indicating where the protrusion contacts the surface of the skin, while the other line arcs more than the first and represents the rise of the lump or bump. Keep one or both ends of the two lines separated by a bit of space to indicate the object is still connected to the surrounding tissue. If the lump or bump is viewed from the top, draw both arcs equally but keep both ends a bit apart. Shade lumps and bumps a different shade than nearby skin.

Chin Upper Line

Draw a gentle upward arc or a straight line so that its tips aim to connect to the tops of the Chin Contours. This Chin Upper Line can stand alone or be included with Chin Contours. The Chin Upper Line is a distinct feature on some faces and not notably visible on others. It is illustrated to the right with Cheek, Mouth, and Chin Contours.

Freckles

Draw freckles as small patches of shading without discernable outlines being different from their fill color. Lack of an outline indicates their flush-with-the-skin nature. As the face gets closer to the viewer, draw more patches while at a distance, draw them as clusters of freckles portrayed as relatively-larger patches. Freckles run the entire wonderful range of human skin color and should contrast faintly-to-strongly with the predominant hue of the character. They can be sparse, moderate, or abundant and can appear gathered together in select regions such as the forehead and upper cheeks, or spread-out across the face.

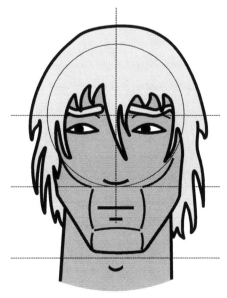

Veins

Blood vessels raised above the surface eventually go back beneath the skin. So, the key is to draw only the sides of the veins but do not cap off the ends. Leave the tips open to depict the veins heading back under the surface of the skin.

A common vein on the face is a forehead one running from near the hairline to the bridge of the nose. It may be visible at all times on some people or only appear during stress, anger, or physical exertion. Raised veins on the head or other parts of the body are more frequently seen on fit individuals, muscular people, and emaciated humans (where loss of body tissue makes veins stand out). Since these veins protrude, they are subject to the same shading approach you apply to other protruding features such as the nose (e.g. lighter tones on the areas with illumination and darker tones on the areas in shadow).

Veins running completely beneath the skin but close to the surface should be drawn using subtle shading or muted red and blue to show blood with and without oxygen traveling from and to the heart and lungs. These types of veins may be visible on the nasal ridge of aging faces when the blood vessels rupture. They also may occur on the faces of people exposed routinely to very cold climates where near-frostbite triggers veins to appear under the surface of the nose and upper cheeks.

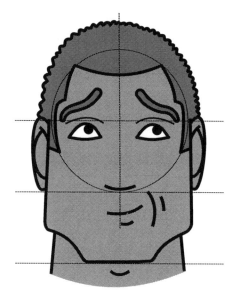
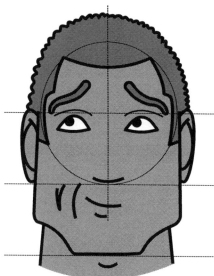
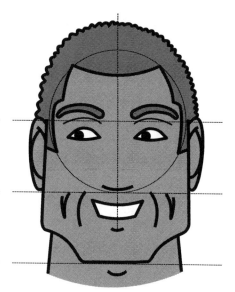

Dimples

The surrounding muscles controlling the mouth cause the Mouth Contours flanking (but not touching) the lips. On some individuals, the muscles along with the flesh of the cheek form small ripples beyond the Mouth Contours. These are dimples - small indents in the cheek - just beyond the Mouth Contours - which appear in response to the upper muscles on one or both sides of the mouth pulling away from the Center Guideline, such as when a person smiles or grins. Slanted Closed Smile, Slanted Open Grin, and even Slanted Neutral Mouth cause one dimple to appear on the same side as the raised side of the lips, while Closed Smile, Teeth Open Grin, Narrow Open Grin, etc. triggers both dimples.

Dimples can be prominent or subtle (e.g. longer or shorter, deep or shallow). Their curve echoes the general curve of their respective Mouth Contour. Draw a dimple as a single curved line outside the Mouth Contour but still inside the jawline in the flesh of the cheek. Since they appear when the corner of the mouth is pulled outward and upward, the curve of the dimples should reflect being pulled outward and upward. If the main curve of the dimple were downward, the line could be mistaken for a puffed cheek. You can also draw the dimple as a curving V-shape with the inner branch of the V longer than the outer, and both curving - the inner more than the outer branch of the V-shape. Include a fractional or full adjacent Mouth Contour whenever you draw a dimple.

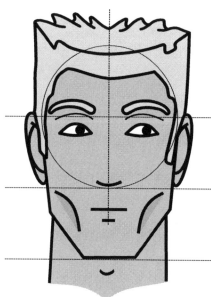

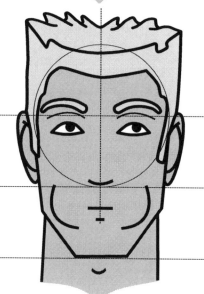

Sunken Cheeks

Some faces have Sunken Cheeks. Draw two curves bending towards the Center Guideline. The lines start below the Nose Guideline and under the Cheek Contours. They remain outside the Mouth Contours and end near but outside of the top of the Chin Contours. This is their maximum length, so shorten them from either or both ends to make them less pronounced. Also, since they are recessed into the flesh of the cheeks, they must be shaded accordingly. For example, in overhead light, they would have a shadow within them. Light shadow means shallow Sunken Cheeks, and dark shadow reveals deep Sunken Cheeks.

Puffed Cheeks

Characters can puff out their cheeks with air, liquid, or food. Draw two curves bending away from the Center Guideline starting at the Nose Guideline and ending slightly below the small line representing the bottom of the lower lip. This means Puffed Cheeks will appear differently based on the mouth type of the face. In any case, the point of the puff farthest from the Center Guideline should be found somewhere along the bend of the curve, closer to the middle, and never at the very beginning or ending of the curve. Puffed Cheeks can protrude out over (and hide) a stretch of the jawline if you decide to draw them farther horizontally from the Center Guideline. The curves of the Puffed Cheeks will always fall outside any Contours (Cheek, Mouth, Chin) you might include on a face.

Breath Lines

Draw lines gently curving away from the mouth. A few should be close but not touching the mouth. Others can begin a bit of a distance away, but collectively these Breath Lines should show the air current moving out and away from the mouth. Create a few curls and place them near the ends of some of the other lines or mingle them among the other lines. Vary the amount of curl in each curl to make them each unique. More Breath Lines means a stronger flow of air.

Add Puffed Cheeks (see the explanation on the opposing page) to indicate a strong exhalation, but don't fully inflate the cheeks since they are already expelling air as indicated by the Breath Lines.

Inhaling reverses the direction of the curls to show the air flow towards the mouth. To indicate a strong inhalation, the cheeks are pulled inward, becoming concave. Use the same starting and ending points as Puffed Checks and change the curve to be inward towards the Center Guideline rather than curved outward away from it. Cheeks are only pulled inward if the face has a Small Rounded Mouth. If you use another type of mouth, the cheeks are not affected by the suction. These inward cheeks are placed closer to the mouth than Sunken Cheeks.

Without Alae Creases	With Alae Creases

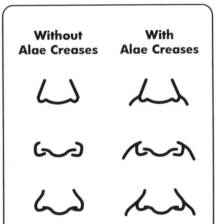

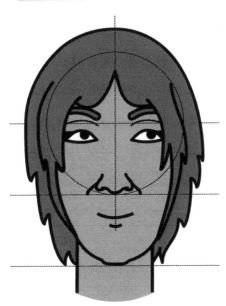

Alae Creases

Alae Creases form where the skin covering the nostrils meets the inner lower edges of the cheekbones. These creases effortlessly blend from the top of each ala (where the ala turns inward towards the ridge of the nose) down towards the point where the Cheek Contour meets the Mouth Contour. If an ala changes position, then the top end of the crease goes with it. The ending points of the creases change position whenever the Mouth Contours change position based on the movement of the mouth. You do not have to include Cheek or Mouth Contours when you include Alae Creases on your faces but you should still determine where the contours would have appeared so you can accurately aim the ends of the creases.

The look of Alae Creases depends on the character. Some faces have very subtle creases, while others have deep creases. Creases can also be very short, moderate, or long. Long creases blend into the Mouth Contours. These merged, continuous lines run from the top of the alae down to the top of the Chin Contours, following the path of the Mouth Contours. Both creases share the same length and appearance. Some subtle creases may be invisible on faces with a Neutral Expression but appear during expressions with a mouth type other than Neutral Mouth or a nose other than Neutral Nose. On some faces, the Alae Creases (and Mouth Contour, if any) are visible even during a Neutral Expression.

GROWING YOUR SKILLS

You will never accidentally grow your skills, because it takes thoughtful practice to get better. Your use of this guide is an example of the dedication you have to your craft. It is this commitment that's essential to growing your skills. Here are additional activities I find helpful.

BREAKDOWNS

Along the way while practicing with this guide, you have acquired an extra skill: breakdowns. You now see complex faces with expressions for their components - their contours, their edges, their inner features, their outer features, and how these all are interrelated. You have the ability to focus on just one aspect of a face at a time, picking it out from the whole rather than letting the entirety overwhelm you and prevent you from tackling it one piece at a time. You can also now contrast faces with one another, noting the details that make each unique.

Doubtless you will find yourself applying this extra skill as you observe all the faces with expressions around you. You may catch yourself analyzing people even when you don't start out to do it. That's a good thing. You'll grow your mental library of the diversity found in humans and this will only serve to further strengthen your power to bring your artistic pursuits to life.

STRUCTURE OVER MEDIA

As an artist you can apply your keen eye while enjoying the work of others. When you see pieces that enchant you, study them to separate the structure underpinning the art from the media used to convey it, such as paints, pastels, pens, pencils, pixels, or any combination. Some will be easily understood, while others will take more effort to comprehend.

The most stunning, detailed rendering will have a basic foundation beneath it, just like bones and muscles holding up a beautiful body, or timber and masonry supporting a magnificently-decorated building. Don't be dissuaded by the seemingly-complex nature of a piece. At face value and first glance, artworks in a medium such as paint or computer pixels may appear daunting, but

think of them like a large banquet table fit for royalty. It is dazzling to behold and scrumptious to consume, yet ask the kitchen staff and they've learned each achievable, mundane part. They know the ingredients of each dish, how to combine them, how long to bake them, and how to set the table one piece after another until the appealing whole comes together after adequate time, energy, and thoughtful consideration are devoted to seeing it come to pass. Becoming aware of the structure hidden under any media covering it is a smart place to begin understanding any work, while awareness that complex undertakings can be broken into reasonable, simple steps is key to accomplishing any complicated work.

That said, it is easy to become enthralled by complex art accomplished with paint, pen, pastels, or pixels. New and developing artists can mistakenly undervalue using pencil and paper, when in reality pencil and paper are the most powerful of media because they are readily available, portable, quick-to-use, erasable, and most-importantly the foundation for the use of other media. Art created with paint, pen, pastels, or pixels is often first drawn with pencil and paper.

UNREALISTIC PERFECTION

Facial features are typically symmetrical - two eyes, two ears, two nostrils, two alae, etc., but it is important to understand that symmetrical does not mean a mirror image if you split a face down the middle into its two halves. You want to avoid unrealistic perfection.

If you were to split and mirror the left and right sides of an average human face, you would end up with two different-looking faces from the original one. That is a result of imperfection built into faces - the same subtle imperfection inherent to organic forms and most environments. If both sides were perfectly identical mirrors of one another, the face would take on an alien, artificial, sterile, even mechanical appearance.

So, it is acceptable, even helpful, if pairs of facial features (eyes, ears, etc.) are similar but not perfectly-equal mirror images. Your eyes expect the imperfection in what you view and readily notice its absence. Its presence or lack thereof is regarded as a quick mental indicator separating the organic world from any artificial subjects. This

overall idea is an extension of the rule of avoiding "doll eyes" by not placing the circles of eyes in the same spot within their respective eye - symmetry without mirrored equality. You want to avoid human faces being those of dolls or mannequins. If you get that impression from a face, check that you haven't inadvertently made it too mirrored down the middle.

ORGANIZE

At this point, you have created plenty of pictures. Organize your drawings so you can reduce the time it takes to locate ones you want to use for projects, for inspiration, or for display. Break your characters down by age and gender to create an easy-to-implement basic cataloging system for your artwork. Begin with six basic categories: female, male, younger female, younger male, older female, and older male.

When you start a project, create a fresh category named after the project. Check your six basic categories for any characters you want to use in the project or as inspiration for the project. Pull these out and make a copy of them. Place the copy of that character into the new project folder. Put the original back into its basic category and keep it there, because even though you may use the character in your current project, it can still serve as inspiration or a launching point for other projects. If you decide not to use the character after all, just discard and recycle the copy from the project folder since you know you kept the original safe.

Also for the same reasons, when you create any new drawings of characters for a project, create a copy to put in the project category and make certain the original is placed in one of your six basic categories so you have it to use in other projects or for inspiration. In the end, all your originals are collected in the six basic categories.

If need be, you can subdivide each of the six basic categories using genre. Place the genre of the picture in parentheses behind the basic name - for instance, female (sci-fi), younger female (western), male (horror), older male (fantasy), older female (mystery), and so forth, keeping the original six basic categories grouped together regardless of genre since characters from one genre may still inspire pictures in another.

Upon completion of any project and before proceeding to the next one, file away the folder for the finished project with previous project folders. Since all of your characters reside in one of the six basic categories, you don't have to go searching through project folders to find and view them.

HABITS

Becoming and remaining organized with your artwork is great timesaver and a really good habit to acquire. Another helpful habit is routinely making time to practice your skills to keep them sharp and expand them. Set aside part of your daily schedule. Even on your busiest days sneak in a few minutes to do some drawing. If you look for time to sketch, you will be surprised when moments pop up - waiting in line, being a passenger traveling by train, car, truck, ferry, bus, or airplane, between bites of a meal, during commercial breaks in your favorite shows, while listening to an outdoor concert, when winding down just before you go to sleep, or any other opportunity that presents itself. Creating a face here and there adds up in a hurry. Each is a step in your journey to bolster and reinforce your confidence, style, and skills.

SKETCHING AND REFINING

If you had to list ten colors, you could name them rather quickly. If you had to list which colors are best for a particular costume you would have to give it some more thought. That is the core difference between sketching and refining. Both are necessary to grow your skills.

Consider sketching as the best way to toss out ideas rapidly and off-the-cuff. You are not going to be overly critical of your sketches. You are just going to get them down on paper so you can see how they take shape. Limit the amount of time you devote to any single sketch. Three minutes at most is a good restriction to aim for. One minute is even better. The power and purpose of sketching is to be quick and nimble, with your creativity leading the way while getting apprehension and self-doubt out of the way of drawing freely.

A series of sketches is your opportunity to visually brainstorm so you can try variations on your desired subject matter. The most captivating interpretation of a char-acter might not be the first one. Sometimes it is created later on, for instance after the third, fourth, or fifth sketch. As you draw, you can always incorporate parts of earlier sketches into later ones, but observe the time limitation you set when creating each one.

Refining is the stage when you study your sketches and pluck out the best one, or the most-promising pieces of multiple sketches you want to merge into the finished piece. Refining is taking the time to smooth out lines, erase unnecessary marks, add final shading and coloring, and so forth.

Time management becomes paramount. Refining takes additional time - minutes, hours, even days. The extra amount is perfectly okay if needed to do the job right. What you are aiming to avoid is engaging in refining on a piece that isn't worth the investment of that time in the first place, such as faces with fundamental flaws in their structure or ones that don't otherwise fulfill your goals for the drawing.

That's why you employ sketching with a time limit. Without a limit, you may segue into refining and not realize it - an easy mistake to make that wastes your time without making real progress. Just set the drawing aside when you reach the time limit and start anew. Remember you can still incorporate elements you like from previous sketches, including the one you just set aside, but start fresh so you don't inadvertently get trapped spending your valuable time refining a flawed drawing.

If your drawing is larger than a face, apply the sketching time principle to each major element of the intended image. Combine together the best of the best from all your sketches of the separate elements for a final drawing you can be confident refining.

STRETCH YOUR RANGE

Don't just draw the familiar. You will be better able to translate your artistic vision to paper if you acknowledge and push past your comfort zone when drawing. For example, the greater the diversity of people you tackle in your drawings, the more empowered you become as an artist when your storytelling calls for a particular character or when you want to introduce more depth or greater impact to the storytelling by ensuring more variety in your project.

ON THE GO

Carry a pocket-sized pad of paper and a writing instrument wherever you go since ideas can appear at any time - in front of you or in your mind's eye. By quickly jotting down a sketch or some notes you free yourself to continue observing the world for insight and inspiration.

Learning to draw in public is important. It builds your confidence as an artist. Make a point out of going outside and practicing your drawing skills. Other folks might show interest in what you are doing, because many often don't see people exercising their creativity publicly. Pay it no mind if it disturbs you to have attracted the attention of others. Chat with any onlookers who strike up a conversation. You will routinely want opportunities to speak with others as an artist to share your vision and interests, so strengthen your interactive conversation skills whenever you get the chance.

RULE BREAKER

You've learned the rules in this guide. Now you are allowed to break them since, rather than arbitrarily, you know to do so only when it best serves the portrayal of your particular character. For example, you know about eye tilts, so perhaps also tilting the Ridge Guidelines will give a face the look you want in your artwork. You know the proper size for eyes, but you might decide to expand the eyes on a face to create a special extra-wide-eyed character. When you have any doubts or things don't appear right to you, you know how to head back to the rules to restore the balance to the face before exploring any other rule-breaking changes.

Several types of drawing are intentionally based on twisting or distorting the rules. Manga, anime, toons, 3D character animation, and so forth routinely exaggerate some features while diminishing others. However, the underlying structure and relationships of the facial features in these kinds of drawings remain aligned with, and built upon, the core rules.

PERSIST

Simple and direct: Keep practicing, nurture your talent, and never give up on yourself. No one can take your artistic spirit from you.

INDEX

29478981R00129

Made in the USA
Lexington, KY
30 January 2019